Portraiture and social identity in eighteenth-century Rome

Manchester University Press

Portraiture and social identity in eighteenth-century Rome

Sabrina Norlander Eliasson

Manchester University Press
Manchester and New York
distributed in the United States exclusively by Palgrave Macmillan

Copyright © Sabrina Norlander Eliasson 2009

The right of Sabrina Norlander Eliasson to be identified as the author of this work has been asserted by her in accordance with the Copyright, Designs and Patents Act 1988.

Published by Manchester University Press
Oxford Road, Manchester M13 9NR, UK
and Room 400, 175 Fifth Avenue, New York, NY 10010, USA
www.manchesteruniversitypress.co.uk

Distributed in the United States exclusively by
Palgrave Macmillan, 175 Fifth Avenue, New York,
NY 10010, USA

Distributed in Canada exclusively by
UBC Press, University of British Columbia, 2029 West Mall,
Vancouver, BC, Canada V6T 1Z2

British Library Cataloguing-in-Publication Data
A catalogue record for this book is available from the British Library

Library of Congress Cataloging-in-Publication Data applied for

ISBN 978 0 7190 7596 4 *hardback*

First published 2009

18 17 16 15 14 13 12 11 10 09 10 9 8 7 6 5 4 3 2 1

The publisher has no responsibility for the persistence or accuracy of URLs for external or any third-party internet websites referred to in this book, and does not guarantee that any content on such websites is, or will remain, accurate or appropriate.

Typeset by SNP Best-set Typesetter Ltd., Hong Kong
Printed in Great Britain
by CPI Antony Rowe, Chippenham, Wiltshire

Contents

List of figures	*page* vi
Acknowledgements	ix
Introduction	1
1 Of Rome or in Rome? Laying claim to the imaginary and the real	26
2 Mythological adaptations: gender and social identity	60
3 'Fare accademia': Arcadian discourse and social preservation	105
Conclusion	151
Bibliography	161
Index	171

List of figures

1 Teodoro Matteini, *Sigismondo Chigi visits the archaeological site at Castel Fusano*, 1792. Private Collection, Rome. Photo: Istituto Centrale per il Catalogo e la Documentazione. page 27
2 Agostino Masucci, *Equestrian portrait of Camillo Rospigliosi*, 1737. Museo di Roma, Rome (MR 765). Photo © Comune di Roma, Museo di Roma. 28
3 Giovanni Domenico Porta, *Equestrian portrait of Pope Clement XIV, 1770s*. Whereabouts unknown. Photo: Istituto Centrale per il Catalogo e la Documentazione. 29
4 Giovanni Paolo Panini, *Roman ruins*. Courtesy of Nationalmuseum, Stockholm. Photo © Nationalmuseum, Stockholm. 34
5 Pompeo Batoni, *Portrait of Peter Beckford*, 1766. Courtesy of Statens Museum for Kunst, Copenhagen. Photo: Statens Museum for Kunst, Copenhagen. 38
6 Pompeo Batoni, *Portrait of Richard Cavendish*, 1773. Chatsworth: Devonshire Collection. Reproduced by permission of the Duke of Devonshire and the Trustees of the Chatsworth Settlement. Photograph: Photographic Survey, Courtauld Institute of Art. 42
7 Pompeo Batoni, *Portrait of John Peachey later 2nd Baron Selsey*, 1774. The Edward James Foundation, West Dean, West Sussex. 43
8 *Mersham Hatch, Kent. The dining room*, 1921. Photo © Country Life Picture Library. 48
9 Bernardino Nocchi, *Portrait of Camillo Borghese*, 1798–99. Galleria Sabauda, Turin. Reproduced by permission of Ministero per i Beni e le Attività Culturali. 50
10 Hugh Douglas Hamilton, *Portrait of Frederick Hervey Bishop of Derry and Fourth Earl of Bristol*, c. 1790. Courtesy of National Gallery of Ireland. Photo © National Gallery of Ireland. 53

List of figures

11 Unknown artist, *Portrait of Cornelia Costanza Barberini as Diana*, 1740s. Private Collection, Rome. Photo: Witt Library, Courtauld Institute of Art, London. 65

12 Jean-Marc Nattier, *Portrait of Louise d'Orléans, Duchess of Chartres as Hebe*, 1744. Courtesy of Nationalmuseum, Stockholm. Photo © Nationalmuseum, Stockholm. 66

13 Carlo Maratti, *Cleopatra*, 1690s. Museo Nazionale di Palazzo Venezia, Rome. Photo © Istituto Centrale per il Catalogo e la Documentazione. 78

14 Pompeo Batoni, *Cleopatra*, c. 1744–46 (copy). Collezione Pallavicini, Rome. Photo: Istituto Centrale per il Catalogo e la Documentazione. 79

15 Attrib. Marco Benefial, *Portrait of unknown Lady as Cleopatra*, 1740s. Courtesy of Collezione Lemme, Rome. Photo: Collezione Lemme, Rome. 81

16 Pompeo Batoni, *Portrait of Girolama Santacroce Conti at her dressing table*, 1760. Museo di Roma. Rome (MC 138). Photo © Comune di Roma, Museo di Roma. 82

17 Alexander Roslin, *Portrait of Maria Felice Colonna, Duchess of Buccheri and Villafranca*, 1750s. Åmells Konsthandel/Fine Art Dealer. Reproduced by permission of Åmells London/Stockholm. 83

18 Sir Joshua Reynolds, *Kitty Fisher as Cleopatra*, 1759. Kenwood House/The Iveagh Bequest, London. Photo © English Heritage Photo Library. 85

19 Pompeo Batoni, *Portrait of Francis Bassett*, 1778. Courtesy of Museo del Prado, Madrid. Photo: Museo del Prado, Madrid. 90

20 Gavin Hamilton, *Portrait of Douglas Hamilton, 8th Duke of Hamilton and 5th Duke of Brandon, Dr John Moore and Sir John Moore as a young boy*, 1775–77. Scottish National Portrait Gallery, Edinburgh. Photo © Scottish National Portrait Gallery, Edinburgh. 92

21 Pompeo Batoni, *Portrait of Sir Sampson Gideon and an unidentified companion*, 1767. Everard Studley Miller Bequest, 1963. National Gallery of Victoria, Melbourne, Australia. Photo: National Gallery of Victoria, Melbourne. 96

22 Pompeo Batoni, *Portrait of Lord Archibald Hamilton*, 1760s. Formerly Dunbrody Castle. Photo: Photographic Survey, Courtauld Institute of Art. 98

23 Pompeo Batoni, *Portrait of Giacinta Orsini Boncompagni Ludovisi, Duchess of Arce*, 1757–58. Courtesy of Fondazione Cassa di Risparmio di Roma, Rome. Photo: Fondazione Cassa di Risparmio di Roma. 106

24 Antonio Canevari, *Project of the theatre of the Accademia dell'Arcadia, Bosco Parrasio*, 1727. Courtesy of Accademia di San Luca, Rome. Photo: Accademia di San Luca. 116
25 Jonas Åkerström, *The reunion of the Accademia dell'Arcadia 17th of August 1788*, 1790. Courtesy of Nationalmuseum, Stockholm. Photo © Nationalmuseum, Stockholm. 117
26 Antonio Canevari, *Project of the theatre of the Accademia dell'Arcadia, Bosco Parrasio*, 1727 (detail). Accademia di San Luca, Rome. Photo: Accademia di San Luca. 119
27 Marco Benefial, *Paola Odescalchi Orsini and her children Giacinta and Filippo Berualdo*, 1746. Museo di Roma (MR 16957), Rome. Photo © Comune di Roma, Museo di Roma. 122
28 Pompeo Batoni, *Portrait of a Lady of the Leeson family as Diana*, 1751. Courtesy of National Gallery of Ireland, Dublin. Photo © National Gallery of Ireland. 127
29 Pompeo Batoni, *Portrait of Sir Matthew Fetherstonhaugh with wreaths of fruit and corn*, 1751. Uppark, The Fetherstonhaugh Collection (accepted in lieu of tax by H.M. Treasury and allocated to The National Trust in 1990). Photo © NTPL/John Hammond. 130
30 Pompeo Batoni, *Portrait of Sarah Lethieullier, Lady Fetherstonhaugh as Diana*, 1751. Acquired by the National Trust from the family in 1971. Uppark, The Fetherstonhaugh Collection (The National Trust). Photo © NTPL/John Hammond. 131
31 Pompeo Batoni, *Portrait of the Rev. Utrick Fetherstonhaugh as Apollo*, 1751. Acquired by the National Trust from the family in 1971. Uppark, The Fetherstonhaugh Collection (The National Trust). Photo © NTPL/Prudence Cuming. 132
32 Carlo Maratti, *Self-portrait with the Marquis Niccolò Maria Pallavicini (Il Tempio di Virtù)*, 1692–95. Stourhead, The Hoare Collection (The National Trust). Photo © NTPL/John Hammond. 137
33 Pompeo Batoni, *Portrait of Sir Wyndham Knatchbull-Wyndham*, 1758. Los Angeles County Museum of Art, Gift of the Ahmanson Foundation. Photo © 2006 Museum Associates/LACMA. 139
34 Laurent Pécheux, *Portrait of Margherita Gentili Sparapani Boccapaduli*, 1777. Private Collection, Rome. 141
35 Unknown artist, *Portrait of a Lady with Cameo cabinet*, eighteenth century. The Walters Art Gallery, Baltimore. Photo © The Walters Art Gallery, Baltimore. 143
36 Sir Joshua Reynolds, *Portrait of Lady Elizabeth Compton*, 1780–82. Andrew W. Mellon Collection. Image © 2006 Board of Trustees, National Gallery of Art, Washington. 152

Acknowledgements

In 2003 I discussed the doctoral thesis on which this present book is based at the Department of Art History at Uppsala University. I wish to thank Manchester University Press for believing in the project and its staff for guiding me through the production process with extreme professionalism and patience. Publishing with MUP has been a true delight!

Although quite different processes, both the completion of the thesis and the subsequent genesis of the book version have gained the interest and support from many people to whom I am deeply grateful. Solfrid Söderlind, my supervisor at the time, set out to follow my work with enthusiasm, acuteness and intellectual generosity. Most of all she trained me into independence, perhaps the greatest gift a scholar might give a pupil. The Department of Art History at Uppsala University constituted an inspiring and friendly environment during my postgraduate years. I am grateful to Hedvig Brander Jonsson, Jan von Bonsdorff and Marta Edling for their constant interest and encouragement. A heartfelt thanks goes to Marta for her never-fading advice and for offering such excellent comments on my writings. Over the years Pamela Marston has patiently and determinedly supervised my language use. Without her sensitive reading and engaged work this book would not have made it to the shelves.

During my time as Assistant Professor at the Department of Art History at Stockholm University I had the pleasure of working in a stimulating environment from which the work on this book greatly benefited. My greatest debt is to Margaretha Rossholm Lagerlöf whose continuous interest and encouragement offered me support and challenging discussions. I also wish to thank Tomas Björk for kind and constant interest in my work and for great talks on art history in general.

Research and teaching are intricately and passionately intertwined. I wish to thank the postgraduate seminar at the department for constantly keeping me on my toes and whose different projects and approaches inevitably have influenced my own work. A special thanks goes to Sonya Petersson and Anna Maria Hällgren for allowing me to follow them through their postgraduate studies.

My time as a guest student at the Courtauld Institute of Art, University of London has been essential to my writing in many ways. I wish to thank my adviser at that time David Solkin for challenging discussions at a crucial point of the work process. Matthew Craske offered generous help and advice for which I am very grateful. Alastair Laing and Robin Simon showed great enthusiasm at different points. My dear friend David Beavers offered hospitality and never-ending support during solitary London days.

Shearer West's interest in my work has been fundamental to the development of the present book and her generous and kind advice during the whole process has been treasured. I also wish to thank Fintan Cullen for his very kind interest in some of the book's themes and for inviting me to join the conference *Display and spectacle* at the Department of Art History, University of Nottingham in 2006. Some of the points that appear in this book were published in the volume *Spectacle and display* and I wish to thank all the conference contributors for great discussions that proved helpful during the completion of the book.

My present colleagues at the Swedish Institute of Classical Studies in Rome have over a number of years offered a stimulating environment for both junior and senior scholars. I wish to thank Margareta Ohlson Lepscky Stefania Renzetti, Astrid Capoferro and Pia Letalick for their generous attitude and professionalism. My predecessor at the Institute, Börje Magnusson, has always showed a kind interest in my work for which I am very grateful. The interdisciplinary atmosphere of the Institute has been truly inspirational. I wish to thank the colleagues from the area of Ancient History and Archaeology, Hedvig von Ehrenheim, Kristian Göransson, Ulf R. Hansson, Dominic Ingemark and Jenny Wallensten, for discussions and insights that proved important in many ways. A special thanks goes to Lars Berggren and Annette Landen for great talks on Rome and art history in general.

Most parts of the book were written in Rome during the start of a new research project. These somewhat difficult working conditions were wonderfully smoothed by the helpfulness demonstrated by a number of people who took care and interest in the book's process. The Department of Art History at the Università degli Studi di Roma Tre has over the years always offered me generous interest. I wish to particularly thank Enzo Borsellino for inviting me to lecture on some of the book's themes. The vibrant enthusiasm that the late Stefano Susinno showed for my work will always be treasured in my memory. Liliana Barroero has constantly offered me great support and advice for which I am very grateful. At the British School at Rome Susan Russell invited me to hold a lecture on Arcadian classicism and its social implications, which proved helpful for the completion of the book's third chapter.

Research in Rome is mostly a pure delight. My deepest gratitude goes to the patient staff at the Soprintendenza Archivistica per il Lazio and the Sopraintendenza per il Polo Museale Romano, in particular Maria Giulia Barberini, Fausta

Dommarco and Angela Negro. Angela D'Amelio at the Museo di Roma helped me out a number of times as well as Angela Cipriani at the Archivio Storico dell'Accademia di San Luca. The Archivio Doria Pamphilj was generously opened to me by Alessandra Mercantini. The helpful and efficient staffs at the Biblioteca Apostolica Vaticana and the Archivio di Stato di Roma deserve sincere praise. Helpful staff of the Photographic Survey, Courtauld Institute of Art, the Witt Library, National Trust Picture Library, Istituto Centrale per il Catalogo e la Documentazione and the Soprantendenza per il Polo Museale Romano provided me with the book's pictures.

Some of the owners of the art works discussed in the book generously opened their homes and offered me kindness and unforgettable hospitality. In this respect I wish to express my deepest gratitude to Giovanna Barberini, Laudamia del Drago and Fabrizio Lemme.

The research on which this book is based would not have been possible without generous grants from several Swedish foundations. I therefore wish to express my gratitude to Fondazione Famiglia Rausing, Stiftelsen Svenska Institutet i Rom, Birgit och Gad Rausings Fond för Humanistisk forskning, Helge Ax:son Johnssons Stiftelse, Stiftelsen Torsten och Ingrid Ghils fond, Ingenjören CM Lericis stipendium, and Torsten och Ragnar Söderbergs Stiftelser.

Friends and colleagues in Sweden have patiently seen me through phases of moaning and exuberant enthusiasm. I wish to particularly thank Charlotte Bydler and Christina Zetterlund for reasons they know. Victor Edman, Stefano Fogelberg Rota, Linda Hinners, Helena Kåberg, Merit Laine, Martin Olin and Lisa Skogh have all been there during the last few years and in different ways been supportive. A special thanks to Stefano for our fantastic talks on Arcadian wonders!

My family in Stockholm and Rome have constantly shown interest and much-needed support for which I am eternally grateful. A particular thought goes to my youngest cousin Tommaso Bergamo who patiently has undertaken the task of driving me around the Roman countryside in search of *documenti sperduti*!

Erik Eliasson shares with me this life of research. His intellectual poignancy, determination and wonderful sense of humour are my guiding lights in everyday life. This book is for him.

Introduction

In 1967, on the occasion of the Pompeo Batoni exhibition in Lucca, the curator Isa Belli-Barsali wrote the following in regard to the artist's rich production of Grand Tour portraits:

> The profusion of monuments and ancient statues was probably desired by the commissioners themselves, as not only a dutiful statement of the new excavation passion but also as a documentation or as a sentimental memory of an intellectual journey. However, these ancient objects never appear in the portraits of Roman princes.[1]

The last sentence of this quotation captures the departure point of this study. The Grand Tour portrait's stereotypical formula, based on classicised landscape settings, well-known antiquities, travel props and slim, elegant young males has come to be viewed as an emblem for the canonical narratives on eighteenth-century European history of art, particularly that of Rome. The vogue for Antiquity, an increasing art market, a cosmopolitan attitude, extensive collecting and architectural enterprises with the purpose of housing museums are only some of the practices and statements that have been linked to the British Grand Tour portrait and its readings. Belli Barsali's initial words entirely confirm this view. Yet she unconsciously reverses the narrative by introducing the existence of other groups of actors within the Roman field, ones who evidently did not visually respond to the ancient heritage in the same way as their British counterparts. This small but significant detail in her text hints at an alternative narrative concerning art (in particular portraiture) and its social function in eighteenth-century Rome, one which would have been difficult to formulate in the 1960s. The text confronts the existence of two groups of portrait commissioners, and singles out the fact that one of these groups constitutes the actual inhabitants of the City, while the other does not. Although Belli Barsali discussed the reasons behind the Grand Tour travellers' wishes to incorporate connoted props within their Roman portraits, she neglected to explore the reasons why Romans wanted to avoid them. Although not fully expressed, the fact that the Grand Tour portrait setting evidently did not correspond to

the needs of the Roman elite as to how to forge a particular relationship with the ancient past is hinted at by Belli Barsali. These apparently different attitudes, particularly regarding their visual results, constitute the topic here.

This study examines portraiture produced in eighteenth-century Rome for the British and the Roman elites. It questions and contrasts the different social discourses which regulated these groups' use of the concept of Antiquity, here mainly understood as 'Rome', and its implications in terms of social affirmation and manifestation. The book explores how the idea of Roman Antiquity could be adapted in order to express and elaborate contemporary myths regarding social status, gender and the material and metaphorical appropriation of land, directly connected to the making and preserving of social status. Moreover, the study discusses these portraits side by side and confronts them as art works produced in the same geographical location, yet ultimately destined for different national contexts. The book's main aim is ultimately to examine the differences between these apparently similar paintings, read directly in relation to the social needs and presumptions of sitters who belonged to the same social class, yet were defined by different elite cultures. My interest in these issues derives from a sceptical attitude towards examinations of eighteenth-century portraiture and its settings and social uses, which see it as a homogeneous practice among the European elite groups.

Contrary to what might be implied by the first lines of this introduction, this study is not about the Grand Tour. Yet it has the aim of acknowledging the Tour portrait, as it was conceived and elaborated by the artist Pompeo Batoni, as a specific kind of 'British' artwork without isolating it from the Roman context in which it was produced. Thus, the study will discuss the Tour portrait with reference to the distinct discourses of the British and Roman elites, in which the experience of the foreign as well as the expectations of the familiar constituted important parts in a process of social affirmation. Political rhetoric, class identity and eventually class mobility were phenomena that influenced the use and elaboration of classical Antiquity. Given the primary position that portraiture held in eighteenth-century England, it is obvious that the varied socio-cultural use of the classical past would be exploited within the portraits' settings. The Grand Tour portrait, however, was a specific portrait type, commissioned and produced outside the home country and eventually shipped back to England in order to take its place within a context of domestic dignity. It must thus be considered as an object made to function outside its context of origin, and beyond the circumstances of its commission. Despite the apparently homogeneous character of the Tour portrait, it is also important to acknowledge those differences that occurred within the genre itself. Settings created for travellers in Venice and in Rome were different.[2] The cities' diverse connotations within the general culture of travel created different conditions for portraiture. Consequently, the Tour portrait made several statements that were connected to the

expectations and aims of travel, but it also skilfully and clearly commented upon the sitters' future in social terms. In the implicit narrative scheme, the antiquities present in the paintings or the general classical setting sought after by the painter play fundamental roles as signifiers. But how far can the reading of these objects be taken? In Pompeo Batoni's portraits of British travellers, the necessary classical elements in the forms of antiquities were always provided with great detail in order to give the audience the possibility of identifying the objects. However, traditional scholarship on Batoni has overlooked the antiquities as important components within the artist's Tour portraits. Despite the fact that a great effort has been made to identify them, their most probable role as chosen signifiers was never discussed further.[3] In recent years there have been healthy attempts to bring attention to this particular omission.[4] The selection, use and elaboration of the classical past in Batoni's oeuvre deserve to be carefully read, since this would more clearly reveal in which ways the ancient past could have been used for contemporary purposes. The particular use of signifiers relating to the idea of Antiquity is consequently examined in their role as desirable metaphors for two elite cultures that were both undergoing transformation.

A scholar on eighteenth-century Rome is confronted with a number of major historiographic issues. Christopher M.S. John's introductory article in the exhibition catalogue *Art in Rome in the eighteenth century*, which accompanied the Philadelphia show in 2000, clearly demonstrates this.[5] Certain fundamental aspects of the field's scholarly tradition are of direct importance for this study, and for a general understanding of the canonical writings on eighteenth-century Roman art.

In 1966, Francis Haskell published his classic work *Patrons and painters: A study in the relations between Italian art and society in the age of the Baroque*. It soon gained the status of an essential work on the relations between commissioners and artists in Italy from the early seventeenth century up to the second half of the eighteenth century. In the preface to the first edition, the author stressed that the study would not address the social scene of eighteenth-century Rome. Instead, Haskell focused all his attention on the Venetian context, emphasising that it was in the city of *la Serenissima* that conditions for a fruitful art scene in eighteenth-century Italy could flourish. Interestingly enough, the groundbreaking 1959 show *Il Settecento a Roma*, in which an impressive number of Italian scholars shed light on the multifaceted artistic contexts in eighteenth-century Rome, must have escaped Haskell's attention.[6] The second edition of *Patrons and painters* was prepared in 1979. In the meantime, the so-called period of 'decline' of eighteenth-century Rome had gained some defenders among Anglo-Saxon art historians. In a review published in *Apollo* in 1963, Hugh Honour elegantly accused Haskell of preserving a 'charmingly old-fashioned distaste for Neo-classicism'.[7] The upswing of the Roman art scene in this context was definitely due to a wish to upgrade this particular style category. With such

an aim in mind, it became difficult to overlook the Roman situation, which, however, was considered a secondary parallel to the artistic productions of pre-revolutionary France with its so-called 'second generation' of Neo-classicists, represented by Jacques-Louis David and his pupils. In his preface to this second edition, Haskell gave respectful credit to pioneering Anglo-Saxon eighteenth-century Rome scholars, including Ellis Waterhouse, Hugh Honour and Anthony Morris Clark. Nevertheless, he was firm in his characterisation of the period's art in Rome: an eclectic production based on the previously gained artistic experiences of the classicism of the sixteenth and seventeenth centuries, conditioned by a socio-economic structure that could no longer provide the great papal commissions of the Baroque era. In this respect, Haskell decided openly not to modify *Patrons and painters* and, consequently, eighteenth-century Roman art remained (at least within the context of Haskell's oeuvre) fixed in a category of exclusion from the canonical narrative of the Western History of Art.

More than forty years have passed since Haskell and Honour diplomatically challenged one another. The scholarly field regarding eighteenth-century Rome has since changed and expanded within both Italian and Anglo-Saxon contexts.[8] Diverse academic discourses have created different paths in which the social history of the Roman art scene, explored through extensive archival research, has been intertwined with critical approaches and specific examinations of the city's art market, the cultural policies of the popes, and different artists. Despite this richness, the field suffers a discrepancy that is due to a gap between the explorations of new material and the need for continous historiographic revision. Without pleading for a synthesis of the kind seen in *Patrons and painters*, the field would nevertheless acquire more clarity if the revision of the established narratives could interact more with the empirical enterprise that is, and must continue to be, ongoing. One difficulty lies in the lack of correlated examinations of those different national groups who lived and operated in eighteenth-century Rome. A common way of describing the city and its art scene in this particular period is by defining it as a cosmopolitan centre, a rather common trope in textbooks and exhibition catalogues. Matthew Craske has convincingly attacked this particular construction, arguing that cosmopolitanism constitutes an ideal of homogeneity that does not correspond to the presence of national subcultures in the city.[9] There are, however, reasons to argue that 'cosmopolitanism' has served a specific rhetorical purpose within writings on eighteenth-century Rome. It has provided a particular unifying theme that has helped to assemble and capture specific characteristics of a certain period in the city's history. In this sense, 'cosmopolitanism' has been used to represent novelty. This is essential within canonical writing, as novelty is that element which allows the narrative to develop. Yet the ideal of cosmopolitanism and the multi-national presence in Rome was not an eighteenth-century phenomenon, and it should not be historically described as such. The criticism regarding the concept of

cosmopolitanism as promoting the idea of a universal discourse of civilisation and taste is approached in this study in a specific manner. The examination of the social use of Antiquity as an existing or non-existing visual sign in elite portraiture is carried out through *contrast*, not with the ambition of securing the idea of a European, 'cosmopolitan' elite dependent on the same social and cultural discourse.

In contrast to the idea of Roman classicism as a universal pictorial language, it is possible to discuss apparently similar specimens within very different contexts. The approach to the ancient past was determined by a desire to appropriate it. Portraiture produced in Rome for sitters with different national identities demonstrate this process of appropriation. The idea of Rome was a complex discourse in itself, in no small part because closely linked to formal classicism as expressed through the Roman school of painting. In 1809, Luigi Lanzi (1732–1810) described the characteristics of this school in the following manner:

> Based on these good principles, that school was formed which we call Roman, more due to the place than the nation, as I noted previously. As the people of that city form a mist of many languages and many nations, among whom the grandchildren of Romolus are the few, the school of painting has therefore always been inhabited and supplied by foreigners, always accepted and hosted by that school and within its academy of San Luca viewed as if they were born in Rome.[10]

Despite the fact that this text describes the characteristics of the institutional practice of painting, with the ambition of categorising a specific Roman style, it equally relates to the consumers as well as the producers of art.[11] Rome represented a centre in which people from all over the Italian peninsula and Europe lived and operated. Lanzi stresses the difference between the actual topographic location of the city ('luogo') and the political definition of it as the capital within the Papal States ('Nazione'). To acknowledge this paradoxical dichotomy between the idea of 'Rome' and its socio-political equivalent is a necessary step in order to fully grasp the visual productions that the city produced and adapted for an entire continent, and the use that these art consumers made of these particular objects.

It has been suggested that the idea of Rome spread from the city throughout Europe as a homogeneous conception of Western cultural dogma through literary codes, pictorial evidence and ancient cultural items.[12] This assumption is certainly right. Yet the discussion may be taken a step further, to test the idea that this homogeneous conception may have originated in Rome. However, once distributed into another country, the possibilities of use and interpretation shifted and changed character, according to socio-cultural needs which were different from those that were current in the city. The elite groups at stake in this study shared a common view on ancient Rome as a multifaceted code in terms of socio-cultural and political discourse. They embraced this code, and

used it for their own status affirmation within an expanding social field. Nevertheless, there were great differences in how this use was displayed and visualised and how these groups claimed their right to their adaptations of the code. One important factor involved the actual vicinity of that real and imaginary territory that was Rome. Different positions in terms of geographical belonging in relation to the city created different strategies in order to appropriate it. Visual manifestations like portraiture depended heavily upon this difference.

The European elite and the use of 'Rome'

The history of the European elite is not uniform. Medieval theories concerning the duties and rights of the aristocracy were expressed through the ideas of military protection and governance. The foundations of genealogical thinking placed the nobles as heirs to the early conquerors of Europe, and they subsequently were expected to occupy a social position of dignity.[13] During the eighteenth century, the European nobility diminished in comparison with previous centuries. Its political function shifted variously according to different social ideals, and so did its social appearance. An example of this shift is illustrated by the modern version of the *Cortigiano*, the gentleman who, at least in England, was not necessarily linked to the traditional concept of nobility, that is to say, inheritance, governance and continuity.[14] A broader concept of nobility was established with a greater focus on aspects such as social ability, knowledge and taste. A gentleman did not necessarily have to claim a noble background in terms of bloodlines and patrimonies in order to prove his social, political and cultural skills. This marked an important rupture within the elite system, and certainly led to a more concrete flexibility for those who succeeded in climbing the social scale. The traditional nobility no longer exclusively occupied important political positions, or commissioned and consumed art. Largely, the crisis of the European elite during the *ancien régime* was due to this loss of hegemony of traditionally established strategies, values and positions. There is a deep contradiction in this crisis. Wealthy people with no traditional rank conquered the traditional noble values through demonstrated ability. On the other hand, the nobility tried to secure their concrete positions and the same values by proclaiming innate ability.[15] From this controversy arises an important issue. Even if the elite expanded and, in a way, abandoned its primary demands on the prerequisites attached to a social position, the visual means of expressing this position's legitimacy remained very much the same. Consequently, the idea of Rome and the ancient heritage continued to play an enormous role within this social discourse, since its importance as a rhetorical tool and visual marker of the European elite was so firmly established. Deeply connected to these social signs was the concept of knowledge on which the exclusiveness of the visual and social culture of the elite depended. Appreciation and understanding of material

culture followed naturally: 'Objects which for centuries had been the privileged possessions of the rich came, within the space of a few generations, to be within the reach of a larger part of society than ever before.'[16] Purchasing and consuming objects that still bore the connotations of an aristocratic lifestyle demanded a financial situation that many born aristocrats were slowly losing. Moreover, losing money meant that sales of the family collections were inevitable. The elite cultures at stake in this study were subject to different financial situations, which influenced their relationship towards the idea of Antiquity.

Eighteenth-century Rome was an epicentre for these social changes. The city represented a geographical spot deeply admired for its history, its art and its cultural achievements, but at the same time it constituted an endless resource from which symbolical and material capital was gained and exported to other countries. This business of exploitation took place on many levels, and involved all branches of cultural activities as well as the more abstract idea of what 'Rome' really meant. This issue, which is far from easily resolved, has been the object of study of many scholars.[17] One of the most important parts of this veritable mythology is the concept of Rome as the mother of Western civilisation. For instance, the historians Andrea Giardina and André Vauchez have shown how Counter-Reformation cultural politics led to a consolidation of an educational system that eventually was promoted by the religious orders and which established Roman culture (and the Latin language) as solid keepers of the true faith through the knowledge of Antiquity.[18] Despite the religious division of early modern Europe, the concept of the dominion of Christianity over Rome became linked to an educational system that involved the formation of the elite, regardless of religious faith. For the Roman nobles, the concept of *Roma Madre* was a part of their own social strategy, while the travellers on Tour expected and sometimes found reminiscences of a childhood education that connected them directly to the physical experience of the city:

> I am now wrapped up in the study of antiquities and fine arts. I have already surveyed most of the monuments of ancient grandeur, and have felt the true venerable enthusiasm. What would I not give, Temple, to have you here with me. How would we recall the days when we used to climb Arthur Seat, when our minds were fresh to all the charms of Roman poetry, and our bosoms gloved with a desire to visit the sacred shades.[19]

The nostalgic words of James Boswell can be contrasted with Peter Beckford's sarcasm in this quote from his Roman travel accounts: 'In vain you look for the SCIPIO'S, the CATO'S and the BRUTU'S of ancient time; Cardinals, Monsignores, and Abbés are their only representatives.'[20] If Boswell's words recall the narratives of traditional elite education, those of Beckford clearly state its impact on Roman society and its ecclesiastical hierarchy. In Rome, the union between the Church and the pagan past meant something more than a mere

Western myth. It constituted in fact the formal ground on which the elite had built its social structure and its precarious link with concrete political power. In discussing how social identity was visually shaped in eighteenth-century Rome, it is necessary to acknowledge the latter.

In 1740 Horace Walpole, discussing the lifestyle of the Roman elite, argued:

> The princesses and duchesses particularly lead the dismallest of lives. Being the posterity of Popes, though of worse families than the ancient nobility, they expect greater respect than any ladies the countesses and marquises will pay them; consequently they consort not, but mope in a vast palace with two miserable tapers, and two or three monsignori, whom they are forced to court and honour, that they may not be entirely deserted.[21]

Walpole's mocking tone sheds immediate light on a particular ancestral pride, whose causes and consequences may be defined as unique within the history of Western nobilities. Its focal point consisted of a precarious balance between transitory and fixed power, and saw the Church as the only possible guarantee of status quo in the city of Rome. For the Roman elite the Church as institution, and indeed its link to the city's ancient heritage, constituted a pragmatic tool within an expanding social arena. At the centre of these concerns were political interests. The institutionalisation of the papal court had been established primarily during the pontificate of Urban VIII (1623–44). Its unique character consisted of the indisputable office of the pope and its complex mythology, which not only involved the Roman and Catholic frontiers but indeed others of different Christian creed.[22] However, the very nature of the papacy in terms of secular power denied, through the vote of chastity, the concept of succession. This paradox disrupted the traditional aristocratic idea of prime inheritance and continuity, both important issues in the establishment of social stability. Against this background, John Moore's words have a clearer context:

> Several of the Roman princes affect to have a room of state, or audience chamber, in which is raised a seat like a throne, with a canopy over it. In those rooms the effigies of the Pontiffs are hung; they are the work of very inferior artists, and seldom cost above three or four sequins: as soon as his Holiness departs this life, the portrait disappears, and the face of his successor is in due time hung up in its stead. This, you will say, is treating their old sovereign a little unkindly, and paying no very expensive compliment to the new.[23]

What appears in this comment is an astonishment regarding the discontinuous approach to the display of a dynastic continuity in a strict political sense. This lack of a prime succession had its effect on the use of portraiture to display the continuity of one single, ruling dynasty. The strict connection between the Church and the elite influenced the display criteria of the latter, who were heavily subjected to the changing policies of the different popes.

In terms of family politics, the fragile nature of the powers of the papacy demanded a different kind of social strategy, compared with those elite cultures in Europe that served and profited from one dynasty. In Rome, political and social power had a transitory character. The families that managed to have at least one of their male members elected pope could rely on social security, precedence right and political influence.[24] The importance of ecclesiastical careers led to a specific policy in which each family divided the most important tasks for social security into two branches: the first-born male would inherit the title and patrimony, while a younger brother would take on an ecclesiastical career which, in the best-case scenario, would result in a cardinal's position or even that of pope.[25] Once the family had reached this high position, its social status was secured for the future.

The historian Maria Antonietta Visceglia has in her studies stressed the important connection between Rome's inherited past and the new ceremonials which were created in the aftermath of the Counter-Reformation.[26] Putting Roman Catholicism on display also meant linking it to the ancient Roman socio-political *triumphans*. The ceremonies contributed to the affirmation of Christian Rome over its pagan past, and secured the secular power of the Church and its nobility. The identity of the city was thus staged through social protection and a claimed unity.[27]

Public ceremonials served to appropriate and secure the structure of social hierarchy, and familial events such as baptisms, marriages and funerals confirmed the role of the elite within this structure. The presence of cardinals, veritable princes of the Church, at these events was both regular and much sought after. On the occasion of the baptism of Vittoria Doria Pamphilj in 1775, daughter of the prince Andrea IV and his consort Leopoldina of Savoy, ten cardinals were among the invited guests.[28] As the ceremony was carried out in the family's private chapel in their palace in Via del Corso, the cardinals were seated in an adjacent room, *stanza del Baldacchino*, a room generally intended to host the portrait of the reigning pope. As previously shown, the canopy indicated the princely status of the family, and was a constant tribute to the sovereign.[29] The cardinals' presence (and precedence) in this room indicated their high rank and connection to the pope, as they represented his presence at the event.

The complex Roman etiquette regulated court ceremonies as well as everyday life within the noble households. The palace became a social arena in which each member fulfilled his or her role in order to uphold family dignity, prestige and tradition.[30] The rank of family members determined their position in terms of role-playing within the ceremonial structure. When Andrea Doria Pamphilj married Leopoldina of Savoy, his consort's royal birth secured her a higher rank than her husband's in relation to public ceremony. In 1776, the family's *maestro di casa* established the procedures on the occasion of a cardinal's visit to the

palace in Via del Corso. The royal rank of Leopoldina was here accurately manifested by her close seating next to the cardinal under the canopy in the *stanza del Baldacchino*. Her husband, though, was only allowed to sit in the immediate proximity of the canopy, not under it. He was also supposed to accompany the cardinal all the way to his carriage at the end of the visit.[31]

The picture outlined above describes a development that essentially began in the late sixteenth century and continued throughout the seventeenth century. During this period, Rome and the papacy grew strong under the influence of Counter-Reformation policy. The city's elite created definite ways of social manifestation through artistic and architectural enterprises, through collecting and the display of knowledge and through a systematic appropriation of the ancient heritage that Rome represented. It is important to acknowledge that this was essentially a social process. Those initially different qualities that had characterised the feudal and ecclesiastical nobility were eventually brought together for a further reinforcement of the status quo of one single elite culture. This elite adopted its artistic activities as an ongoing and essentially novel process of making itself politically and visually defined.

It is possible to suggest that eighteenth-century Roman elite culture was largely a consequence of the fact that this social process had slowed down once its actors had defined its mechanisms. Hanns Gross affirmed in his study on the city's eighteenth-century history that Rome came to lack the religious (and thus political) energy which had characterised the previous century and its intellectual enterprises.[32] Gross saw this lack of energy as a symptom of the Counter-Reformation and its climax with the council of Trent (1545–63), that is, a religious matter. Yet from a strictly social view, the problems and difficulties of the Roman elite did not spring from religious issues. Their patterns of social manifestation, in terms of collecting, commissioning and displaying, remained the same as those seen during the previous century.[33] Despite Francis Haskell's classic (and dated) notion that elite art commissions weakened during the eighteenth century, the Roman nobility proceeded during the course of the century to protect and promote artistic endeavours.[34]

In contrast, great difficulties were involved in actual survival. Philippe Boutry has argued that a combination of less prosperous fecundity and socio-economic changes directly contributed to the end of several family lines.[35] This fertility crisis was not exclusively Roman. All European elite cultures experienced an increasing number of sterile couples and fewer children.[36] Remedies included strategic marriages and adoptions, which helped to preserve not only a name but also those family patrimonies that held such symbolic positions within the elite milieu. Thus, new family names were created, Barberini Colonna di Sciarra (1728) and Doria Pamphilj (1769), for example. The weakened demographic situation was not the only reason behind the crisis. Elite finances were increasingly troubled, although most of the Roman families held extensive

landholdings, with profits controlled directly by the family itself.[37] The apparently apathetic attitude to industrial enterprise, so much commented upon by foreign travellers, has convincingly been analysed by the historian Marina Caffiero. She stresses that the strong connection between the Roman nobility and the Church was decisive in the former's approach to its own wealth. The traditional absolutist scheme that characterised the policies of the popes, including social assistance, protectionism and the assignment of privileges, defined and alienated the elite's attitudes towards ways of increasing finances.[38] As the elite depended upon the Church for its own social legitimacy it could not act differently, even if that meant renouncing an innovation that might have led to financial security and to a possible strategy for a future that would definitely change the elite's conditions. In 1746, Pope Benedict XIV acknowledged in the bull *Urbem Romam* those groups of nobility in the city who were entitled to hold public offices.[39] The basis of the bull's purpose involved the right of being nominated as Roman noble, *nobilis romanus*. This division of the elite was controversial, since the final list of *nobiles Romani conscripti a Pontefice designati* who could claim an established genealogy of confirmed nobility in Rome dating back at least one hundred years excluded many of the most prominent families of papal dignity, as well as those of strictly feudal origins. The delimitation of public and civic offices to include other families than those with the highest prestige and most secured patrimonies shows an interesting political intervention that clearly demonstrates the reform policy of Benedict XIV. The consequence of the bull, due to its social reinforcement of newer families, in part generated a similar field for competition to that which had occurred during the sixteenth century, when Tuscan families affirmed themselves as Roman. New families could challenge the papal nobility in terms of political influence. Eventually, at the end of the eighteenth century, the presence of noble ecclesiastics within the papal government had almost vanished.[40]

The Grand Tour: complex contradictions on foreign and familiar grounds

In 1996, there was a major exhibition on the Grand Tour organised at Tate Britain in London. The lavish show exposed numerous artworks and items connected to the complex and apparently feisty phenomenon of educational travel in eighteenth-century Britain. The show's narrative was in many ways structured by the theme of 'cosmopolitanism', enhancing the idea of a homogeneous cultural appropriation carried out by young, elite males. When Ian Littlewood published his study, *Sultry climates: Travel and sex since the Grand Tour* in 2001, he commented upon the Tate show in the following way: 'It was an exhibition the travellers themselves would have been happy to sponsor.'[41] Behind such a comment there are some interesting aspects that go beyond the principal theme

that Littlewood was interested in bringing forward, namely sexual practice and its consequences and links to travel culture. It is indeed true that the sexual aspect of elite travelling at the time had been neglected as an important part of general travel discourse. Yet it is possible to understand the issue of sexuality in this context in a different way. At *Documenta 11* in Kassel in 2002, the artist Yinka Shonibare presented the installation *Gallantry and Criminal Conversation*. The piece consisted of a centrally suspended horse carriage and eleven groups of headless mannequins, surrounded by travel trunks. All were engaged in complex sexual activities and positions. The associations with the eighteenth-century Grand Tour discourse were obvious and intended.[42] Shonibare's work, which complexly discussed the theme of colonial appropriation through the evident signifiers of eighteenth-century Grand Tour travellers in the sense of cultural conquerors, also shed light on the concept of sexuality as a metaphor for general transgression and exploitation of the foreign. In this sense, *Gallantry and Criminal Conversation* constitutes an interesting contrast and parallel to the Tour portraits that Pompeo Batoni completed in his Roman studio for the British commissioners. Among other things, the installation discussed those issues that Littlewood sought after in the Tate exhibition: an alternative narrative for travel discourse and its consequences.

Scholarly efforts regarding the Grand Tour have increased immensely during the 1980s and 1990s. Art historians, historians, gender scholars and literary historians have examined in several ways and with different aims the Tour's discourse and its social ambitions, its failures, critics, mythologies and narratives. Yet there have not been any serious attempts to look more closely upon those portraits that were produced abroad for the travellers. This neglect has a historiographic reason which has been apparent in general scholarship regarding primarily Pompeo Batoni and his activity as a portrait painter for mainly British commissioners. In the 1982 Batoni exhibition at Kenwood House in London, an interesting issue was brought to light in the catalogue. The authors discussed the reasons why Batoni's reputation in Britain, which had been well established in the eighteenth century, declined so rapidly during the course of the following century. One of the reasons launched was the fact that Batoni had been unknown to the expanding art audience in Britain. Almost all of his portraits of British sitters were commissioned in Rome, and as soon as possible were sent to Britain and placed in their final context, which often consisted of a country house or at least a family home. His paintings, with one exception, were never exhibited in London.[43] The authors of the catalogue, who were eagerly concerned with Batoni's historical status as artist, claimed that it was the character of his portraits for British commissioners that had contributed to his vague position within the History of Art: 'Mostly of the same age, engaged in the same pursuits in Rome, and largely of the same social standing, there is a uniformity about the sitters which means that the portraits are to some extent

lacking in the individuality which later generations find so attractive when looking at portraits.'[44]

In eighteenth-century Britain, the commission of more than one portrait of oneself during a lifetime was not unusual. Self-fashioning and the painters' style and ability to adapt existing settings for individual needs were crucial factors within this process. Accordingly, the Grand Tour portrait constituted a specific kind of portrait, painted during precise circumstances and expected to contain a certain content. The idea of 'uniformity', which in the 1982 catalogue article was addressed as a possibly negative connotation under these circumstances, should be seen more as a positive characteristic. Visual uniformity reinforced the social aims and ambitions of a social class who expected a particular result from the Tour. The specific moment in life that the Grand Tour represented within the British elite demanded a kind of portraiture which Pompeo Batoni consistently delivered. Scholars concerned with his oeuvre have carefully stated that Batoni did not invent this particular portrait type, which must be seen as a result of a series of joined traditions.[45] Still, it would not be unfair to give Batoni credit for an outstanding ability to adapt and vary this particular setting. The readability of his paintings in a broader context than that of mere biography or identification of displaced antiquities is due to his capability of making the complex relationship between the foreign and the sitter clear to a wider audience. In this sense, Batoni's Tour portraits strictly connect to a broader discussion regarding the discourse of eighteenth-century travelling and its socio-cultural predicaments. The paradoxes that surrounded the Grand Tour were related to a complex comprehension of what could be considered familiar and what considered foreign. In terms of appropriating the ancient heritage while on travel, this complicated dichotomy is central and vital to all sorts of visual manifestations that the Tour resulted in. In order to explore these visual manifestations properly, it is necessary to accept the eighteenth-century elite Grand Tour as a specific and chronologically bound phenomenon, and to accept its portraiture as a similarly specific kind of artwork. As Brian Dolan has indicated, current historiography concerning eighteenth-century travel has tended to avoid discussion on the plurality of travel forms. And he rightly states that the Grand Tour of classic proportions was basically no longer in use at the beginning of the nineteenth century.[46] Interestingly enough, this break in a chain of elite tradition coincides with a decrease in the use of ancient Roman rhetoric in Britain. This allows for two equally important observations. First, travel culture was beginning to lose its aristocratic connotation. New groups of travellers entered the scene with other expectations, in contrast to the rigid socio-cultural aims that the elite had demanded from the Tour. Second, travel in Europe, and to Rome, did not necessarily imply the concept of appropriation. The dichotomy foreign–familiar became less problematic and perhaps partly dissolved. If the traveller did not need to seek familiarity, the experience of the foreign changed. Moreover, if the

Different approaches to portraiture

In Jane Austen's novel *Pride and prejudice* (1813), portraiture plays a dramatic role at a decisive moment in the narration. During an unexpected visit at Pemberley, Elizabeth Bennet is shown to the family portrait gallery where, among the many effigies of Mr Darcy's relatives, she suddenly recognises his own picture. For the heroine, this is a moment of decisive change in her attitude towards the principal male character. Her prejudices are challenged by a different reality. Previous encounters with Darcy have been determined by his social persona. While in his home she confronts new sides of his character, determined by the opinions of those who know and love him. Equally, she becomes aware of his material wealth through Pemberley's architectural grandeur and its extensive grounds.[47] Interestingly enough, Austen explores this process of change through the viewing of a portrait. The painting is in itself an assurance of social status, as the sitter is wealthy enough to be portrayed. The painting is displayed within a family gallery that symbolically secures wealth and status over time, and replaces the sitter's physical presence in times of absence. Thus, in a few lines, Austen gives a direct indication of the importance and status of portraiture within an elite domestic context in Britain. Through the *topos* of the country house visit, she indicates the precise functions of portraiture as works of art as well as biographical objects with strong social purposes.

This literary example shows the strong connection between the portrait genre and the concepts of social status, identity and family continuity in eighteenth-century Britain. The genre's importance as a socio-cultural phenomenon cannot be overestimated.[48] Twentieth-century Anglo-Saxon scholarship, with Marcia Pointon's groundbreaking *Hanging the head: Portraiture and social formation in eighteenth-century England*, published in 1993, has indeed demonstrated the broad spectrum of social understanding and artistic elaboration that portraiture provoked in the British context. Portraiture became of interest to the entire social sphere, but it is equally true that it also maintained its status as an important social signifier for elite families. Kate Retford's recently published *The art of domestic life: Family portraiture in eighteenth-century England* has extensively contributed to the uncovering of the social uses and ambivalences of portraiture as it was conceived within the British elite family context. Many of the factors that can be extracted from Austen's description of the picture gallery at Pemberley are examined here.

The actual scholarship on British eighteenth-century portraiture constitutes a methodological landmark for any portrait scholar interested in the genre within the early modern European context. Yet it is of major importance to

acknowledge that the prime position that portraiture held in eighteenth-century Britain does not necessarily correspond to the genre's use and status within other contemporary elite contexts.

The extensive British demands of portraiture while in Rome must be understood against this background. Nevertheless, the context of portrait production in Rome was not only dependent on these demands. It responded as well to the particular needs of the local elite and their use and regard of portraiture.

In 1781, Doctor John Moore wrote in his influential travel description *A View of Society and Manners in Italy*:

> With countenances so favourable for the pencil, you will naturally imagine that portrait painting is in the highest perfection here. The reverse, however, of this is true; that branch of the arts is in the lowest estimation all over Italy ... [T]he Italians very seldom take the trouble of sitting for their pictures. They consider a portrait as a piece of painting which engages the admiration of nobody but the person it represents or the painter who drew it. Those who are in the best circumstances to pay the best artists, generally employ them in some subject more universally interesting, than the representation of human countenances staring out of a piece of canvas.[49]

Moore's comments upon his observations on the status and use of portraiture in Italy are crucial, since they indicate the two different roles that portraiture occupied in early modern Europe. Marcia Pointon has examined these roles through the definitions of the *self in art* and the *self as art*.[50] The first of these distinctions describes a portrait as a social object with a functional purpose, where the sitter's identity and status are the most important characteristics and are strictly connected to the portrait's place of display. A portrait that responds to the *self as art* distinction is appreciated based on the painter who produced it and his or her canonical position within the field of art and its consumers. Sometimes these two distinctions were joined together, and it would not be too bold to claim that during the second part of the eighteenth century European portrait painters worked increasingly hard in order to achieve a combination of both. Still, these efforts were only possible in places where portraiture provoked interest, meaning and, indeed, social glamour. Moore's observations on the Italians' negative attitude to the genre and their poor interest in portrait investments indicate that quite different art works held the same status on the Italian peninsula that portraiture held in England. Moore's surprise was equally strong when he actually experienced the Roman elite homes and looked in vain for those vast portrait hangings that characterised the stately homes in Britain, and constituted one of its most important social markers: 'In palaces, the best furnished with pictures, you seldom see a portrait of the proprietor, or any of his family. A one-quarter length of the reigning Pope is sometimes the only portrait of a living person, to be seen in a whole palace.'[51] Here, the combination of contrast and confrontation between familiar and foreign eventually helped in

making the new experiences intelligible.[52] Moore was probably struck by what he experienced as a lack of presenting family history in a context where he, used to the British fashion of picture hanging, sensed that it was required. 'Family portraits . . . are a very appropriate decoration for the first entrance into a house. . . . They remind us of the genealogy of our families, and recall to our minds the hospitality, &c. of its former inhabitants, and on the first entrance of the friend, or stranger, seem to greet them with a SALVE, or welcome.'[53] This quote from the antiquarian Sir Richard Coalt Hoare's (1758–1838) views is directly involved with the idea of the portrait gallery as status assurance and as a biographical archive. At the same time, it points to a distinct way of constructing the image of the elite, and of connecting this image with a building and the concept of a family home, just as previously indicated in Jane Austen's description of the portrait gallery at Pemberley.

How reliable are Moore's comments on Roman portrait display? His experiences were indeed based on his possibilities of movement and his permitted access within those Roman palaces he actually visited. The traditional museum visits generally took place in the morning hours, when travellers and art students were admitted to the collections. Travellers of reasonable rank who were equipped with letters of recommendation easily gained access to the evening gatherings of the Roman elite, known as *conversazioni*.[54] Moore described these events from the moment of his entrance into the palace, including the solemn walk through a number of rooms until reaching the one where the general company was assembled.[55] Consequently, Moore had a very good opportunity to reflect upon and observe those art works that were on display in that particular apartment where the assemblies usually took place, the *piano nobile*. His comments on the lack of portraiture must be seen in the light of the high position that the *piano nobile* held in terms of social space. No family portrait in this context, where strangers were welcomed and entertained, was clearly the total opposite of the British custom.

In 2006, the Museo Nazionale di Palazzo Venezia organised an exhibition entitled *Il Settecento a Roma*, a show which in many ways was a homage to the 1959 landmark exhibition with the same title. The curatorial efforts and indeed the articles in the catalogue were carefully updated with recent scholarship, and they gave due attention to the importance of specific cultural discourses such as that of the Accademia dell'Arcadia with its influence on the general artistic and visual productions in eighteenth-century Rome. Portraiture was presented in the show's first section, where the art works were used as introductory elements to eighteenth-century Roman society. It was clearly a display of *selves in art* which gave space to individual artists and their style as well as their sitters. Nevertheless, neither the status of the genre nor its general formal characteristics were discussed. Portraiture appeared as an isolated outpost in the artistic world, totally dependent on the single artist's interest in formal solutions. Possible questions

of didactic proportions like 'was there ever a Roman portrait tradition?' and 'how would it compare to other portrait traditions in eighteenth-century Europe?' were clearly avoided. It is significant that Pompeo Batoni's Grand Tour portraits were not displayed along with their Roman counterparts but were instead saved for the sections dealing with antiquarianism and educational travelling. This sharp separation clearly underlined that Batoni's works were not properly regarded as Roman art works, but more connected to a 'cosmopolitan' erudition and elegance linked to that particular art of export that the city's artists indeed depended upon.

Still, it is important to back up this sort of criticism with some relevant and significant data. Studies on Roman portraiture are subject to a number of difficulties that include actual access to the paintings and the lack of specific portrait archives in the Roman context. A scholar interested in early modern elite Roman portraiture meets with many practical difficulties. When, at the end of the nineteenth century, the city's nobility undertook major sales of their patrimonies, the art collections were included.[56] Eventually, the Italian government would interfere in order to stop the uncontrollable export of national treasures. This led to complex conflicts with the families in question. The paintings which were sold abroad on the open market included family portraits. A famous example is the 1932 Rospigliosi sale, when a significant number of family portraits were sold and consequently deprived of both their original physical setting and their collection context.

Portraits may still be found in Roman elite collections, but these are not always completely catalogued nor available to the public. This essentially means that there might be a great number of interesting privately owned portraits that cannot be taken into consideration when the field of Roman portraiture is approached. This problematic, which is not a small one, has unquestionably contributed to hampering any scholarship on Roman portraiture as a social phenomenon linked to family history and continuity. This is clearly visible in museum contexts, where family histories are important issues within the institutional narrative. The Museo di Roma in Palazzo Braschi discusses the history of early modern Rome through its institutions and the papal court, contexts in which the elite families played important parts. Yet portraiture hardly appears in this institution, a significant lack that implies both the problematic related above and a disinterest in the genre itself. An important contrast can be observed in the extensive portrait displays offered in the British stately homes in the care of the National Trust. These examples stress the complex links between museum display, canonical narrative and scholarly traditions and their diverse directions in different parts of Europe.

The scholarship oriented to Roman portraiture has essentially been preoccupied with the artists themselves, and not with the sitters and their particular use of the genre. Anthony Morris Clark's pioneer works on artists like Agostino

Masucci (1690–1768), Francesco Trevisani (1656–1746), Placido Costanzi (1702–59) and Antonio Cavallucci (1752–95), not to mention his devoted and groundbreaking work on Pompeo Batoni, did indeed examine their activities as portrait painters from the point of view of form and style.[57] The 2006 exhibition in Palazzo Venezia and its undefined way of displaying and discussing portraiture as an integral visual part of eighteenth-century Rome can certainly be explained by the circumstances related above.

During the preparation of this book, these difficulties have been fully experienced by the author. One way to challenge them has been to turn from the examination of available paintings to that of documentary evidence that provides proof of the social status that portraiture held in eighteenth-century Rome. This archival approach was undertaken not only in order to contextualise those paintings that actually could be examined, but to essentially compare and contrast the social status of portraiture within those elite groups included in the study. Such a comparison and contrast allows the possibility of raising different questions regarding the Roman artists' extraordinary abilities to adapt to the commissioners' needs and concerns regarding the social understanding of portraiture.

In 1812, the portrait painters Gaspare Landi (1756–1830) and Vincenzo Camuccini (1771–1844) were engaged by the Barberini family to make an estimate of the art collection of the prime inheritance.[58] The document consists of a classification of the art works based on artistic quality and monetary value, and the paintings are divided into five different classes. These divisions give a clarifying insight into the formation of an almost institutional art taste as well as an enlightened view of the hierarchies of the genres. In the first and highest class, there was one single painting by the Venetian master Titian (1488–1576) mentioned. Although the painting in question represented a portrait of an unidentified sitter, it is quite clear that it is the painter's fame and canonical position within an art history in the making and not the motif of the painting that secured the prime position of the artwork. In the second and third classes it is still the mention of the artists' names, like Angelo Bronzino (1503–72), Federico Barocci (1526–1612) and Anthony Van Dyck (1599–1641), that constitutes a guarantee of the paintings' ranking. It is only in the fourth and fifth classes that the mentioning of the names of family members occurs. Well-known and estimated artists and portrait painters like Carlo Maratti (1625–1713) are still mentioned, but it is clear that within these particular categories it is the sitter's identity that establishes a presumed value, not the hand of an artist that may not be identified or was considered too insignificant to be named. With reference to Marcia Pointon's definition of a portrait bearing a strict social function, it is clear that these classes contain portraits that can be defined as *self in art*. Camuccini's and Landi's estimation was based on the particular financial character of the commission, but the document also

provides interesting insights into the status of family portraits within an art collection as such. The consequent question must be whether the low ranking given in such a document was illustrated through specific display criteria. John Moore's observations have already given important clues to the resolving of this question. It is not sufficient, however, to examine the inventories related to the more prominent spaces of a palace. It is equally necessary to approach those apartments that were assigned to different family members in order to get a wider view on the use of family portraiture in the Roman elite context. Studies of Roman inventories in the archives of the families Barberini, Pallavicini Rospigliosi and Doria Pamphilj have partly confirmed Moore's observations, and indicate a prevalent use of portraiture within more private contexts than the principal apartment of a family palace.[59] Still, it would be inappropriate to make too general of remarks on the subject, since every Roman family took an independent view in regard to art commissions and consequently to portraiture.[60] It is equally clear that portraits of foreign sovereigns had frequently been placed in the Roman palaces as important and valuable signifiers of the family's political orientation.[61] The importance of demonstrating political connections was, however, a different practice from that of putting family history on display through portraiture. The separation between family effigies and spaces of prominence might indicate that different visual means replaced portraiture in order to display the social affirmation of the family in question.

Antiquity and portraiture: a new mythology for socially reliable portraits

The acceptance of a diverse use and conception of portraiture as a social tool should accompany any analysis of the settings and narratives of the genre. It is equally important to look closely at how these narratives were adapted in order to satisfy commissioners with different needs. In eighteenth-century Europe, there were many portrait types that related to the ancient world in different ways. The varieties offered in the visual field were supported by rapid changes in society. The crisis of the class system, industrialisation, urbanisation and the expansion of an increasing public sphere were all components which contributed to the growing portrait market. Despite a growing number of possible settings, these portraits dealt with Antiquity in essentially two ways: they could either assimilate the sitter within a fictive context of narrative related to ancient history or mythology or they could stress a firm border between the sitter and the ancient past, demonstrating a clearly different relationship in comparison with the former. In Rome, both these types were frequently used, but it is clear that the groups of commissioners did not prefer the same settings. The reason for this difference lies undoubtedly in Rome's particular position as the mythical centre of Western civilisation. Thus, in Rome the idea of Antiquity was experienced and set in quite a different manner from other parts of the continent,

simply because of its status as centre to the ancient past. This geographical circumstance was constantly present within the discourse of the foreign travellers, their writings and patterns of consumption, as well as those of the Romans themselves. Moreover, the different ways of claiming *romanitas* influenced the choice of portrait setting.

Assimilation to classical narratives constituted, from the late Middle Ages to the collapse of the *ancien régime*, a well-established part of social strategy in Europe.[62] Yet it is clear that its use and need shifted during different periods. The historian Peter Burke has stressed that the late seventeenth century represented a period of rupture, with particular emphasis on France, causing a crisis that also affected the artistic and literary representations of rulers. The classical exemplar declined as a cultural model, and caused a decline of the previously stated correspondence between the person exalted and the model itself.[63] In terms of portraiture, this shift turned a representation of worldly and heavenly order, expressed through the ruler and his guise, into a conscious rhetorical tool aimed at persuasion rather than just manifestation. This is an important remark, since it implies that the worldly and the heavenly orders might not correspond to each other or constitute an analogy. Burke has seen this shift as due to the scientific revolution and the transition from feudalism to capitalism.[64] The point is good, but what is equally true is that the extreme consequence of such a notion was that classical rhetoric needed to defend the social status quo from the possible existence of other orders of the world. In terms of portraiture, an art form which is directly involved with placing the sitter into a comprehensible and socially accepted context, this notion becomes essential. During the eighteenth century, which is the focus of this study, the classical formula excelled within portraiture. Multiple possibilities for portrait settings were created for the established and the upcoming elite throughout Europe. It has been a rather frequent commonplace in art history to regard these settings as less serious in comparison with the ones of the preceding century.[65] Likewise, it has been stated that the classical model in eighteenth-century portraiture offered a possibility for the sitters to consciously play a role.[66] The first notion places eighteenth-century portraiture in contrast to a relatively short period in Western history, when sitter and setting were regarded as correspondents.[67] The second sheds light on those consciously elaborated settings where a firm limit between sitter and narrative was inserted in various ways. Architectural elements or combinations of ancient and temporary clothing are examples of signifiers that point to the distinction between a social reality and fiction. The questions that rise from this kind of portraiture should place less emphasis on the correspondence problematic and instead explore what social needs it arose from. Perhaps more important is the question of diversity: did these settings and elaborations of the classical formula differ in different geographical spots, regulated by differing socio-economic and political discourse?

At this point, it is necessary to look more closely upon the classical model's process of adaptation. In a convincing article, the historian Maiken Umbach has analysed the possible readings of eighteenth-century visual culture based on the multiplicity of meaning and the subversion of narratives present during the century. She emphasises correctly that these narratives should be read as quotations.[68] This suggestion is based on the broader use that the classical formula inevitably gained during the course of the eighteenth century, and which is in contrast to its position as a normative code within previous centuries. The myth of the ancient past became enlarged by an acceptance of its historical status and place within a written chronology. Umbach sheds light on the paradoxical distance that the increasing archaeological activities caused between the temporary and the past: 'Ancient Rome and Greece became an "other"; they were remembered in quotation marks. Classical notions of order and reason quoted them, retold them – and turned them into fiction. These fictions were ambiguous and multiple.'[69] Umbach's point is similar to what appears in the French literary critic Roland Barthes's (1915–80) classic work *Mythologies* from 1957, where the modern myth is traced out of its multiple adaptations of one primary discourse and out of social use.[70] While the discourse in this case is fixed and conditioned by its historicity, there is still a multitude of ways that myths are expressed. Yet this variety of myths is conditioned by the discourse's material predisposition. If a myth is able to communicate, which is an absolute prerequisite, it must work out of what can be communicated. This is a crucial notion when it comes to portraiture, a genre that depends upon its ability to function within various contexts and as such with various roles.[71] The portrait's purpose is to relate something that is relevant to the viewer. Although what that is may vary, it is out of the question that a portrait's narrative works beyond the discourse it arose from. The classical formula adapted for eighteenth-century portraiture was not directly interested in the discourse itself. On the contrary, it worked for a social use and turned the available narratives into a fiction or a modern myth perfectly comprehensible to its audience.

This study is divided into three chapters and, through examining different approaches and portrait settings, discusses the diverse use of Antiquity as a social sign as it occurred within portraiture produced in eighteenth-century Rome. The first chapter examines the differences between the British and the Roman sitter and the concept of land as a metaphor of an ancient territory and its appropriation. The second chapter discusses how different gender discourses interact within the choices and reception of particular portrait settings and how ancient mythological narratives could be shaped into contemporary mythologies. The third and final chapter enters into a discussion regarding the particular discourse of the literary Accademia dell'Arcadia, particularly the institutionalisation of the myth of Antiquity and its influence on Roman portrait settings.

Notes

1 I. Belli Barsali, 'Il Batoni ritrattista', in I. Belli Barsali (ed.), *Mostra di Pompeo Batoni* (Lucca: 1967), p. 85.
2 B. Redford, *Venice and the grand tour* (New Haven and London: 1996), p. 81.
3 A.M. Clark, *Studies in Roman eighteenth-century painting*, E.P. Bowron (ed.) (Washington: 1981); A.M. Clark, *Pompeo Batoni: A complete catalogue of his works with an introductory text*, E.P. Bowron (ed.) (Oxford: 1985).
4 C.M.S. Johns, 'Portraiture and the making of cultural identity: Pompeo Batoni's *Honourable Colonel William Gordon (1765–66)* in Italy and North Britain', *Art History*, 27:3 (2004), pp. 384–6. An upcoming exhibition on Pompeo Batoni in Houston Texas will undoubtedly examine further these particular aspects of the artist's work.
5 C.M.S. Johns, 'The entrepôt of Europe: Rome in the eighteenth century', in E.P. Bowron and J.J. Rishel (eds), *Art in Rome in the eighteenth century* (Philadelphia and London: 2000), pp. 17–18.
6 The show took place at Palazzo delle Esposizioni in Rome and exposed 2,656 objects. The catalogue is still an invaluable source for anyone interested in this particular period in Rome's modern history.
7 Hugh Honour, 'The great sham disproved', *Apollo*, 78 (Dec. 1963), pp. 521–2.
8 The works of Italo Faldi, Giancarlo Sestieri, Stella Rudolph, Steffi Roettgen, Elisa Debenedetti, Stefano Susinno and Liliana Barroero have clearly defined the Italian field of Roman *Settecento* studies. From an Anglo-Saxon point of view, Anthony Morris Clark, Edgar Peters Bowron, Christopher M.S. Johns and Jeffrey Collins have extensively contributed to the field as it appears today.
9 M. Craske, *Art in Europe 1700–1830* (Oxford: 1997), pp. 137–43.
10 L. Lanzi, Storia pittorica della Italia dal Risorgimento delle belle arti fin presso al fine del XVIII secolo, M. Capucci (ed.) (Florence: 1968), pp. 310–11. Da questi lieti principi ebbe stabilimento la scuola che noi chiamiamo romana dal luogo piu che dalla nazione, come notai. Anzi come il popolo di quella città è un misto di molte lingue e di molte genti, fra le quali i nipoti di Romolo sono i meno; cosí la scuola pittorica è stata popolata e supplita sempre da forestieri, ch'ella ha accolti e riuniti à suoi, e considerati nella sua accademia di San Luca non altramente che se nati fossero in Roma.' All translations are mine unless otherwise stated.
11 On Luigi Lanzi and the historiography of art history see for instance, G. Pacchioni, 'Il Lanzi e le "scuole pittoriche"', *Scritti di Storia dell'Arte in onore di Lionello Venturi* (Rome: 1956) and L. Grassi, *Teorici e storia della critica d'arte* (Roma: 1979), pp. 186–91.
12 L. Barroero and S. Susinno, 'Roma arcadica: Capitale universale delle arti del disegno', *Studi di Storia dell'Arte*, 10 (1999), p. 91.
13 J. Dewald, *The European nobility 1400–1800* (Cambridge: 1996), p. 57.
14 J. Dewald, *The European nobility*, pp. 58–9.
15 J. Dewald, *The European nobility*, pp. 150–1.
16 N. McKendrick, J. Brewer and J.H. Plumb, *The birth of a consumer society: The commercialization of eighteenth-century England* (London: 1983), p. 1.
17 C.M.S. Johns, 'The entrepôt of Europe', pp. 17–45.

18 A. Giardina and A. Vauchez, *Il mito di Roma da Carlo Magno a Mussolini* (Roma: 2000), p. 100.
19 J. Boswell, *Boswell on the Grand Tour: Italy, Corsica and France 1765–1766*, F. Brady and F.A. Pottle (eds) (Melbourne, London and Toronto: 1955), p. 71.
20 P. Beckford, *Familiar letters from Italy, to a friend in England* (2 vols, Salisbury: 1805), vol. 2, p. 109.
21 M. Foss (ed.), *On Tour: The British traveller in Europe* (London: 1989), pp. 220–1.
22 J.A. Hook, 'Urban VIII: The paradox of a spiritual monarchy', in A.G. Dickens (ed.), *The courts of Europe: Politics, patronage and royalty 1400–1800* (London: 1977), pp. 213–31.
23 J. Moore, *A View of Society and Manners in Italy with anecdotes relating to some eminent characters* (2 vols, London: 1781), vol. 2, pp. 164–5.
24 D. Carpanetto and G. Ricuperati, *L'Italia del Settecento: Crisi, trasformazioni, lumi* (Rome and Bari: 1998), p. 22.
25 P. Boutry, 'Nobiltà romana e curia nell'età della restaurazione: Riflessione su un processo di arretramento', in M.A. Visceglia (ed.), *Signori, patrizi, cavalieri nell'età moderna* (Bari: 1992), p. 410.
26 M.A. Visceglia, *La città rituale: Roma e le sue cerimonie in età moderna* (Roma: 2002), p. 101.
27 M. Caffiero, 'Istituzioni, forme e usi del sacro', in G. Ciucci (ed.), *Roma moderna* (Rome and Bari: 2002), p. 151.
28 Archivio Doria Pamphilj (hereafter ADP), *Memorie della Casa*, scaff. 93, busta 69, intemo 8, no pagination.
29 F. Cappelletti, 'La Galleria Doria Pamphilj: Introduzione alla storia del palazzo e della raccolta', *Nuova Guida alla Galleria Doria Pamphilj* (Roma: 1996), p. 488.
30 R. Ago, 'Giochi di squadra: Uomini e donne nelle famiglie nobili del XVII secolo', in M.A. Visceglia (ed.), *Signori, patrizi, cavalieri nell'età moderna*, pp. 256–64.
31 ADP, *Memorie della Casa*, scaff. 93, busta 69, intemo 8, no pagination.
32 H. Gross, *Roma nel Settecento* (Bari: 1990), pp. vii–viii.
33 M.A. Visceglia, 'Figure e luoghi della corte romana', in G. Ciucci (ed.), *Roma moderna*, pp. 71–2.
34 F. Haskell, *Patrons and painters: A study in the relations between Italian art and society in the age of the Baroque* (New Haven and London: 1980), pp.vii–ix.
35 P. Boutry, 'Nobiltà romana e curia nell'età della restaurazione', in M.A. Visceglia (ed.), *Signori, patrizi, cavalieri nell'età moderna*, pp. 400–1.
36 G. Delille, *Les noblesses européennes au XIXe siècle*, Actes du colloquies de l'École française de Rome (Rome: 1988), pp. 3–7.
37 On this subject see C. Castiglione, *Patrons and adversaries: Nobles and villagers in Italian politics, 1640–1760* (Oxford: 2005).
38 M. Caffiero, 'Tradizione o innovazione? Ideologie e comportamenti della nobiltà romana in tempo di crisi', in M.A. Visceglia (ed.), *Signori, patrizi, cavalieri nell'età moderna*, pp. 373–5.
39 An analysis of the bull and its social consequences is offered in M. Piccialuti, 'Patriziato romano e cariche di Campidoglio nel Settecento', *Roma moderna e contemporanea*, 4:2 (1996), pp. 403–21.

40 P. Boutry, 'Nobiltà romana e curia nell'età della restaurazione', pp. 390–3.
41 I. Littlewood, *Sultry climates. Travel and sex since the Grand Tour* (London: 2001), p. 11.
42 *Documenta 11* (Kassel: 2002), pp. 583–4.
43 E.P. Bowron (ed.), *Pompeo Batoni and his British patrons* (London: 1982), pp. 7–8.
44 E.P. Bowron (ed.), *Pompeo Batoni and his British patrons*, pp. 7–8.
45 E.P. Bowron (ed.), *Pompeo Batoni and his British patrons*, pp. 13–14; A.Wilton and I. Bignamini (eds), *Grand Tour: The lure of Italy in the eighteenth century* (London: 1996), pp. 51–2; A.M. Clark, *Pompeo Batoni*, p. 50.
46 B. Dolan, *Exploring European frontiers: British travellers in the age of enlightenment* (Basingstoke: 2000), p. 12.
47 J. Austen, *Pride and prejudice*, James Kinsley (ed.) (Oxford: 1990), p. 220.
48 S. West, 'Patronage and power: The role of the portrait in eighteenth-century England', in J. Black and J. Gregory (eds), *Culture, politics and society in Britain, 1660–1800* (Manchester and New York: 1991), pp. 131–53.
49 J. Moore, *A View of Society and Manners in Italy*, vol. 2, p. 71.
50 M. Pointon, *Hanging the head: Portraiture and social formation in eighteenth-century England* (New Haven and London: 1993), p. 1.
51 J. Moore, *A View of Society and Manners in Italy*, vol. 2, p. 71.
52 C. Chard, *Pleasure and guilt on the Grand Tour: Travel writing and imaginative geography 1600–1830* (Manchester: 1999), pp. 20–2.
53 Quoted from A. Laing, *In trust for the nation: Paintings from National Trust houses* (London: 1995), p. 17.
54 On this subject see, A.M. Clark, 'The development of the collections and museums of 18th century Rome', *Art Journal*, 26 (1967).
55 J. Moore, *A View of Society and Manners in Italy*, vol. 1, pp. 382–3.
56 On this subject, see for instance G. Agosti, 'Adolfo Venturi e le gallerie fidecommissarie romane (1891–1893)', *Roma moderna e contemporanea*, 1:3 (1993), pp. 95–114.
57 A.M. Clark, *Studies in Roman eighteenth-century painting*.
58 Biblioteca Apostolica Vaticana, Rome (hereafter BAV), Archivio Barberini Colonna di Sciarra, tomo 344, fasc. 17: 1812 *Descrizione e Perizia di tutti i Quadri spettanti al maggiorasco Barberini redatta dagli Esimj Pittori Gaspare Landi e Vincenzo Camuccini. Classificazione dei Quadri esistenti nel Palazzo Barberini* (sic!) *alle quattro Fontane appartenenti al Maggiorasco Barberini*.
59 S. Norlander Eliasson, 'A faceless society? Portraiture and the politics of display in eighteenth-century Rome', in D. Cherry and F. Cullen (eds), *Spectacle and display*, Art History Special issues (Oxford, UK and Boston, USA: 2008), pp. 29–46.
60 S. Norlander Eliasson, 'A faceless society?', pp. 29–46.
61 D.H. Bodart, 'I ritratti dei re nelle collezioni nobiliari romane del Seicento', in M.A. Visceglia (ed.), *La nobiltà romana in età moderna: Profili istituzionali e pratiche sociali* (Roma: 2001), pp. 307–52.
62 F. Polleroβ, 'From the *exemplum virtutis* to the apotheosis: Hercules as an identification figure in portraiture. An example of the adoption of classical forms of representation', in A. Ellenius (ed.), *Iconography, propaganda and legitimation* (Oxford: 1998), pp. 37–62.

63 P. Burke, 'The demise of royal mythologies', in A. Ellenius (ed.), *Iconography, propaganda and legitimation*, p. 247.
64 P. Burke, 'The demise of royal mythologies', pp. 249–50.
65 P. Burke, 'The demise of royal mythologies', p. 251.
66 D. Shawe-Taylor, *The Georgians: Eighteenth-century portraiture and society* (London: 1990), pp. 165–73.
67 P. Burke, 'The demise of royal mythologies', pp. 247–8.
68 M. Umbach, 'Classicism, enlightenment and the "other": Thoughts on decoding eighteenth-century visual culture', *Art History*, 25:3 (2002), p. 336.
69 M. Umbach, 'Classicism, enlightenment and the "other"', p. 333.
70 R. Barthes, *Mythologies* (London: 1993), pp. 109–59.
71 M. Pointon, *Hanging the head*, p. 1.

1

Of Rome or in Rome? Laying claim to the imaginary and the real

Landowning, archaeology and social legitimacy

In 1792, the artist Teodoro Matteini (1754–1831) painted a portrait of the Roman prince Sigismondo Chigi (1736–93) on horseback in a vast and extended landscape (Figure 1). The portrait, which was a copy of a painting by Gaspare Landi in 1785, differed slightly from the first version, mostly in the up-to-date clothing of the sitter.[1] The Prince takes a central position, which is stressed by his firm gaze towards the beholder. Sigismondo Chigi was an intriguing and complex personality who, in addition to scientific and literary interests, was a trained archaeologist. His excavations included those of Tor Paterna at Castel Porziano near Ostia in the years 1777–80.[2] The antiquarian Ennio Quirino Visconti (1751–1818), whose father had succeeded Johann Joachim Winckelmann as supervisor of Rome's antiquities, was Chigi's librarian. Visconti, as well being a skilled archaeologist, appears in the portrait next to the Prince, pointing to some objects on the ground. These are some of Chigi's most famous finds, including a bust of Antonius Pius and the so-called Chigi Vase.[3]

The portrait of Sigismondo Chigi is a rare exception among eighteenth-century portraits of male Roman nobles. In many ways, the painting connects to that specific portrait type that had been created for foreign visitors on Tour. The sitter is immersed in a landscape with a straightforward connection between himself and the identifiable antiquities, both displayed equally clearly to the viewer of the painting. A comparison with a full-length portrait of Duke Camillo Rospigliosi painted by Agostino Masucci (1690–1768) in 1737 (Figure 2) shows the same landscape context, with the exclusion of antiquities. Despite the fact that this setting probably was chosen because of the Duke's immense love for his horses, the equestrian portrait as such did not occupy a prominent role within eighteenth-century Roman portraiture.[4] In a wider European perspective, however, the setting had traditionally been linked to the idea of male control and aristocratic self-awareness as expressed in conduct manuals.[5] In Rome, this idea had been adapted in order to suit the city's particular supreme position of secular power, and consequently the setting related to a specific portrait type

1 Teodoro Matteini, *Sigismondo Chigi visits the archaeological site at Castel Fusano*, 1792. Private Collection, Rome. Photo: Istituto Centrale per il Catalogo e la Documentazione.

used for the popes. Giovanni Domenico Porta's (1722–80) picture of Clement XIV (Figure 3) shows accordingly the pontiff on horseback, dressed in civil clothes. Within the extended landscape the city of Rome appears from a distance, identifiable by the cupola of Saint Peter.[6] Porta painted at least four equestrian portraits of Clement within a familiar landscape, including that of the lake Nemi south of Rome where the Pope loved to take his walks during his stays.[7] These biographical data might support a claim that landscape in this context could relate to personal preferences and as such not be more than vaguely valid for a more discursive examination. Yet the biographical explanation is not adequate when discussing the presence or non-presence of land in portraits of the ruling elite in Rome at this time. In comparison with the contemporary Grand Tour portraits, produced as conspicuous commodities for export outside the city, it is rather the lack of landscape that is striking. In the Tour portraits, the established relationship between the sitter and the type of adapted land constitutes an important key to that particular travel discourse these portraits relate to, one which was essentially current and socially significant within contexts far beyond Rome. In contrast, the display of Chigi's archaeological

2 Agostino Masucci, *Equestrian portrait of Camillo Rospigliosi*, 1737. Museo di Roma, Rome (MR 765). Photo © Comune di Roma, Museo di Roma.

3 Giovanni Domenico Porta, *Equestrian portrait of Pope Clement XIV, 1770s.* Whereabouts unknown. Photo: Istituto Centrale per il Catalogo e la Documentazione.

activities and that of Clement XIV's horse-riding over the vast Roman Campagna indicate a different interest in the landscape. Land becomes a social metaphor connecting these images to the existing and innate elite discourse in Rome, related to the importance of materially appropriating the city.

The local nobility in Rome had a firm secular tradition based on landowning.[8] According to the Dutch lawyer Theodor Ameyden's important treatise on the

history and hierarchy of the Roman nobility in the 1640s, the feudal families had secured their rank through the claimed antiquity of their lineage within the city.[9] Yet most of them were originally from other parts of the Italian peninsula, and it was through acquired feudal holdings in the Roman countryside that their social status had risen, particularly during the high Middle Ages. Eventually their titles and patrimonies came to be inherited from father to son, securing the primogeniture system.[10] Families like Colonna, Massimo, Frangipane and Orsini could claim such a history. However, a new elite was to respond differently. During the second half of the sixteenth century, a period completely dominated by Counter-Reformation policy, the papacy became increasingly and intimately connected with the social rise of new families, many of them originating from Tuscany or Liguria. This newly established elite was not initially made up of landowners. On the contrary, it was their forceful focus on ecclesiastical careers and the papal court and its family politics that secured them their positions within Roman society. The ecclesiastical fortune of one single member would eventually lead to an affirmation in the city for his entire clan.[11] Being an established social marker, landowning quickly followed.

Important consequences of this extensive growth of the elite included an internal hierarchical struggle that was to accompany the Roman nobility until the late nineteenth century and perhaps even later.[12] An important, and early, reaction to this social mobility consisted in the publication of the celebratory poem *Li Nuptiali* (1506) by the Roman nobleman Marco Antonio Altieri, a member of a feudal family whose primary aim was to attack the newly established families through one single concept: the maintenance of the ancient chain of noble values, based on the heritage from Republican Rome.[13] Altieri's aim was to demonstrate clearly that the feudal families could claim a particular right to the city through a series of constructed genealogies that affirmed their descent from ancient patrician contexts. This was a practice which eventually came to involve even more fanciful claims of lineage from the mythical heroes of Roman history.[14] Significantly, Altieri's text was still in use in the eighteenth century as an iconographic source for the refurnishing of an apartment in Palazzo Altieri. Enterprises such as this clearly show the vivid importance that the fictive genealogies had come to hold in elite Rome.[15] Davide Silvagni, an important nineteenth-century source of the social customs of the papal court, has wittily stated on the subject: 'The ancient Romans pretended to descend from the Gods, the modern and more modest ones are happy to descend from the ancient Romans.'[16] The importance of a claimed classical heritage was a fundamental tool within the struggles of the social hierarchies. Ancient Roman traditions and customs were reverenced through different social practices such as the treasuring of public ceremonies or the keeping of family archives.[17] The visual (and social) qualities of this heritage involved an equally firm adherence to ancient form. Classicist preferences in architecture or painting were certainly not untouched

by the elite's social use of Antiquity in order to affirm themselves in the city. Within this discourse, secular and spiritual powers were closely linked, and the forms of Antiquity were consequently appropriated as important parts of social control. Significantly, the visual adaptations of ancient form were established through control over the cityscape. The elite took charge of the city through the building of palaces, churches and urban gardens. They claimed it socially, and placed its history as well as their own appropriation of it on display through increasingly magnificent collections of material culture. Although natural rivals, the feudal and papal elites shared this social culture and eventually they were, by reciprocal necessity, to be connected. The landowning nobility married their daughters to the secular branches of the papal families, and thus finance and status were happily joined.[18]

Landowning represented an essential part of social strategy and held a symbolic value.[19] The extensive garden and villa projects that developed within Rome and the nearby villages of feudal dominion represented a parallel activity in which new families based on ecclesiastical fortunes were able to actually appropriate the Roman countryside.[20] According to the imaginative geography of classicist pictorial tradition, this land held also a strong mythical importance through literary associations that could be adapted and used for social purposes. In the oeuvre of artists like Claude Lorrain (1600–82), Andrea Locatelli (1695–1741) and latterly Giovanni Paolo Panini (1691–1765), the bucolic tradition, with its reference to pastoral life as a lost golden age of innocence, was consequently and skilfully combined with a concrete visualisation of the exploitation of the very same landscape.[21] This juxtaposition shifted according to the specific prerequisites and demands linked to the commissioners. Landscape art that became a desirable and collectable genre during the course of the seventeenth century could, in a Roman context, link the importance of landowning to the foundations of its new economy: pastoral culture. As Mirka Benes has rightly shown, a shift between the traditional cultivation of land, with the raising of livestock, and a pastoral economy was closely connected to a phase of transmission when land was passed from the feudal families to the papal ones.[22] In terms of social legitimacy, the metaphorical (and social) importance of landowning coexisted alongside its concrete maintenance. Consequently, Romans and foreign visitors experienced the social geography of the city's surroundings in terms of the diverse uses connected to aristocratic property and its economy.[23] Specific buildings, vineyards and agricultural activities were uniformly spread all over this imaginary map, indicating a natural hierarchy of elite enterprise. Garden design and the pictorial landscape genre reflected these different levels of social understanding. The Roman villa context, consciously modelled on its ancient forerunner, came to reflect, on a smaller scale and with a metaphorical purpose, the general elite economy based on territorial appropriation and cultivation. A good example of this, pointed out by Benes, is the Villa Borghese, in

which an elite territorial economy was clearly illustrated through the transformation of original vineyards into designed formal gardens in contrast with a large, apparently natural, hunting park. The latter contained a lake, meadows with livestock and large groves, all clearly claiming their heritage from ancient Rome and the Golden House of Emperor Nero.[24]

The organisation of the rural economy and its impact on the elite villa culture was not always apparent to foreign visitors. In his description of the Roman Campagna, Tobias Smollet's harsh words reflect a disappointment based on his increasing expectations as he came closer and closer to the city of Rome:

> A few other very inconsiderable places we passed, and descended into the Campania of Rome, which is almost a desert. The view of this country, in its present situation, cannot but produce emotions of pity and indignation in the mind of every person who retains any idea of its antient cultivation and fertility. It is nothing but a naked whithered down, desolate and dreary, almost without inclosure, cornfield, hedge, tree, shrub, house, hut of habitation; exhibiting here and there the ruins of an antient castellum, tomb or temple, and in some places the remains of a Roman via.[25]

Vast parts of the Campagna were definitely quite similar to Smollett's description. There were farmhouses or medieval towers once used for defence purposes, but trees were scarce. As a whole, the territory was grand and varied with no apparent internal structures and a rather deserted look.[26] Nevertheless, visitors on their way to Rome could easily pass through this landscape without seeing those parts of the city's immediate surroundings which were actually more fertile. Consequently, they were not able to conceive a total picture of the city's rural organisation and its existing natural resources. Yet Smollet's disappointment gives interesting insights into the traveller's view of the mythological aspects of the Roman landscape. His harsh visual experience of the Campagna can be contrasted with the literary and pictorial genre of idyllic pastorals, which in his texts is given a status as 'past' and consequently related to ancient Rome, the lost paradise for all travellers. In contrast, contemporary landscape painting and its implicit display of a rural economy also reflected the necessary prerequisite for social position and financial wealth of the elite: the ownership of land. The evident popularity of landscape painting within Roman collections in the seventeenth and eighteenth centuries stresses how the elite also wished to display the origin of their status within the contexts of their urban palaces.[27] The intricate designs of urban villas related to the fundamental importance of landowning and the cultivation of land, and landscape art filled the same function.

The link between landscape painting and an elite economy can be discussed further if one takes into consideration specific shifts within the genre itself. During the course of the eighteenth century, the motif became increasingly involved with ancient buildings and archaeological props. The latter were easily

readable as metaphors concerning both the travellers' discourse regarding the abstract values of classical learning and a prosperous innate market which saw the Roman families as main actors (Figure 4). Archaeology was certainly not a new activity, but its financial importance to the city's economy greatly increased. The elite culture in Rome was intimately linked to the idea of the city's historical status, in the duplicate sense of Christianity being both the promoter and the caretaker of the ancient heritage. The collections of antiquities were thus social markers which guaranteed the elite's right to rule through knowledge and birthright. Since these objects were accurately displayed, the claimed status of the owner family was constantly confirmed and viewable for a larger audience than the elite itself. The collections of the Roman families had been opened to the public on a regular basis long before the opening of the Museo Capitolino or the Pio-Clementino, and it was rather common that the prince himself acted as host and guided the visitors around.[28]

Travel accounts frequently give evidence of the complex views on the appropriation and reception of Antiquity which were current among the Roman elite:

> Prince Spada told me a curious anecdote relating to this statue . . . It was found partly on his ground, partly on that of another person, and occasioned a lawsuit. The Spada family pretended, that where the head, the noblest part, lay, the rest of the body ought to belong. His antagonist replied, that however good that argument might be with regard to a man, it signified nothing with regard to a statue. That the most ignoble part of the body, which beyond doubt was the most considerable, lay on their ground, and consequently gave them the best title to the whole. The Judge, like another Solomon, without his wisdom, after deliberating hearing both the parties, adjured the Statue to be cut in two, and divided equally between them. Luckily, with less barbarity they settled the difference, the Spada family, purchasing the other half.[29]

The quotation sheds important light on the close connection between the multifaceted values of the archaeological sites and the elite's properties. The agricultural economy had evolved into an exploitation of landscape that nurtured a new market and the development of professions such as the restorer and the antiquarian.[30] Landscape painting responded to this shift, and the transformation of the elite economy from agriculture to archaeological exploitation became fully visible. Claude's pictures had shown systematically organised sceneries with evenly spread signs of life. Houses, huts, temples, animals and people were painted within precise distances from each other. These distances were actually imaginative, since one glance would allow control over a landscape in reality of too vast proportions for such a view. Despite this metaphorical quality, Claude also offered accurate topographical imagery, readable as different sectors of Roman rural economy.[31] In contrast, landscapes containing archaeological evidence offer very different images characterised by substantial material accumulations (Figure 4). The narrow space between often easily identifiable antiques and

4 Giovanni Paolo Panini, *Roman ruins*. Courtesy of Nationalmuseum, Stockholm. Photo © Nationalmuseum, Stockholm.

buildings contains people who sit on, contemplate in front of or discuss the exposed pieces. These figures are in a sense analogous to the shepherds and shepherdesses that populated the landscape in the Claude tradition, as they are placed to respond to the natural context they are inserted in. Nevertheless, they primarily reflect a different context, the economic exploitation of the Roman resources, and point at the didactic purpose of display which was an aim of the antique market. In this sense, the figures and their 'museum' attitudes also evoke the tourists and that foreign gaze which experienced and ultimately appropriated the ancient material culture through extensive purchases. The literary pastoral, economic pastoral and the expanding antiquities market were thus some of the different levels involved in the understanding of the imaginative topography of the city, all displaying different aspects of economic transactions within and outside the Papal States.

Socio-cultural constructions of landscape constitute an effective instrument of cultural power.[32] Consequently, the way in which land is presented in portraiture is not a negligible element to the reading of that particular genre, and the shift between different levels of imaginative or actual topography is of fundamental importance to their reading.[33] With reference to portrait production in eighteenth-century Rome, landscape settings constitute important signifiers that reveal the sitter's geographical origin and claimed position within the imaginary and the real Rome. Or more explicitly: the chosen approach to landscape defined the sitter's particular need of appropriating it. This need was clearly stressed and visualised through implicit solutions within the painting that related to the sitter, the landscape setting and the presence of material culture evoking the myth of the classical past, which Rome represented.

In the portrait of Sigismondo Chigi (Figure 1) the extended and not particularly idealised landscape presents a deep perspective that primarily emphasises the extensiveness of a territory which was actually owned by the sitter. His supreme social position in this precise context is equally stressed through his body language which references that of the Marcus Aurelius sculpture on the Capitoline hill.[34] The villa-like buildings in the background also indicate the elegant architecture of the elite's domain. The prince on horseback holds a traditional feudal position and control over the landscape, a control that he shares with the Duke Rospigliosi (Figure 2). Moreover, the papal portrait of Clement XIV (Figure 3) reinforces the socio-political character of the landscape metaphor by evoking the *possesso*, the complex and spectacular ceremonial based on the ancient triumph in which a new pope entered Rome on horseback and, surrounded by members of the nobility, took symbolical possession of the city.[35] The reference to the juxtaposition of ancient and modern political manifestation is implicit in the painting through the presence of the man, the horse and the territory, easily identified through the eminent presence of Saint Peter's cupola.

As a contrast, the Chigi portrait introduces a striking element that is lacking in the other two paintings, and which relates to a different discourse regarding the appropriation of ancient land. The antiquities, placed on the ground before the sitter, are displayed as the result of a scientific activity. Furthermore, Visconti's didactic pointing stresses that they have been successfully identified as precious findings and, accordingly, are being given a just amount of attention. These findings are in the Prince's possession in every sense: by legal right, by education and by family history through the ownership of the archaeological site. The bust and the vase are strategically placed at the feet of the horses, almost like the kill after a successful hunt. Bearing in mind the most stereotypical formula for Grand Tour portraits and the socio-economic aspects of elite landowning, it is vital to pose the question of how a picture like the Chigi portrait compares to those which were created for the foreigners to the city. In order to examine further the diverse attitudes involving the relationship between sitter, landscape and the myth of Antiquity it is necessary to look more closely at that specific portrait type related to the Grand Tour in Italy.

'No history, surely, can be so interesting to us as that of the Romans'

If the Roman elite who resided in the city approached the ancient past from their claimed hereditary right given by the sanctions of the Church, the travellers on Tour had different strategies and needs in their appropriation of *romanitas*. Portraits of British travellers in Rome contained carefully marked details in order to signal the territorial identity of the sitter. At the same time, these signifiers display a relationship between elements that the traveller would find both familiar and foreign in Rome, a dichotomy that was equally constant within the travel literature of the period.[36] There is reason to argue that the Tour portrait settings depended as much on this particular dichotomy as on the prescribed opinions of the travel accounts. The painters of these portraits simply could not introduce too many elements which would not be readable or assimilated in the sitter's country of origin.[37] The complex culture of the Grand Tour and its very discourse incorporated both the home country's expectations of cultural assimilation and the experienced impressions of the city that hosted the travellers. In order to give the Grand Tour portrait its proper status as an ambiguous kind of artwork, this particular juxtaposition must be acknowledged.

The previous examination of the social significance of landscape metaphors in Rome can be applied with reference to the travellers, although from a slightly different perspective. The Grand Tour in the eighteenth century was essentially an elite affair. In terms of social identity, most of the travellers belonged to an expanding elite culture in which a careful class system was upheld, also noted by the Romans themselves:

I shall here remark that the Romans arranged their English Visitors into three Classes or degrees – like the Positive, Comparative and Superlative of the Grammarians – the first Class consisted of the *Artisti* or artists, who came here, as well for Study and Improvement, as endurement by their profession – the second, included what they termed Mezzi Cavalieri – in this Class were ranked all those who lived genteely, independent of any profession, kept a servant – perhaps – and occasionally frequented the English Coffeehouse – But the true Cavalieri or Milordi Inglesi were those who moved in a Circle of Superior Splendour – surrounded by a group of Satellites under the denomination of Travelling Tutors, Antiquarians, Dealers in *virtù*, English grooms, French valets and Italian running footmen – in short, keeping a carriage, with the necessary Appendages, was indispensable to the rank of a true English Cavaliere.[38]

For the traditional elite, travelling Europe had at least since the seventeenth century been considered to be an essential preparatory part of male aristocratic education. Yet as social competition increased in eighteenth-century Britain, social mobility became possible and the consumer culture changed accordingly.[39] The elite aura that surrounded the Tour was not necessarily changed. On the contrary, the aristocratic connotation of the Grand Tour gave wealthy people with social ambitions the possibility of claiming local affirmation through an aristocratic practice. This was not very different from the internal struggle of the Roman elite, who tried to achieve status by means of material possessions and genealogical fictions.

In 1766, the Tour artist *par excellence* Pompeo Batoni (1708–87) painted a portrait of Peter Beckford (1740–1809) (Figure 5).[40] Beckford, who had reached Rome on his first trip in 1765, was a sharp-tongued music lover who eventually, in his *Familiar letters from Italy, to a friend in England* (1805), demonstrated his skill at witty and sarcastic prose regarding his experiences in Italy. Peter Beckford's words on the importance of Roman history, quoted as the title of this section, shed important light on how the views on and the use of ancient Rome developed in Britain during the eighteenth century: 'It [the history of the Romans] is not only full of the greatest events – it not only affords the brightest examples of virtue, but the affinity that Government once bore to our own excellent constitution renders it more particularly worthy the attention of an Englishman.'[41] The literary historian Philip Ayres's extensive study on the influence and elaboration of the Roman *exemplum* in eighteenth-century England has discussed the main reasons for this increasing use of the idea of Rome connected to the making of a different England in the aftermath of the politics of the 1680s and the Glorious Revolution. The influence of Roman habits of mind on the social and political elite during the first part of the century was substantial and could very well be compared to the strong appropriation of classical forms and ideas that had occurred during the Carolingian era or in fifteenth-century Italy. In England, the Republican concepts of *virtus* and *libertas* were to be part

5 Pompeo Batoni, *Portrait of Peter Beckford*, 1766. Courtesy of Statens Museum for Kunst. Copenhagen. Photo: Statens Museum for Kunst, Copenhagen.

of the gentry's social strategy in order to protect its oligarchy and privileges.[42] This appropriation of classic civic virtue was associated with the Roman counterpart of the Republican, and not the Imperial, era.[43] The Republican ideal was motivated by the desire to create associative analogies between the contemporary defenders of civic liberties against Stuart absolutism and Cato's and Cicero's defence of the Roman Republic.[44] The political rhetoric was followed by practices that assured a firm continuity between a claimed historical past and a glorious present. Consequently, archaeological activities were compared to contemporary architectural enterprise. Newly constructed classical spots in the country were to be seen as equivalent to those ancient remains that showed that England was once part of Roman Britannia.[45] This is a crucial issue to the use and reception of the ancient heritage in eighteenth-century Britain. Classical architecture would stress a utopian possibility of revitalising a culture, one which once had embraced England. These carefully arranged contexts, in which statements consisted of showing both a territorial and cultural vicinity to ancient Rome, would use display in order to make the ideals of ancient virtue visible.[46]

As a portrait painter, Batoni had come to work almost exclusively for foreign commissioners, mostly British travellers passing through Rome.[47] He became increasingly aware of the tastes, manners and the portrait traditions of these clients. Although his paintings might be eclectic in style, with obvious reverence for Roman-classicist tradition and the travel portrait tradition experienced by Carlo Maratti (1625–1713) or Francesco Trevisani (1656–1746), the complex and careful accumulation of pictorial elements and props relating to Rome and Roman art generated a result that clearly displayed the important issue of national belonging through a common idea of the ancient past. Through the elaboration of landscape, chosen antiques and body language, Batoni managed to satisfy demands that greatly differed from those of the Roman elite. A quote from Peter Beckford's *Familiar letters* gives a good example of the travellers' binary experience of Rome and the constant importance given to their own nationality while on Tour:

> In the courtyard [palazzo Barberini] you may read the following curious inscription: – 'Tito Claudio Augusto quod reges Britanniae domuerit, et gentes barbaros subegerit'. I am not a little proud of that country which is thus represented as barbarious, when at the present moment some of the first Palaces in Rome are not better glazed than an English cottage, and are not half so comfortable.[48]

Beckford's criticism of what he defined as the present decay of Rome, a rather common *topos* in travel literature, is compared here with a Latin quote that refers to Britain as a Roman colony, a conquered territory. This is a crucial point. Primarily, Beckford's words reflect a conflict that incorporates the necessary opposition between the foreign and the familiar, essential to the genre of travel writing.[49] Moreover, his sarcastic tone and the contrast between the present

(decayed) state of Rome and the ancient city which once held parts of his own country as a colony, indicate that the situation has been reversed. The prevalence of Britain over Rome is stressed through the concepts of comfort and cleanliness that constantly return within Beckford's writing as indication of a civilised society: 'You arrive at an immense palace; ascend a magnificent, but dark staircase, frequently crowded with poor, and always covered with dirt.'[50]

As previously mentioned, the concept of Roman Britannia played an important role in general and cultural politics in eighteenth-century Britain. Nevertheless, the obvious differences between ancient Roman society and that of contemporary Britain raised severe criticism. Critics like Horace Walpole (1717–97) or William Hogarth (1697–1764) claimed that England could never be anything else than a caricature of ancient Rome.[51] At the same time, the Britain's success in military actions and the strength of its armed forces created a revised view on the abilities of the English as real conquerors:

> Rome has nothing to fear from the catholic powers, who respect it with a superstitious veneration as the metropolitan seat of their religion: but the popes will do well to avoid misunderstandings with the maritime protestant states, especially the English, who being masters of the Mediterranean, and in possession of Minorca, have it in their power at all times, to land a body of troops within four leagues of Rome, and to take the city without opposition.[52]

A growing sense of strong nationalism, clearly visible in Peter Beckford's travel account, became a parallel discourse to that of Rome as an eternal political and cultural model. Hence, England was perfectly capable of establishing its own future without borrowed elements from the ancient world. As this sense of nationalism increased, so did the efforts to shed light on prehistoric periods in English history. This being seen as a patriotic duty, the myth of ancient Rome was questioned: 'The history of Greece and Rome all seek for in the fountains: and why should not the history of Great Britain obtain even greater attention from every native? As the study of our own history has declined, true patriotism has declined; and to attempt its revival may, it is hoped, be regarded as a service both to patriotism and to literature.'[53]

The nationalistic attempts and the contrast between the civilised, clean and fashionable Britain and a dirty Rome politically in decline within Beckford's writings may be traced as a basic narrative contained in the portrait that Batoni painted of him in 1766 (Figure 5). Topographically the setting has a vague character that evokes the different sections of landscape present in the Claude tradition. A vast meadow spreads before an unidentifiable building of classical proportions, which lies at the foot of higher mountains. The sitter, placed in the immediate foreground, seems to be accidentally leaning on an antique. The extended landscape, its perspective and the eager dog at the sitter's side suggest a temporary pause during a long walk. The chosen antique is the easily

identifiable statue of the divinity *Roma*, placed on top of a pedestal showing the relief of *Weeping Dacia*.[54] Clement XI had bought the sculpture ensemble from the Cesi family in 1719, and installed it in the courtyard of the Palazzo dei Conservatori. The ensemble was definitely among the most famous antiquities that travellers ought to see while in Rome.[55]

The *Roma* divinity was a personification of the city, and her cult had been particularly strong in the Roman provinces. It was closely linked to the general Imperial cult and had as such a great political importance. The goddess's iconography was related to military characteristics, which probably was the reason why few women during the Imperial era chose to associate themselves with this particular goddess in their portraits. *Roma* was, despite her sex, part of the male sphere and was associated with the deeds and virtue of the emperors.[56] In contrast, the *Weeping Dacia* relief refers to Trajan's conquest of ancient Romania, and thus celebrates a political event rather than a religious cult. The fanciful sculpture ensemble is a clear statement of the complex relationship between conquerors and conquered, as is visually exemplified through the superior position of the female divinity on top of a worldly province's female personification. As such, its presence in a Grand Tour portrait of a British traveller indicates a theme of appropriation that goes beyond those actual ancient colonisation events that the objects connote. This complexity may be read according to the sitter's and the artefact's particular physical interaction, which Batoni skilfully avoided repeating despite the fact that he used *Roma* or the entire ensemble in at least five different Tour portraits.[57] In the portrait of Lord Richard Cavendish (1752–81), a three-quarter length painted in 1773, the sitter leans his left arm in *Roma*'s lap while she holds out the sphere of the world close to his mouth (Figure 6).[58] The painting's setting is similar to the one Batoni adopted for the portrait of John Peachey, later 2nd Baron Selsey (1749–1816), in 1774 (Figure 7).[59] The portraits are of a similar posture, but while Lord Cavendish takes a confident attitude towards *Roma* and the expected audience of the portrait, Peachey avoids physical contact with the sculpture as well as avoiding meeting the eye of a presumptive viewer. He turns to *Roma* as if he is accidentally passing by, and looks at the sphere in her hand with a distanced attitude.

As Christopher M.S. Johns has rightly stated, the complex iconographies and compositions of Batoni's Tour pictures must have, at least in some cases, been the consequences of a particular ambition of the sitters in which the antiquities play a crucial role.[60] Yet even if these particular ambitions were not expressed or indeed did not exist, it is fully possible to presume that Batoni was well aware of the Tour's discourse in Britain as well as in Italy, and offered pictorial solutions that would in different ways evoke the social use of the Grand Tour and its desired consequences on a more discursive than personal level.

In the three paintings examined here, it is the attitudes of anthropomorphic artefacts and the sitters that establish differences in the inferred narratives. In

6 Pompeo Batoni, *Portrait of Richard Cavendish*, 1773. Chatsworth: Devonshire Collection. Reproduced by permission of the Duke of Devonshire and the Trustees of the Chatsworth Settlement. Photograph: Photographic Survey, Courtauld Institute of Art.

7 Pompeo Batoni, *Portrait of John Peachey later 2nd Baron Selsey*, 1774. The Edward James Foundation, West Dean, West Sussex.

the case of Lord Cavendish, the confident gesture of the sitter and the sculpture's almost seductive offering of the globe indicate a mutual relationship of confident consumption. What *Roma* offers is going to be consumed and assimilated. In the portrait of John Peachey, the beholder experiences the tourist at an earlier stage of an imaginary Tour, clearly indicated by the inevitable equipment of the eager tourist out in the field: hat, walking stick and a map. The portrait setting stresses the fact that the sitter and the sculpture still are considering if and how to form a bond between two strangers. This elegant metaphor consequently relates to the expectations of the ideal meeting between the British aristocrat and the classical past. The eventual bond, which is completely exhibited in the Cavendish picture, is taken to a final stage in the composition featuring Peter Beckford. If considered together, the main theme of these paintings is the reception of the foreign; they display the various stages of this process and its final, anticipated phase. The choice of artefact is crucial to this discussion, since it constitutes a specific metaphor of which aspect of the past these men are about to appropriate. Thus *Roma*'s historical status as the divinity of the Roman provinces provides an intriguing link between the educational appropriation of something foreign and the fact that Britannia was once part of the Roman world. The Cavendish portrait demonstrates an appropriation of Rome that is concrete and physical. The female divinity offers the sitter the world with a gesture of erotic character, which is reinforced by his leaning his arm in her lap. The mutual consumption between the traveller and the city is thus stressed through the metaphor of sexual consumption. In the Beckford portrait, however, *Roma* takes a relaxed attitude, contemplating the sitter from above without offering him the sphere of world, which is lying in her lap. Since Batoni has used the entire sculpture ensemble in this full-length portrait, the theme of conquest is evinced more than in the other two pictures. The sitter's almost neglectful attitude towards the sculpture and *Roma*'s reserved position indicates that the appropriation of the foreign has taken place and that the sitter's preoccupations are now oriented elsewhere.

'The charms of simple nature': the foreign landscape and the country house context

The full-length composition permitted Batoni to insert an element of crucial importance to the reading of the Tour portrait: the landscape. In the Beckford portrait it is carefully set into the background and its division into different sections stresses the sitter's possible movement through a vast territory in which the *Roma* ensemble constitutes a fictive stop, probably one among others. The imaginative character of this landscape is not similar to the pastoral descriptions of Roman nature current in the Claude tradition, but evokes something rather different:

In a fine extensive garden or park, an Englishman expects to see a number of groves and glades. Intermixed with an agreeable negligence, which seems to be the effect of nature and accident. He looks for shady walks encrusted with gravel; for open lawns covered with verdure as smooth as velvet, but much more lively and agreeable; for ponds, canals, basins, cascades, and running streams of water; for clumps of trees, woods and wilderness, cut into delightful alleys, perfumed with honeysuckle and sweetbriar, and resounding with the mingled melody of all the singing birds of heaven: he looks for flowers in different parts to refresh the sense, and please the fancy; for arbours, grottos, hermitages, temples and alcoves, to shelter him from the sun, and afford him means of contemplation and repose; and he expects to find the hedges, groves and walks, and lawns kept with the utmost order and propriety. He who loves the beauties of simple nature, and the charms of neatness, will seek for them in vain amidst the groves of Italy.[61]

These lines clearly contrast those their author Tobias Smollett used in order to describe the desert land of the Roman Campagna. Paradoxically, he described the expectations and experience of the very same imaginary landscape but he related it to different geographical places: in Italy where it ought to have been, and in England where he considered it to actually exist. The comparison involves an experienced presence of a particular territory – the Campagna – that cannot exhibit the grandeur of its own literary and pictorial mythology. In contrast, the carefully studied, designed and neat eighteenth-century English parks constitute a remedy. They are what the Roman Campagna cannot be: a display of a pastoral mode filled with carefully arranged objects and buildings that connect the ancient past to the present. Smollett's elaborate description of the Englishman's ideal of nature is closely connected to the complex concept of country living as it developed during the course of the eighteenth century.[62] Within the British elite, landowning had represented the same firm social signifier as in Rome, and its importance had equally evolved from its origin in a rural economy to a symbol of social power.[63] The consciousness of ownership and territorial supremacy paralleled the carefully constructed country house context, in which bucolic literary themes were linked to the ancient Roman villa concept. A retreat from the urban world came to be praised as definitive proof of a good sense of ethics and civic virtues. These were linked to the literary genre of country house poems that essentially appeared from the seventeenth century onwards.[64] The country house and its surroundings was also a traditional setting for English portraits.[65] This is perhaps best manifested through the production of the painter Arthur Devis (1712–87), whose detailed conversation pieces displayed the landowner and his family in the actual surroundings of their country seat, clearly demonstrating the importance of land and cultivated life in association with family status and continuity.[66]

In the Beckford portrait the unidentifiable character of the landscape, in contrast to Devis's portraits for instance, plays a decisive role since its elaborate

structure, divisions and the presence of an elegant building clearly point more at the idea of an elite landscape than one singled out in particular because it could be biographically linked to the sitter. This imaginative use of the landscape was especially effective in the Grand Tour portrait, which had to work metaphorically in order to convey a number of important narratives, including both national and foreign discourses. In this sense, the presence of *Roma* in the portrait's landscape indicates two different issues. First, it reflects the fanciful use of sculpture within garden design and house settings in the country house context. To the initiated audience the portrait setting could thus be linked to a previous portrait tradition in England as well as to the elite milieu of the countryside. Placing paintings, sculptures and books on display in a carefully constructed architectural setting surrounded by a designed park had become a way of demonstrating an awareness of the link between material possessions, social status and ethical living. Indoor and outdoor settings complemented each other.[67] Second, the presence of the sculpture points to an implicit narrative that deals with the painting's main theme: the Grand Tour and its expectations in terms of appropriation. *Roma* represents all those casts or copies bought abroad, but it also acts as a signifier of a reversed colonisation. With reference to the Tour discourse, Rome has been consumed and appropriated and consequently brought back in the form of a comment upon the complicated relationship between cultural (and indeed political) domination and subordination. *Roma* thus represents a duplicate idea with both its historical status as conqueror and its status as conquered being itemised, copied, transformed, adapted, purchased and taken out of context.[68] In these terms, Beckford represents a new type of conqueror who dominates the past through the possibility of purchasing knowledge and knowledge-connoted objects through travelling. The presence of *Roma* in a landscape of a specifically English character shows that the idea of bringing antiques back to the home country was synonymous with a gain in social prestige through the virtuous act of re-building the ancient past in a worthy territory.

Reinforcing foreignness: the Van Dyck costume in the Grand Tour portrait

The Grand Tour portrait had to cover a broad spectrum of narratives and pictorial traditions in order to suit the final home context of the sitters. The landscape setting was one of these. The choice of costume constituted another, which clearly can be seen as one of the more important signifiers tied to the dichotomy foreign/familiar and to the concept of exact national identity.[69] In most of his Grand Tour portraits, Batoni portrayed the sitters in their contemporary and very fashionable clothing.[70] Yet the painter occasionally used a specific type of costume that bore radically different connotations, the so-called Van Dyck costume:

The great variety of excellent portraits with which Vandyck has enriched this nation, we are not content to admire for their real excellence, but extend our approbation even to the dress which happened to be the fashion of that age. We all very well remember how common it was a few years ago for portraits to be drawn in this fantastick dress; and this custom is not yet entirely laid aside. By this means it must be acknowledged very ordinary pictures acquired something of the air and effect of the works of Vandyck, and appeared therefore at first sight to be better pictures than they really were.[71]

Sir Joshua Reynolds's words on the subject address at least one aspect of the vogue for this particular dress within portraiture: claimed artistic quality based on the reputation of the seventeenth-century painter Anthony Van Dyck. Yet the seventeenth-century dress held other implications. Primarily, it indicated an increasing focus on the immediate past which, at least in Britain, was intended to promote a national sentiment for the Tudor and Stuart periods.[72] Paralleling a vivid interest in the political events of the seventeenth century, there was an acknowledged interest in its visual arts. Horace Walpole's *Anecdotes of Painting*, published in 1762, displayed a clear interest in the painters of the Carolingian court.[73] A portrait painter such as Thomas Gainsborough (1727–88) used the Van Dyck idiom in different ways. He excelled at his predecessor's technique for acquiring a specific pictorial quality, and assumed the seventeenth-century dress in order to reinforce an impression that decidedly involved a historical vogue for the painter Van Dyck, as well as to relate the sitter to the past in a highly fashionable way.[74] Shearer West has rightly suggested that the Van Dyck costume helped to insert contemporary portraits within ancestor galleries where old and new portraits could be placed together, united by the idiom of the seventeenth-century dress.[75] In a photograph from 1921 taken of the dining room at Mersham Hatch in Kent, Batoni's portrait of Sir Wyndham Knatchbull-Wyndham (1737–63) is shown displayed above a chimneypiece designed in 1763 by Robert Adam, and surrounded by three sixteenth-century female portraits (Figure 8).[76] West's observations are fully supported here. The anachronistic clothes of the sitter insert him into a continuum of family history, with the result that the chronological distance between Sir Wyndham and the female sitters is lessened.

Since portrait signifiers cannot be regarded as fixed, the use of the Van Dyck dress in Batoni's Tour portraits has a different implication. For instance, Sir Wyndham's costume is contrasted to classical signifiers such as the bust of Minerva, columns and the distant Temple of Sybil, all appearing in the elaborated landscape set. The previously stated aim of the Tour portrait, to visualise the relationship between the foreign and the familiar, puts the presence of the dress in an interestingly ambiguous position. Being closely connected to a canonical seventeenth-century artist, highly regarded within the British elite collections, the dress is closer to the concept of familiar despite its anachronism.

8 *Mersham Hatch, Kent. The dining room*, 1921.
Photo © Country Life Picture Library.

The detailed artefacts that surround the sitter appear inevitably as linked to that experience of the foreign through travelling.

Carlo Maratti's Tour portrait of Robert Spencer, 2nd Earl of Sunderland, displayed the sitter in the full outfit of an ancient Roman. Spencer was thus inserted into a setting equipped with a reversed identity that clearly displayed the expected fulfilment of the travel's aim: the experience of Rome had actually turned him into a Roman. Batoni's use of the Van Dyck costume appears much more complex, since his sitters most probably rejected the idea of wearing an ancient Roman costume. They preferred their own clothing, which was associated with travel equipment, or the Van Dyck dress, which created a straightforward link to the home country and had useful implications from a practical point of view. The dress not only connected the sitter to England through a well-known portrait tradition, but also indicated the sitter's future place within an ancestral gallery and, consequently, future responsibilities and social status. According to the dichotomy of travel discourse, the Van Dyck costume constitutes that familiar signifier which contrasts with foreign signifiers holding classical implications, and eventually made the travel experience comprehensible and appropriable.

Purchasing and selling antiques: gaining and losing social prestige

In 1798–99 the artist Bernardino Nocchi (1741–1812) painted a portrait of the Roman prince Camillo Borghese (1775–1832) sitting in a park by a lake with a suggestive temple building in the background (Figure 9). The Villa Borghese, which is the setting of the portrait, had a history that went back to the earliest days of social affirmation of the Borghese family in Rome. As a result of the activities of Cardinal Scipione Borghese (1579–1633), nephew to Pope Paul V (1550–1621), the *villa suburbana* developed, as previously shown, from simple vineyards to a designed structure aimed at the privileged leisure activities of the elite. The Villa was a museum, a place of erudition and recreation, and by no means was intended only for private enjoyment. The cardinal's art and antiquities collections were installed in the Casino, where his foreign guests and intimate friends were met with great festivity.[77] During the last thirty years of the eighteenth century, Marcantonio IV Borghese began a radical re-planning of the Casino and the Villa.[78] As a part of the project, the architect Antonio Asprucci (1723–1808) created the Giardino del Lago, beginning in 1784 and completing it in 1790.[79] The lake was adorned by a Greek temple building dedicated to Aeusculapius, the God of medicine and son of Apollo and Coronide, the daughter of the king of the Lapiti.[80] In the *Metamorphoses*, Ovid includes a detailed account of the events that preceded the arrival of the cult of Aeusculapius to Rome. A terrible pestilence in Latium had taken numerous lives and since no medication or human care had made any difference, the Romans decided to

9 Bernardino Nocchi, *Portrait of Camillo Borghese*, 1798–99. Galleria Sabauda, Turin. Reproduced by permission of Ministero per i Beni e le Attività Culturali.

plead for help at the Sanctuary of Delphi. Apollo sent his own son to help out in the guise of a giant snake, and after honouring his father's temple in Antium, Aeusculapius arrived in Rome, where he chose a small island in the Tiber for his sanctuary. As soon as he was settled, the god took human form and restored health in the city of Rome.[81]

In 1785, Marcantonio IV had purchased an ancient sculpture representing Aeusculapius from the sculptor and restorer Vincenzo Pacetti (1746–1820).[82] The theme of the temple in the lake was probably due to this important addition to the family's collection.[83] Nevertheless, the theme also suited the complexity of the narrative of Villa Borghese as an entity. As previously shown, landscape painting and villa culture were linked together, but they were essentially dependent upon the realities of the elite economy. Villa Borghese was structured as a

microcosm in which all components of elite life were represented, including its basis in the rural economy, through the presence of livestock. Equally, the Villa and the Giardino del Lago were part of the strict family mythology. As with many elite families, the Borghese had followed their fictive genealogy back to the heroes of Roman literature. For instance, the mythical family descent had been the main theme of one of the painted ceilings executed in 1779 in the Casino Borghese within the Villa, pointing to the fictive genealogical connection between Aeneas and the Borghese family.[84]

The presence of Aeusculapius' temple at the family villa indicated according to such a mythology that the strategically chosen spot was on the territory of the rightful heirs to the Roman founders. The pursuit of the Giardino del Lago should therefore be seen as intended to emphasise not primarily the glorious past of Rome but instead the glorious past of the Borghese family as Roman citizens. A newly created ancient spot involved a social strategy of personal interest based on adaptations of literary sources and the fundamental concept of landowning. In Nocchi's portrait of Don Camillo, the villa is a spot of pure leisure, in which the Roman prince is presented as a romantic hero, stretched out in front of the audience, close to a musical instrument and the inevitable dog. The portrait is surely connected to a contemporary European portrait type that involved somewhat new concepts of masculinity, nature, education and sensibility, for instance, as seen in the portrait of the poet Brooke Boothby painted by Joseph Wright of Derby in 1781. Yet the strong connotation of the identity of the Borghese landscape links the painting to a narrative that clearly involves the importance of a specific ownership and social legitimacy. The book in Don Camillo's hand, and to which he is pointing, shows an illustration of one of the most famous antiques in the Borghese collection, the *Gladiatore*. The sculpture had been a part of the family's collections since it was unearthed in Nettuno, south of Rome in 1611.[85] Eventually it was installed in a room named after it in the Casino within the Villa.[86] On 27 September 1807, Don Camillo sold the *Gladiatore* along with approximately three hundred antiquities from the family collection to his brother-in-law and the emperor of France, Napoleon Bonaparte.[87] When Nocchi painted the portrait, the sculpture had not yet been sold and it represented one of the most famous pieces owned by the Borghese family. Casts in bronze and full-sized copies were made for several European courts. In Britain, its popularity increased during the course of the eighteenth century and the early nineteenth century, and its presence in the country house context became frequent.[88]

Now, the Borghese sales were not entirely due to Camillo's needs. On the contrary, it was his father Marcantonio IV who had begun the process of dispersion before his death. When Nocchi painted the portrait of the young prince, this process was already underway. The singularity of the setting in terms of appropriation of Rome through material possessions is reinforced by the circumstances that the Borghese family were experiencing at the time of the painting's

genesis. The ideal portrait of Camillo, inserted into the context of social and museum display that the Villa Borghese involved, is an image of family policy and family mythology that was slowly falling apart.

As shown, portraits intended for travellers on Tour tended to emphasise the concept of appropriation of the myth of Antiquity, while the issue of actual ownership remained more complex and related to the idea of conquest in both an abstract and concrete sense. This contrast is best demonstrated through comparing the portrait of Camillo Borghese in the Giardino del Lago with Hugh Douglas Hamilton's (1740–1808) portrait of Frederick Augustus Hervey, Bishop of Derry and 4th Earl of Bristol (1730–1803) and his granddaughter in the very same setting (Figure 10).[89] The Villa Borghese was more than a suitable setting for this painting, since both the Temple's architect, Asprucci, and the designer of the Giardino del Lago, the Scottish landscape painter Jacob More (1740–93), were contracted by the Bishop, respectively as architect and agent.[90] Yet it is the interaction between the girl and the object and eventually the role of the Bishop that is of prime interest here. The painting shows Hervey comfortably leaning on a tree while his granddaughter Lady Caroline Crichton (1779–1856) points to an ancient object and simultaneously addresses her grandfather. The Bishop's poised attitude in contrast to the more active and engaging body language of the little girl stresses a didactic situation in which the younger one demonstrates her newly gained knowledge to her elder. The antique that Lady Caroline is tactically showing to her grandfather is the so-called *Ara Borghese*, one of the Roman antiques that Napoleon later purchased from his brother-in-law Camillo.[91] The misplaced antique, in the open air, holds a double function, since it represents a museum object of desire in terms of both education and financial appropriation. Evidently, the Bishop had nurtured plans to purchase the altar from Camillo Borghese before the antique went to France.[92] The presence of the sitters in this particular setting stresses a peculiar and ambiguous museum context *en plein air*, which represents a new direction if compared to the similar setting used for Prince Borghese. The Hamilton portrait exemplifies a foreign space of learning and cultural appropriation which is nevertheless inaccurate, since the antique, despite its status as part of the Borghese collections, represents an unrealistic addition to the spot. This detail brings the painting closer to, for instance, Batoni's portrait of Peter Beckford, a picture which clearly evokes the idea of a re-established ancient spot in a foreign country.

> We English, before we see Italy, are apt to think that we can purchase the best works of the great masters, and that many of them have actually been brought away within these few years. There cannot be a grosser mistake. The Italians are too cunning to suffer the market to be removed out of Italy. As for parting with a valuable antique statue, they would much sooner give up their seven sacraments. The Pope could make his people Protestants much more easily, than persuade them to let the Apollo out of Rome.[93]

10 Hugh Douglas Hamilton, *Portrait of Frederick Hervey Bishop of Derry and Fourth Earl of Bristol*, c. 1790. Courtesy of National Gallery of Ireland. Photo © National Gallery of Ireland.

Sir Philip Francis's (1740–1818) comment shows how the sales of antiquities in eighteenth-century Rome created a tense situation, involving both the purchasing actors and those who made the market possible by selling off these objects that held such major connotations for Roman identity. Besides the Vatican museums, the British constituted the strongest group of buyers of newly discovered and transacted antiquities in Rome.[94] These purchased artefacts created a gain in prestige within the elite of a Britain that had channelled its political rhetoric through that of the Roman Republic. In addition, the art

market in England changed in the 1750s. Dealers, painters and collectors were the prime actors involved in promoting this particular scenario where the audience was to be shaped into holding specific interests and ideas about taste.[95] The eagerness with which these practices were institutionalised shows the quick rise of an expanding English nation which knew how to engage the visual arts as well as other spheres of intellectual production. This engagement resulted in the process of visualising unity and prosperity out of a culture of heavy consumption.[96] As previously stated, the increasing flood of money was partly due to the possibility of social competition. The consumer culture was strongly influenced by the fact that the passing from one social rank to another became possible.[97] As consumption increased within the country, based on the explosion of industrial enterprise and profit, buyers could also extend their consumption abroad. Pictures and antiquities bought in Italy gave that particular sign of acquired taste which would reinforce the status of an acknowledged elite and support the rise of the up-and-coming.[98]

The Roman nobility experienced the reverse situation. Their fortunes were tied up in material possessions which were important signifiers of social power: urban palaces, *villae suburbanae*, and collections of ancient and contemporary art. Some of the families had deposited money abroad, but generally the Roman elite lacked liquidity. Newer families who could not claim a long line of baronial or ecclesiastical fortunes and consequently lacked those material signifiers which upheld social status initiated attempts at industrial enterprise. The complex apparatus of ceremonies linked to the affirmation of the elite had created an idea of conspicuous consumption that was a natural part of the nobles' lives. Such consumption, uncompensated for by any kind of relevant production, made Rome a fruitful market for purchasers from other parts of Europe.[99] At the beginning of the eighteenth century most elite collections were intact, but at the century's end families like Altemps, Altieri, Barberini, Borghese and Chigi, to mention just a few, had effectuated large sales of their collections on the public market and to the Vatican museum.[100] The popes' hostility towards this market was strong, as shown in Sir Philip Francis' comment, and so were their efforts to avoid complete dispersal of the Roman patrimonies.[101] The popes' actions in this matter should not only be interpreted as a wish to keep important art works within the city. Ancient Rome and its material culture constituted an essential part of the mythology of Christian Rome and its social system and hierarchy. Losing these signifiers meant an important loss that not only involved the official prestige of the papacy in diplomatic terms. It also involved the elite culture from inside and weakened its continuous struggle in a social arena where actual power was transitory.

The regular lack of ancient artefacts appearing in eighteenth-century portraits of Romans must be understood in the socio-economic terms of the importance of the antique sales. The portrait of Sigismondo Chigi and that of Camillo

Borghese assume in this context a significant and peculiar role, since they point at a problematic that essentially had financial roots. A comparison between these paintings and that of Peter Beckford clearly shows an acknowledged difference in their use of landscape, material culture and social appropriation connected to the idea of the ancient past. In the portrait of Sigismondo Chigi, the artefacts are related to the land they, so to speak, came from. The ancient objects form a direct link between the sitter and the ancient past. The Prince's *romanitas* lies in the precise balance of his own empirical activity and an embodied ownership of the exploited territory. Knowledge and material culture are thus skilfully linked to the implicit culture of the Roman elite, who saw the collecting of antiquities as a superior way to claim a righteous social position in the city. In contrast, Camillo Borghese's appropriation of social rights is indicated through the elaborately constructed site of new antiquity that was the family villa. The clear-cut concept of placing material culture on display in order to gain social status is in this painting underscored twice, through its physical setting and through the reference to the famous artefact in the family's possession.

The Grand Tour portrait relates differently to this discourse. Peter Beckford and Lady Caroline Crichton both address objects that had been taken out of their context and physically transformed in order to suit the portrait's narrative. In Beckford's case, the object was inserted into a landscape of imaginative character that easily could recall the English elite's carefully elaborated natural settings in the countryside. Lady Caroline, on the contrary, acts in a Roman setting where the museum purpose of the site is evident. Nevertheless, the general and imaginative character of the Beckford portrait landscape, compared to the identifiable settings of the Chigi and Borghese portraits, reinforces the concept of a stressed alienation from that ancient past which was clearly an important *topos* in the travel discourse of the foreign elite while in Rome.

Notes

1 F. Mazzocca et al. (eds), *Il neoclassicismo in Italia da Tiepolo a Canova* (Milano 2002), p. 413.
2 M.T. Caracciolo, 'Un patrono delle arti nella Roma del settecento: Sigismondo Chigi fra Arcadia e scienza antiquaria', in E. Borsellino and V. Casale (eds), *Roma: 'Il tempio del vero gusto'* (Florence: 2001), pp. 101–21.
3 S. Grandesso, 'La vicenda esemplare di un pittore "neoclassico": Gaspare Landi, Canova e l'ambiente erudito romano', *Roma moderna e contemporanea*, 10:1 (2002), p. 190.
4 On the biography of the sitter, see A. Negro, *I Rospigliosi* (Roma: 1999), p. 155.
5 M. Warnke, 'Das Reiterbild des Baltasar Carlos von Velázquez', in K. Badt and M. Gosebruch (eds), *Amici amico: Festschrift für Werner Gross zu seinem 65. Geburtsag am 15.11.1966* (Munich 1968), pp. 217–27.

6 O. Michel, 'Giovanni Domenico Porta', *Mélanges d'archéologie et d'histoire: École française de Rome* (1968), p. 341, no. 45.
7 O. Michel, 'Giovanni Domenico Porta', p. 303 and pp. 324–5.
8 M. Benes, 'Landowning and the villa in the social geography of the Roman territory', in A. von Hoffman (ed.), *Form, modernism and history* (Cambridge, Mass.: 1996), p. 188.
9 T. Ameyden, *Storia delle grandi famiglie romane*, C.A. Bertini (ed.) (Roma: 1915).
10 T.L. Ehrlich, Landscape and identity in early modern Rome: Villa culture at Frascati in the Borghese era (Cambridge: 2002), p. 18.
11 M.A. Visceglia, 'Introduzione', in M.A. Visceglia (ed.), *La nobiltà romana in età moderna*, p. xx.
12 On this subject, see G.C. Jocteau, *Nobili e nobiltà nell'Italia unità* (Roma-Bari: 1997).
13 M. Piccialuti, *L'immortalità dei beni: Fedecommessi e primogeniture a Roma nei secoli XVII e XVIII* (Roma: 1999), pp. 12–13. See also, N. La Marca, *La nobiltà romana e i suoi strumenti di perpetuazione del potere* (3 vols, Roma: 2000), vol. 1, p. 30.
14 M. Piccialuti, *L'immortalità dei beni*, p. 14.
15 F. Speroni, 'Il gabinetto nobile: Un manifesto estetico in Palazzo Altieri', in E. Debenedetti (ed.), *Temi di decorazione: Dalla cultura dell'artificio alla poetica della natura. Studi sul Settecento Romano*, 6 (Roma: 1990), pp. 227–42.
16 D. Silvagni, *La corte e la società romana nei secoli XVIII e XIX* (Roma: 1884), p. 95: I romani antichi pretendevano discendere dagli Dèi, i moderni più modesti, si contentano di discendere dagli antichi romani.
17 M. Piccialuti, *L'immortalità dei beni*, pp. 14–27 and pp. 228–31. On the importance of the Roman noble archive, see S. Pagano, 'Archivi di famiglie romane e non romane nell'Archivio Segreto Vaticano', *Roma moderna e contemporanea*, 1:3 (1993), pp. 189–231.
18 T.L. Ehrlich, *Landscape and identity in early modern Rome*, p. 21.
19 T.L. Ehrlich, *Landscape and identity in early modern Rome*, pp. 18–27.
20 M. Benes, 'Pastoralism in the Roman baroque villa and in Claude Lorrain: Myths and realities of the Roman Campagna', in M. Benes and D. Harris (eds), *Villas and gardens in early modern Italy and France* (Cambridge: 2001), pp. 88–93.
21 On Claude Lorrain and the relationship between Roman economy and the landscape genre see M. Benes, 'Pastoralism in the Roman baroque villa and in Claude Lorrain'.
22 M. Benes, 'Pastoralism in the Roman baroque villa and in Claude Lorrain', p. 100.
23 M. Benes, 'Pastoralism in the Roman baroque villa and in Claude Lorrain', p. 104.
24 M. Benes, 'Pastoralism in the Roman baroque villa and in Claude Lorrain', pp. 104–5.
25 T. Smollett, *Travels through France and Italy*, F. Felsenstein (ed.) (Oxford: 1979), pp. 245–6.
26 M. Benes, 'Pastoralism in the Roman baroque villa and in Claude Lorrain', p. 104.
27 See, for instance E. Borsellino, *Musei e collezioni a Roma nel XVIII secolo* (Roma: 1995).

28 A.M. Clark, 'The development of the collections and museums of 18th century Rome', pp. 136–43.
29 P. Beckford, *Familiar letters*, pp. 239–40.
30 S. Pasquali, 'Roma antica: Memorie materiali, storia e mito', in G. Ciucci (ed.), *Roma moderna*, p. 346.
31 M. Benes, 'Pastoralism in the Roman baroque villa and in Claude Lorrain', p. 111.
32 W.J.T. Mitchell, 'Imperial landscape', in W.J.T. Mitchell (ed.), *Landscape and power* (Chicago and London: 1994), p. 2.
33 H. Langdon, 'The imaginative geographies of Claude Lorrain', in C. Chard and H. Langdon (eds), *Transports: Travel, pleasure and imaginative geography 1600–1830* (New Haven and London: 1996), pp. 151–78.
34 F. Mazzocca et al. (eds), *Il neoclassicismo in Italia*, p. 413.
35 On the *possesso*, see M.A. Visceglia, *La città rituale*, pp. 68–82.
36 C. Chard, *Pleasure and guilt on the Grand Tour*, pp. 20–2.
37 C. Chard, *Pleasure and guilt on the Grand Tour*, p. 20.
38 T. Jones, 'Memoirs of Thomas Jones', *Walpole Society*, 32 (1946–48), pp. 70–1.
39 N. McKendrick, J. Brewer and J.H. Plumb, *The birth of a consumer society*, pp. 20–7.
40 A.M. Clark, *Pompeo Batoni*, no. 296.
41 P. Beckford, *Familiar letters*, p. 105.
42 P. Ayres, *Classical culture and the idea of Rome in eighteenth-century England* (Cambridge: 1997), p. 1.
43 P. Ayres, *Classical culture and the idea of Rome*, pp. 165–7.
44 P. Ayres, *Classical culture and the idea of Rome*, pp. 2–3.
45 P. Ayres, *Classical culture and the idea of Rome*, p. 48.
46 P. Ayres, *Classical culture and the idea of Rome*, p. 48.
47 A.M. Clark, *Pompeo Batoni*, pp. 29–31.
48 P. Beckford, *Familiar letters*, p. 237.
49 C. Chard, *Pleasure and guilt on the Grand Tour*, pp. 20–2.
50 P. Beckford, *Familiar letters*, p. 280.
51 C. Chard, *Pleasure and Guilt on the Grand Tour*, pp. 165–7.
52 T. Smollett, Travels through France and Italy, p. 260.
53 Quoted from S. Smiles, *The image of antiquity: Ancient Britain and the romantic imagination* (New Haven and London: 1994), pp. 8–9.
54 F. Haskell and N. Penny, *Taste and the antique: The lure of classical sculpture 1500–1900* (New Haven and London: 1981), no. 28.
55 C.M.S. Johns, 'Portraiture and the making of cultural identity', pp. 388–9.
56 T. Mikocki, *Sub speciae deae: Les impératrices et princesse romaines assimilées à des déesses*. Étude iconologique (Roma: 1995), pp. 110–11.
57 C.M.S. Johns, 'Portraiture and the making of cultural identity', pp. 388–90.
58 A.M. Clark, *Pompeo Batoni*, no. 360.
59 A.M. Clark, *Pompeo Batoni*, no. 376.
60 C.M.S. Johns, 'Portraiture and the making of cultural identity', pp. 384–5.
61 T. Smollett, *Travels through France and Italy*, pp. 263–4.
62 On this social phenomenon, see M. Girouard, *Life in the English country house: A social and architectural history* (New Haven and London: 1978).

63 M. Girouard, Life in the English country house, p. 2.
64 V. Kenny, *The country house ethos in English literature 1688–1750: Themes of personal retreat and national expansion* (Brighton: 1984), pp. 2–6.
65 S. West, 'Patronage and power', p. 135.
66 On Arthur Devis, see for instance E. d'Oench, *The Conversation Piece: Arthur Devis and his contemporaries* (New Haven and London: 1980).
67 See for instance A. Guilding, 'The classical sculpture gallery in the 18th century country house', MA report, University of London: Courtauld Institute of Art (1994).
68 On the status and meaning of copies see, for instance, V. Coltman, *Fabricating the Antique: Neoclassicism in Britain, 1760–1800* (Chicago: 2006), pp. 123–63.
69 A. Ribeiro, *The art of dress: Fashion in England and France 1750–1820* (New Haven and London: 1995), p. 7.
70 A. Ribeiro, 'Batoni's use of costume', in E.P. Bowron (ed.), *Pompeo Batoni and his British patrons*, p. 21.
71 Sir J. Reynolds, 'Discourse VII', *Discourses on art*, R.R. Wark (ed.) (New Haven and London: 1988), pp. 138–9.
72 T. Castle, *Masquerade and civilisation: The carnivalesque in eighteenth-century English culture and fiction* (Stanford: 1986), pp. 30–1.
73 D. Cherry and J. Harris, 'Eighteenth-century portraiture and the seventeenth-century past: Gainsborough and Van Dyck', *Art History*, 5:3 (1982), p. 287.
74 On Gainsborough and fashion, see for instance, M. Rosenthal and M. Myrone (eds), *Gainsborough* (London: 2002), pp. 144–7.
75 S. West, 'Patronage and power', p. 138.
76 A. Bolton, 'Mersham Hatch, Kent', *Country Life*, 64, 26 March 1921, pp. 368–75.
77 T.L. Ehrlich, *Landscape and identity in early modern Rome*, pp. 29–41.
78 P. Mangia, *Il ciclo dipinto delle volte: Galleria Borghese* (Roma: 2001), p. 5.
79 B. Di Gaddo, *Villa Borghese: Il giardino e le architetture* (Roma: 1985), pp. 109–36.
80 R. Graves, *The Greek myths* (London: 1992), pp. 173–6.
81 Ovid, *Metamorfosi*, P.B. Marzolla (ed.) (Turin: 1979), pp. 622–745.
82 A. Campitelli, 'Il tempio di Eusculapio', in A. Campitelli (ed.), *Il Giardino del lago a Villa Borghese: Sculture romane dal classico al neoclassico* (Roma: 1993), pp. 45–6. See also A. Campitelli, *Villa Borghese: Da giardino del principe a parco dei romani* (Roma: 2003), pp. 272–301.
83 A. Campitelli, *Villa Borghese*, p. 274.
84 P. Mangia, *Il ciclo dipinto delle volte*, p. 21.
85 F. Haskell and N. Penny, *Taste and the antique*, no. 43.
86 P. Mangia, *I ciclo dipinto delle volte*, p. 7.
87 F. Haskell and N. Penny, *Taste and the antique*, no. 43.
88 F. Haskell and N. Penny, *Taste and the antique*, no. 43.
89 See for instance, F. Cullen, 'Hugh Douglas Hamilton in Rome 1772–92', *Apollo*, 115 (Feb. 1984), pp. 86–9.
90 A. Wilton and I. Bignamini (eds), *Grand Tour*, p. 59; A. Campitelli (ed.), *Villa Borghese: I principi, le arti, la città dal Settecento all'Ottocento* (Milano: 2003), p. 285.

91 A. Campitelli (ed.), *Villa Borghese*, pp. 286–7.
 92 A. Wilton and I. Bignamini (eds), *Grand Tour*, p. 59.
 93 Quoted from J. Black, *The British abroad: The Grand Tour in the eighteenth century* (New York: 1992), p. 266.
 94 I. Bignamini and I. Jenkins, 'The Antique', in A. Wilton and I. Bignamini (eds), *Grand Tour*, p. 203.
 95 J. Brewer, *The pleasures of the imagination: English culture in the eighteenth century* (London: 1997), p. 202. On the making of a public art scene in England see D. Solkin, *Painting for money: The visual arts and the public sphere in eighteenth-century England* (New Haven and London: 1993).
 96 J. Brewer, The pleasures of the imagination, passim.
 97 N. McKendrick, J. Brewer and J.H. Plumb, *The birth of a consumer society*, pp. 20–7.
 98 C. Hornsby, 'Introduction, or why travel?', in C. Hornsby (ed.), *The impact of Italy: The Grand Tour and beyond* (London: 2000), p. 8.
 99 See for instance H. Gross, *Roma nel Settecento*, pp. 98–100 or C.M. Travaglini, 'Economia e finanza', in G. Ciucci (ed.), *Roma moderna*, pp. 79–114.
100 I. Bignamini and I. Jenkins, 'The Antique', p. 204.
101 S. Pasquali, 'Roma antica', in G. Ciucci (ed.), *Roma moderna*, p. 344.

2

Mythological adaptations: gender and social identity

Classical mythology was an ambiguous issue in eighteenth-century Europe. There was both a clear acceptance and, at the same time, a sceptical attitude towards the world of the ancient gods.[1] As James Engell has pointed out, the dilemma involved the difference between the historical values of the primary sources and the adaptations and literary conventions developed during the early modern period, which were based on the ancient narratives.[2] In portraiture produced in eighteenth-century Rome, the relationship between the cultural consumer and the idea of Antiquity and its mythology was clearly manifested in two separate ways. As previously shown, one solution for visually discussing this issue through portraiture was to create a specific boundary between the sitter and the past. This boundary was essentially constructed from a strict use of body language and physical attitudes through which the sitter, as the contemporary element within the painting, clearly manifested control over the given past presented through imaginative geography, territorial acknowledgement and material culture. As shown, these portrait settings were particularly useful for British tourists in the city, with their desire to visualise a reinforced connection with the classical past through the experience of travelling.

Another way to exemplify a relationship between the sitter and the past was through the 'historical portrait', a painting in which the sitter was assimilated to an ancient mythological figure or a literary character often taken from ancient Roman literature.[3] Theoretical assumptions within the traditional academic context praised the setting for its capacity to construct an identity partly released from the boundaries of the contemporary, which placed the generally low positioned portrait on the superior level of history painting. Indeed, Sir Joshua Reynolds claimed in his fourth Discourse that 'if a portrait-painter is desirous to raise and improve his subject, he has no other means than by approaching it to a general idea'.[4] However important these theoretical statements might be, it is necessary to consider them in light of general academic discourse and, consequently, as separate from the social contexts where the paintings were actually consumed after leaving the painter's studio and, perhaps, a public exhibition's sphere. As Kate Retford has recently observed, the various artistic elaborations

associated with the historical portrait were connected to accepted and expected gender roles.[5] Contrary to a rather common view on the genre of portraiture offered within the academies of art in Europe, these gender roles shifted according to the different societies and different countries in which they were found. It is therefore important to consider not only the choice of narrative that occurred in different contexts and for different purposes, but also how these settings were formally resolved, and which emphases were given to different components within the painting. This leads, essentially, to an examination of the wider implications of Reynolds's 'general idea', and the possibility of connecting this portrait type more strongly to its field of final consumption, social expectations and ambiguities.

A Trojan hero and a princess of Latium at an eighteenth-century wedding

The visual lack of signifiers pointing to a close relationship between the Roman elite and the idea of Antiquity was compensated by texts pointing to such a relationship. Elaborated literary family mythologies were important components within Roman elite culture. These were carefully expressed through poetry and ultimately linked to the city's (and the families') complex ceremonial structure. The literary associations in use were decisively connected to those carefully set fictive genealogies which had supported the legitimacy processes linked to the families' desired appropriation of high rank within the city of Rome. These texts helped to visualise and to regulate in which ways Antiquity was socially elaborated and made fit for manifestations of both a verbal and visual character. As will be discussed, these literary efforts and their discourse constituted the framework in which the artistic manifestation of social identity, i.e. portraiture, took place.

In 1758, the Prince of Palestrina, Giulio Cesare Colonna di Sciarra and his consort Cornelia Costanza Barberini assisted at the marriage between their daughter Maria Felice and the Prince of Sismano, Bartolomeo Corsini.[6] The event constituted an important connection between two families of Tuscan origin who had succeeded socially in Rome as a result of certain members' ecclesiastical careers. On the occasion of these festivities, a number of poems and texts were composed and published in which the glorious past of the couple's families was exalted. These texts clearly demonstrate the exuberance of Roman aristocratic self-awareness, and give evidence of the imaginative use of ancient literature for social purposes. The duplicate choice of genres in this case, that is, poetry versus drama, served to spread the image of the marriage's importance both within and outside the family circle. In Fabio Devoti's highly expressive and entertaining fictive account of the event, it is the theatre of Hymen, the god of marriage, which constitutes the set of his drama.[7] As the couple's parents take their seat on an actual stage, ancient gods and poets are busy assisting them. In

contrast, modernity is represented here through the stage's carefully elaborated scenography, signed by both Michelangelo and Bernini. The eclectic choice of artistic entrepreneurs in this context is clearly used to link both Rome's literary and architectural history to the grandeur of the Barberini and Corsini families. The juxtaposition of ancient and modern characters ultimately evokes the double heritage of Roman society in terms of pagan and Christian religions.

Maria Felice holds an active part within this peculiar setting, and her controlled movements on the stage while observed by the seated parents and the implicit reader of the text are connected to her initiation into a new marital state. This becomes particularly evident in the scene where she is suddenly confronted with a series of portrait busts of famous Corsini ancestors from which she learns about the history of her future husband's family.

In contrast, the collection of poems published in celebration of the marriage offers a number of well-known metaphors in order to manifest present and past powers.[8] The introductory part opens with a large number of classical references used in order to compare the groom's literary activities with those of Maffeo Barberini (1568–1644), eventually Pope Urban VIII and the man who definitively secured the social position of the Barberini family in Rome. After mentioning the river Arno, a subtle metaphor for Italian poetry as well as the Tuscan origin of both families, the Tiber is skilfully used as a double metaphor for the families' hierarchical (and physical) journey towards the city of Rome. Public good will, a traditional aristocratic virtue, is highlighted through the opening of the Corsini library in 1754 in Trastevere, an area of Rome that had previously lacked public libraries.[9] The display of and the emulation of culture is shown here as linked to civic virtue and as such part of a process of social legitimacy. But the leitmotif in the text is undoubtedly family continuity, expressed through the poetical description of the young Maria Felice:

> The Lady of Gentle Soul
> That joyful and shy
> Shines with sweetness in her face
> Of the BARBERINI
> Is that seed, but almost Divine;
> In her soft limbs
> the golden beautiful Mother,
> And for the majestic brow
> She resembles Juno;
> Pallas for her ways of speech
> For her actions, and her advice;
> And if she laughs, she appears to me like Thetys, who plays at sea.[10]

Here, the characteristics of the ancient gods have been used to describe the bride. The images are skilfully contrasted with previous lines in which Maria Felice's female virtues are associated with Christian values. Motherhood and family

continuity were not dependent upon the past, but on a future secured by Providence. The association to the ancient gods was useful in order to clearly express the girl's social position. Her famous family name is associated directly here with divine status ('quasi è Diva'). In her physical appearance she resembles Venus, the 'bella Madre' of Rome and the hero Aeneas. Her majesty is compared to that of Juno while in wisdom, wit and prudence she resembles Pallas. And her smile recalls the joyful water playing of Thetys, consort to Oceanus, clearly pointing to the importance of female sociability within the elite milieu.

The issues of motherhood and family continuity were thus initially stressed through Christian themes. In the following text, these precise virtues are manifested again, but this time through ancient Roman sources. Three nymphs present the bride with a small ivory sculpture of Gaia Caecilia, wife to the fifth king of Rome, Tarquinus Priscus. The rituals linked to the ceremonial of matrimony in ancient Roman society included the figure of this mythical woman.[11] It is understandable that the authors used the comparison, stressing the fatal connection between Maria Felice and Gaia Caecilia, both daughters of Rome and spouses to kings. The elegant and understated reference to Bartolomeo Corsini as a king should not be viewed only as courteous rhetoric. On the contrary, it offers an important insight into an elite structure in which each family in a way represented its own court. Moreover, the use of a semi-historical figure connected the bridal couple in a stronger way to Rome than more common comparisons to ancient divinities might have done. In the end, the authors use an additional image in order to assure the couple a Roman identity:

> And Fame who arose an adorning laurel on the Tiber
> At the time when the unhappy Aeneas
> Arrived to settle new residence,
> A Bride and the Reign of Heaven awaited him there
> On another top a swarm of bees were seen
> And everyone said
> So happy for Lavinia such a day glowing from nice auspices.
> You Rome that knows how such behaviour creates such famous heroes,
> Still today no less happy are Your auspices.
> I already foresee other Bees crowding the ether, another Bride, other Heroes,
> but am I thinking? Fool! It must be the real that I describe and adorn.[12]

The theme is taken from Virgil's *Aeneid*. The choice is appropriate and strategic, since Virgil's oeuvre itself had been an important tribute to the process of legitimacy of the emperor Augustus. The deeds of the pious hero Aeneas who, after leaving Troy and a hard journey into the underworld, married the daughter of Latium's king, Lavinia, and eventually founded the city of Rome, could easily appeal to those elite families of other regional origins who had become Roman citizens.[13] In the Barberini/Corsini poem, bees, that is to say the members of the Barberini family whose armory contained three bees, accompany Aeneas and

Lavinia. The insects are surrounded by the glory of continuity: just as Rome had created other heroes, she will continue to produce them in the name of Barberini.

The texts examined above point out two distinct issues which are relevant when examining Roman elite portraiture. The first regards the elaborate use of classical metaphors, which appears to be firm, ambitious and propagandistic with the ultimate aim of linking the elite commissioners to Rome's ancient and modern history. The second, and perhaps the more important in this context, was the determination to manifest this social appropriation through display. As the poems exalted the innate ruling rights of Maria Felice and Bartolomeo, Fabio Devoti's fiction put these rights on display within a distinctive theatre context, featuring a clear separation between those who acted on the stage and those who were supposed to view and consequently legitimate the act. Accordingly, the theatre of Hymen in Devoti's book constitutes a literary counterpart to an elite discourse based on the necessity to constantly display a modern mythology referencing ancient divinities, Christian virtues and values, and episodes and personages from ancient and modern history.

How did Roman portraiture relate to this mythology? Were there visual equivalents to those text productions that deliberately placed elite families on a divine social level? In order to examine the question, it is necessary to look more closely at the relationship between this particular mythology and the historical portrait as such.

'Lady, everything in you is Great': Diana/Artemis and the ambiguities of female virtue

It is possible to explore the question further by discussing a portrait of the bride's mother Donna Cornelia Costanza Barberini Colonna di Sciarra (1716–99) (Figure 11).[14] The somewhat anachronistic pose of the Roman matron, with her hand firmly placed on the left, takes as its influence a typical male position within the tradition of European portraiture, even if it did occasionally occur in female imagery.[15] The arrow in her right hand references a similar tradition within the genre, alluding to Diana/Artemis, the ambivalent goddess of hunting and Apollo's sister. The reference as such was undoubtedly considered as important. In an 1845 inventory taken in Palazzo Barberini the portrait is recalled as *Portrait of the princess Lady Cornelia dressed as Diana by an unknown.*[16] The Diana myths were probably among the most common narratives in eighteenth-century portraiture, and were deeply rooted in pictorial tradition.[17] A major reason for this vogue, which parallels other goddess narratives, was undoubtedly the numerous possibilities of interpretation of the goddess's virtues and skills, which appealed to the commissioners. As a contrast, twentieth-century scholarship has tended to examine this type of historical portrait through what has been

11 Unknown artist, *Portrait of Cornelia Costanza Barberini as Diana*, 1740s. Private Collection, Rome. Photo: Witt Library, Courtauld Institute of Art, London.

established (and consequently selected) as the basic characteristic of the narrative in question. This rather simplistic approach has sometimes resulted in somewhat rigid readings, with paradoxical results. A representative example can be extracted from the portrait production of the French painter Jean-Marc Nattier (1685–1766) whose fame was linked to female portraits in ancient divine settings. The painting showing Louise, Duchess of Chartres (1726–59) (Figure 12), portrays

12 Jean-Marc Nattier, *Portrait of Louise d'Orléans, Duchess of Chartres as Hebe*, 1744. Courtesy of Nationalmuseum, Stockholm. Photo © Nationalmuseum, Stockholm.

the sitter gracefully seated on a cloud, dressed in white and adorned with a garland of flowers. The cup and the pot in her hands give, together with the aggressively thirsty eagle, a clear hint of the divinity she is associated with. The story of the goddess Hebe, daughter of Zeus (here represented in his most well-known disguise), is a perfect example of a narrative that has been strictly

connected to concepts such as physical beauty and youth. Yet Hebe's complex mythology and her particular status on the Olympe and within the divine family give further possibilities as to how to read a painting that was carefully produced to fit within French elite society. Kathleen Nicholson, for instance, has argued that the success of this particular portrait type, which she places during the first half of the eighteenth century, occurred in a period when images of men in divine disguise were decreasing.[18] This observation has been shared by Gill Perry, who points to men's public roles, which women could not share, as a reason for the ease with which women were associated with seductive and supernatural portrait settings.[19]

Nicholson attributes these images to misogynist writing, and particularly to the negative criticism of Nattier's oeuvre as expressed through Denis Diderot (1713–84).[20] In contrast to Perry, she discusses the paintings as results of a struggle between women's social aspirations and the gendered roles offered them in society. The mythological setting would grant women a place in the public sphere because of the accepted assimilation to female divinities. Consequently, Nicholson views the portraits of the royal mistresses Jeanne Antoinette de Pompadour (1721–64) and Jeanne Du Barry (1743–93) as examples of women who took control over their own visual mythology by using settings that recalled pastoral, divine or religious contexts.[21] Nicholson's arguments shed light on an important question regarding the complex ambiguities of the historical portrait. Yet the example of the royal mistresses' visual self-control may appear in this context as more unique than representative for the average elite eighteenth-century woman. Pompadour and eventually Du Barry occupied official positions that had been only partially accepted as an institutional right of the French kings. The portraits produced for them were part of a specific process of legitimisation with its own tradition, linked to the court milieu of Versailles.[22] Several of these paintings were exhibited at the Salon, including those of Pompadour, who took immense care with her public image. As the Salon represented a context of artistic opinion, it was above all a place where social order was displayed.[23] Consequently, the position of the king's mistress became socially anchored in a forum of acceptance by the display of her effigy. Comparing the settings of these portraits with those of elite women who did not, at least apparently, live beyond the norms of sexual morals is less fruitful, since the generalised female role did not allow for the exuberance shown by the royal mistresses. The use of ancient associations, which Nicholson sees as proof of the sitter's independence and the conquest of a public sphere, may therefore be interpreted as a rigid idiom in which a prescribed order based on accepted gender roles was to be upheld. A comparison with Sir Joshua Reynolds's portrait of Mrs Sophia Musters in the guise of Hebe painted in 1782 may shed further light on this important issue. The Musters portrait offers a similar setting to that of the Duchess of Chartres, with the difference that the sitter is shown in full length. Despite the fact that

Mrs Musters acts according to Hebe's domestic duties, the display of her entire body gives the setting that typical spectacular flair which characterised Reynolds's work for the elite and, indeed, the *demi-monde* in late eighteenth-century England.[24] Reynolds's elaboration of the motif was clearly dependent on the portrait tradition that Nattier had popularised at an earlier stage. Nevertheless, the way in which he let the female sitter physically take charge of the canvas, in comparison with the neatly seated Duchess of Chartres, connects the painting to a strictly British discourse in which portraiture, social display and public fame were co-related.[25]

Leaving for a moment the important issue of specific regional elite discourses, it is useful to consider the prescribed female order and the case of Hebe as crucial to this discussion. Despite her apparently protected position as Zeus' daughter, she represents perhaps one of ancient mythology's most fragile female figures, and the one whose story could most easily be adapted to early modern gender ideology. Hebe's fortunate career as server at the gods' table was soon to be destroyed through physical clumsiness. Slipping on the floor with her cup, she fell into a position of such considered indecency that her father, who eventually replaced her with a young mortal, Ganymede, immediately dismissed her from her duties.[26]

A broader look at the content of the Hebe myth thus gives indications that portraits using this setting might be read differently, without simply referring to themes of youth, beauty and divine (socially supreme) status. It is fully possible to suggest that the popularity of the setting was due to the fact that it actually displayed a general social order in which the gendered roles of elite women appeared to be under careful control. When Diderot argued that Nattier 'always painted women as Hebe, as Diana, as Venus etc. All his portraits look alike; one thinks one is always seeing the same face', he unconsciously indicated a desirable stereotyped image of femininity as it was broadly accepted in elite eighteenth-century France.[27] Such an image required uniformity. Hebe's status as daughter was eventually followed by her role as consort when she was given to Hercules at the moment of his ascension to the Olympe. Associations to the goddess could thus appeal to the expected conduct codex of elite women. Hebe was neither aggressive nor independent. The polite Duchess of Chartres turns to the viewer while offering the father figure his nectar. Despite her position in the triumphant centre of this carefully set portrait, the Duchess embodies socially accepted subordination.

Denis Diderot's criticisms regarding the historical portrait were certainly not unique. Equivalents were to be found in academic contexts in both Britain and Italy.[28] Portrait settings where the female sitter was shown adorning a statue of Hymen or reading and wandering in gardens were alternative images that clearly stated the physical and social possibilities of the genteel woman.[29] Nevertheless, the servile attitude of Hebe and its consequences was no less recognisable to the

portrait consumers in terms of expected female virtues than the presence of a book or a child within a female portrait. Still, the difference between settings is crucial, since one linked the sitter to a supernatural world which the other clearly denied.[30]

The portrait of Cornelia Costanza Barberini was a product of a rather different elite discourse from those which were current in France or in Britain. Its reading may be based on a combination of discursive, biographical elements which work as counterparts. This somewhat paradoxical approach aims at exposing how a society's ambiguities sometimes challenge its visual culture.

An overview of the Diana/Artemis mythology provides an essential starting point. During Antiquity, the cults in her honour were numerous, with an iconography that smoothly shifted according to which of her qualities were in focus.[31] Her many skills were extended to the protection of hunting and the world of animals, as well as to the female sphere of giving birth.[32] She was connected with light, perhaps due to her brother Apollo's most famous signifier, but also with the moon. Sometimes she was associated with other goddesses like Selene or the Egyptian Isis, whose cult was firmly established in Rome during the reigns of Augustus and Tiberius and popularised by several other emperors.[33] In the eighteenth century the more frequent signifiers of this particular narrative were the bow, the arrow and a crescent on the sitter's forehead. Pompeo Batoni's portrait of Carlotta Ondedei Caetani, Duchess of Sermoneta, painted in 1750–52 and Francis Cotes' portrait of Lady Stanhope and her sister the Countess of Effingham, painted about a decade later in 1767–70, are both examples of a portrait setting that appeared in all parts of Europe.[34] The ambiguity of the figure's narrative offered extensive possibilities for portrait painters. The ancient myths attested to the goddess's capacity to care as well as to her cruelty. The chastity motif, one of her more famous characteristics, was in itself a marital virtue. Diana also protected mothers from infidelity and spared the lives of both them and their children.[35]

Terry Castle has pointed out that much of the eighteenth-century disguise culture examined the possibilities of the inversion of one's sex and personality.[36] The ambiguous characteristics of Diana and Apollo, as they appear in their tales and within the numerous functions of their cults, seem particularly intriguing in this sense. As Castle points out, the figure of the goddess was seen as disturbing in the eighteenth century.[37] Yet her ambivalence and paradoxical characteristics could challenge (and confirm) traditional female roles. In contrast to the family girl Hebe, Diana was independent and authoritarian, and consequently a suitable sign for the more powerful aspects of elite femininity.

In the portrait of Cornelia Costanza Barberini, as a result of the expressive body language of the sitter and the pointed way with which she shows Diana's arrow to the viewer, the mythical narrative and the biography of the sitter are clearly associated. When Cornelia Costanza Barberini at the age of twelve

married Giulio Cesare Colonna di Sciarra (1705–87) she was the last heir of the powerful Roman family and its entailed patrimony.[38] Being the only child of Don Urbano Barberini, Prince of Palestrina (1664–1722) and his third consort Donna Maria Teresa Boncompagni, Duchess of Sora, her marriage became an affair of great importance for the prolongation of the Barberini dynasty. The process that led to the final matrimony was not without its complications.[39] The final candidate Giulio Cesare Colonna di Sciarra, Prince of Carbognano, was the eldest son of Francesco Colonna di Sciarra (1683–1750) and Donna Maria Vittoria Salviati (1692–1744). His military career had brought him to service at the court of Philip V in Spain and subsequently to Naples and Charles III. His marriage to the young Cornelia Costanza had been carefully arranged by the girl's tutor and uncle, Cardinal Francesco Barberini junior and Giulio Cesare's mother. The conditions of the matrimony were clear: Giulio Cesare had to join his own name to that of Barberini and accept that only the second born son would inherit the name and patrimony of the Colonna di Sciarra family. By special permission granted from Benedict XIII, Cornelia Costanza received the right to let her husband enjoy the Barberini inheritance and to accept the unification of both patrimonies.[40] Entitled to the entailed estate and the last heir of one of Rome's most important families, Donna Cornelia held a particular role that was not common among elite women. Since childhood, she was used to an unusual amount of attention from people in her immediate surroundings that was exceptional for a girl. As Caroline Castiglione has pointed out, the young Cornelia was brought up in the midst of a complex conflict relating to her own future that was engaged in by her mother Maria Teresa Boncompagni and her uncle the cardinal Francesco.[41] Donna Teresa had been determined to keep her daughter in her care after her husband's death. This ambition, surely not unnatural in itself, gives, however, evidence of a strong female determination and intervention in family affairs that was surely not uncommon in early modern Italy, yet not fully acceptable.[42] Although Donna Teresa lost the battle over her daughter, it is probable that Cornelia Costanza was greatly influenced by the force with which her mother had claimed her right to her daughter. As a mother, Cornelia Costanza herself would take a sometimes rather harsh attitude towards her children, especially in terms of strict family affairs. Her husband, Giulio Cesare, seems on the contrary to have acted as an intermediary between his wife and their children, and a preserved correspondence demonstrates the latter's confidence in their father. When the couple's daughter Maria Artemisia (1736–?) begged her parents for permission to become a professed nun in the convent Santa Caterina da Siena a Magnanapoli where she was being educated, the letter was addressed to her father. The emotional tone of the fifteen-year-old does not hide the fact that her father was the first to know about her wish, and that it was only then that he brought Cornelia to visit their daughter in order to learn the news: 'When Your Excellency came to

favour me and to comfort me after learning about my hasty wish to enter the religious state, you had the goodness to tell me that you would have brought Mother to see me and with whom I could have explained my sentiments.'[43] It appears equally clear from the letter that Cornelia hesitated when confronted with the decision. When she finally indicated that Artemisia should wait longer before taking such a complicated decision, the girl promptly confided in her father who eventually managed to please his daughter. The intense and intimate tone of Artemisia's letter is also to be found in Giulio Cesare's correspondence with the eldest son Urbano Maria, written in the 1780s when the latter had moved to Naples in the aftermath of a major inheritance conflict caused by his mother.[44] While Giulio Cesare tried to reconcile the hostile parties, his consort skilfully avoided the subject in her own letters, very well aware that she had disinherited her first-born on unfair grounds.[45]

The poems composed in honour of Cornelia Costanza during her lifetime offer clear indications of the particular importance that she held within her family in terms of dynastic matters:

> For Her Excellency the Princess Cornelia Barberini
> Lady, everything in you is great and everything inspires
> In us respect, wonder, and love
> And expresses the mind, and the speech and
> The Wit, and the heart,
> What is Just, the truth, the grave and the sweet:
> If the Grand Tiber had you, when the feminine value reached the heights in glory
> And the other Ladies, through the paths of Honour,
> Won over Time that oppresses the grand names.
> Less luminous did they go during the ancient century
> For their value, patience and their wit
> Portia, Veturia, and Augustus' consort,
> For to save the Fatherland from every danger
> Your noble, excellent skill,
> And the wrinkling of your genteel brow.[46]

The main theme of the text deals with an intersection of male and female values, emphasised by ancient references. Among Cornelia Costanza's virtues are governmental abilities (For to save the Fatherland from every danger / Your noble, excellent skill). She is described as using physical gestures that traditionally are attributed to men (the wrinkling of your genteel brow). Mind, reason and speech are contrasted with righteousness, love, gravity and wit. Consequently, Cornelia Costanza's important position as the last member and the saviour of the Barberini family bloodline is translated into a poetical figure which combines the traditional virtues of both men and women. The anonymous author of the text chose to depict the Barberini princess through a social reality which had placed her in an exceptional position according to traditional gender roles. The poem's

ambiguous use of male and female virtues probably derived from her noted social position and an unconventional behaviour in public. The diarist Francesco Valesio recorded how the then fifteen-year-old Cornelia Costanza deliberately used men's clothing during her country stays and how the priests' strong aversion to her resulted in forbidding her to attend mass.[47] These attitudes clearly indicate that Cornelia Costanza was very well aware of her duplicate role within her family, and that the social liberties she took were due to this prominent position.

The setting of her portrait is relevant to what has been related above. The female signifiers associated with Diana contrast here with a body language linked to the idea of supreme masculinity. The choice of signifiers and the sitter's attitude make it possible to read the setting in relation to one of the goddess's many characteristics, namely the protection of motherhood. The arrow that Cornelia Costanza so pointedly includes may allude to the tale of Niobe, Queen of Thebes, who challenged Letho, Diana's and Apollo's mother during the annual festivities of the latter. Niobe claimed, despite being a mortal, to be worthier of people's praise not only in terms of divine descent but due to the fact that she had given birth to fourteen children in contrast to Letho's two. Letho's anger resulted in her twins' famous revenge and the consequent death of Niobe's children by Apollo's and Diana's arrows.[48] Since the arrow plays such a fundamental part in this story, the portrait closely links its narrative to this particular myth. Cornelia Costanza's peculiar position within her family made her public body connected to male virtues in terms of concrete power and government, but she was also inevitably linked to the traditional female virtue of having produced numerous offspring. She alone could maintain the Barberini bloodline, and she succeeded. Ten surviving children, all born during the first decade of her marriage when she was still a very young woman, secured the family name but also guaranteed her own supreme position within both an intimate and a wider, public circle. The Niobe tale's terrifying message of the consequences when power is challenged perfectly fits the Princess's position, since the power in question is divine. In early modern terms it must be understood as strictly connected to the status quo of social hierarchy: as heiress and mother, Cornelia Costanza cannot be defeated.

The poem cited above was not the only one written to Cornelia Costanza in which her duties and virtues were stressed. At the occasion of her daughter Maria Felice's marriage, the bride's mother was praised as follows: 'Yet You, that were predestined / By the grand Fate, friend of Rome, to save the Barberini blood / Could triumph among Latin mothers of generous offspring.'[49]

The Roman theme, with its association to the benevolent Fate, indicates Cornelia Costanza's duty to bear children. The mention of Fate as friend to the city of Rome is a subtle hint at the thematic promoter of the *Aeneid* where the important point is Aeneas' founding of the city through the will of Fate. Since

Cornelia Costanza is described as chosen by Fate to save her family, the comparison to the Virgilian hero is evident and perfectly in line with the Roman elite's strategic genealogies, where divinities and semi-mortals were placed on top of a fictive family tree.

The portrait analysed above is only partly visually connected to its narrative. Cornelia Costanza wears her own fashionable clothes and precious jewels. The bow and the arrow in her hands are not reinforced by a crescent on her forehead, which would have weakened the boundary between real and supernatural contexts. The relationship between the ancient past and the present is therefore strictly held apart in a way that is reminiscent of Batoni's Tour settings. The main difference here lies in how the mythological adaptations are constructed from the social discourse of Antiquity upheld by the European elite. In the Tour portraits, the importance of Antiquity is visualised through signifiers of a decisive material character. Antiquity appear as conquerable, controlled, itemised and definitely conceived of as 'past'. In the portrait of Cornelia Costanza Barberini, the material aspects of Antiquity are neglected in favour of a juxtaposition of a personal mythology and that of an ancient divinity.

This use of mythology in order to establish social hierarchies or gender specifications was deeply rooted in Imperial Roman culture and consequently portraiture, personal biography and divine assimilation were strictly connected. Exhibiting portraits of members of the imperial family in the guise of divinities was an important part of political propaganda, and served as dynastic legitimacy. Numerous women of the imperial dynasties were portrayed as assimilated to, for instance, the goddess Diana in her various roles. Several factors decided the choice of narrative, such as dynastic policy and the propaganda of merits.[50] The imperial women could gain the guise of a female divinity through either their own personal merits or through pre-established aspirations and qualities based on family expectations.[51] Assimilation to divinities was also in recognition of the difference between the living and the dead as well as between the private and the public sphere.[52] This pragmatic attitude and the vivid sense of biography as well as family history connected to portraiture were certainly to continue into the early modern world. In eighteenth-century Rome, this was particularly relevant since the elite depended on the ancients' social practices in order to affirm themselves and their supreme, 'divine' status.

The rigidity of ancient Roman portrait assimilations was undoubtedly due to the socio-political discourse, which considered the rulers of Rome as actually equivalent to the gods. This correspondence between sitter and his/her guise has already been mentioned in this study as a relatively short-lived phenomenon. The allegorical elaboration of the portraits of rulers aimed at an abstract visualisation that only partly included the concept of personal biography.[53] Yet eighteenth-century elite portraiture faced a number of different issues that would have made the rigid assimilation scheme of the Romans impossible to relate to

for the audience. This was essentially due to the fact that a chosen assimilation in a portrait very rarely excluded the possibility of adopting a different one in another portrait. This reversible and, sometimes, ambiguous play with the possibilities of social identity constitutes an intriguing and yet difficult issue to examine. Primarily, it shows that the strict link between biographical details had been replaced by a diversity of *exempla* that related to the social and gendered possibilities of certain social groups.

In order to broaden this discussion, it is worthwhile taking into consideration that a setting also acquired different implications due to the geographical circumstances of its commission. A portrait painted in Rome by an Italian artist for a British commissioner and equipped with a particular historical setting would most probably gain a different reception at its homecoming compared to a historical portrait painted in Britain by a British artist. The very circumstance of the Grand Tour portrait process and its commemorative function responded to a discourse that was divided between the sitter's roles of traveller/foreigner and social persona/integrated in the country of origin. It may be convenient to draw a parallel to the complex phenomenon of masquerade as it appeared in eighteenth-century Europe. Excluding the explanation of the historical portrait as simply an illustration of these entertainments, it is nevertheless possible to discuss the masquerade as a moment of reversed identity on display.[54] Terry Castle, in her studies on the masquerade phenomenon in Britain, discusses the co-relation between dress and social codes and how a reversal of the code would lead to the possible exploitation of a system creating inverted meanings far from the established truth of cultural discourse.[55] If the masquerade event constituted a euphoric event based on the betrayal of social codes through costume, then the travel experience equally represented a transitional period outside the sociocultural discourse of origin.[56] A portrait commissioned abroad would gain a stronger sense of the foreign, since the portrait process was linked to a moment in which the sitter was absent from the home context.

'Before marriage their women are nuns, and after it libertines': the multiple roles of Cleopatra

The portrait of Cornelia Costanza Barberini is a carefully balanced picture in which biography, personal mythology and the ancient narrative co-relate. The multifaceted Diana narrative, which evidently could have been adaptable to any portrait of elite women at the time, forwarded those expected superior female virtues that made Cornelia Costanza a both singular and perfectly confirmed lady: chastity, nobility, motherhood and hidden seductiveness. More explicitly, this type of narrative supported women's role as relational to other people: daughter, wife, mother and widow.[57] The Roman elite women were strictly confined within a domestic sphere that only extended to incorporate their family

home and the home of their future husband. Between these primary and final stages, the convent constituted either a context of temporary transition or the only accepted alternative to conventional marriage.[58] Symptomatically, portraits of very young girls almost always included Christian signifiers such as crucifixes or prayer books.[59] They helped to visualise the girls' virtues and intact bodies before a marriage, and referred to the inevitable convent education that most elite girls received. Before marrying Bartolomeo Corsini, Maria Felice Barberini spent at least one year in the convent of Santa Caterina da Siena a Magnanapoli, with her sister Maria Artemisia. The latter chose to become a nun, while the former was brought back home on the occasion of the engagement to Corsini.[60]

Differences in gender roles were largely written about in the travel accounts at the time, and the British tourists often remarked upon the strict divisions of female social spheres in Italy. In 1780, Lady Phillipina Knight (1726–99) wrote: 'You know that here the ladies are not seen till very near marriage; however, at the villegiatura [summer holidays] they are permitted to visit, by which means Cornelia [Ellis Cornelia Knight, the author's daughter] was seated beside the young Princess Giustiniani, who only awaits her apartment being furnished to espouse the Prince of Ruspoli.'[61] Lady Anne Miller expressed herself even more sharply when observing the social life of the Roman ladies: 'At twelve years they are immured in a convent, from which there is no return, but upon the hard condition of receiving from their parents a husband whom they have never seen.'[62] The strong aversion expressed in the latter quote should probably be seen in the framework of the dichotomy foreign/familiar within the travel writing genre rather than as simple indignation of anti-Catholic proportions. As Amanda Vickery has indicated, the eighteenth century, at least in the non-Catholic parts of Europe, saw an increasing vogue for the freely chosen marriage of the romantic (and literary) model, which, however, did not correspond to most marital markets and their strict and material conditions.[63] Yet it should be stressed that young or unmarried women of the British elite enjoyed greater possibilities of physical and social movement than their Roman counterparts. This wider context, in terms of the rules of social life, which obviously was tutored and guarded by mothers, sisters or governesses, did allow the two sexes to meet, interact and form attachments that could lead to marriage if the other prerequisites were fulfilled. In Rome, these opportunities were non-existent. Young women were educated to fulfil their marital duties outside that social scene in which they were expected eventually to take part. The marquise Margherita Sparapani Boccapaduli (1735–1820) relates the following in her memoirs, describing her leaving of the convent Tor de' Specchi, where she had spent four years of education. Since a forthcoming marriage awaited Margherita, her mother introduced her immediately into society in order to prepare the daughter for the rules and tricks of mundane life:

> Before I was a bride my mother brought me to the assemblies and to the theatre, a completely new thing for me and I examined everything and enjoyed myself. My mother gave me a lot of instructions so that I would behave, as she desired. She told me: be sure that due to the novelty all eyes will be upon you; speak only little, keep a wise and proper conduct, it is important not to be judged because if they start to say that you're a fool they will say so for the rest of your life, be always aware of yourself, don't pay attention to praise but be sure to earn it by your conduct.[64]

Unlike the wicked Madame de Merteuil in Laclos's novel, Donna Costanza Gentili, the Marquise's mother, quickly prepared the eighteen-year-old to navigate in a society that treasured its paradoxes, especially in terms of female gender roles. These paradoxes were visually outlined in portraiture through the choice of a narrative that displayed ambiguous potentials connected to the married or unmarried state of women. Despite the treasured Diana narrative, the most frequent setting used for married women in eighteenth-century Rome was based on the mythical life of Egyptian queen Cleopatra (69–31 BC). Since references to Antiquity in the form of associative objects, disguises or physical settings are relatively scarce within the known portraiture produced for the Roman eighteenth-century elite, the high number of portraits with the Cleopatra motif requires attention and investigation.

A myth already in her lifetime, Cleopatra was adopted during the early modern period as a significant trope which had been used since Antiquity.[65] The ancient sources concerning her life and influence on contemporary policy had been mixed with modern accounts in which artistic efforts like painting, literature or melodrama played a significant role. Ancient authors like Pliny and Plutarch had given their version of her life story, as well as the Italian early Renaissance writer Boccaccio. Since the predilection for portrait settings with narratives that went beyond Western mythology to the foreign world of the Orient increased during the eighteenth century, the Cleopatra myth gained a revived interest.[66] A consideration of the particular episodes that were chosen as settings for portraits gives a crucial indication as to which aspects in Cleopatra's life and character were focused upon and connected to female contemporary portraiture. In 1803, the feminist writer Mary Hays (1760–1843) published *Female Biography; or Memoirs of Illustrious and Celebrated Women of all ages and countries*. An entire chapter was dedicated to the life of Cleopatra. The text resembles a traditional conduct manual, although with some important differences. The women selected for the book are described as having their marital virtue, cultural skills and physical beauty eventually translated into sexual power, an element that rarely occurs in traditional conduct literature, but is present in the work of Mary Hays.[67] Such a text stresses those aspects of the life of the Egyptian queen which could be considered useful for an eighteenth-century female reader, and consequently serves as a tool in order to explore these

narratives' visual effects on portraiture. Although Mary Hays operated within an intellectual context that was very different from the conventional female spheres in eighteenth-century Rome, she definitely explored one important aspect of Cleopatra's persona that in a way constitutes the very basis of the Queen's personal mythology and which connected to particular conformed regulations within the Roman elite: sexuality.

One of the more famous episodes in the Cleopatra mythology involves a seductive game between the Queen herself and a man. The episode was first narrated by Pliny in *Naturalis Historia*.[68] Mary Hays relates it as follows:

> But, admit her aspiring projects, she omitted not, by inexhaustible varieties of luxury and pleasure, to rivet her chains on the voluptuous Anthony. At a splendid feast which he had caused to be prepared for her, she affected to undervalue the entertainment, boasting that she would, in her turn, provide for him a supper, on which should be expended more than a million of sesterces. Anthony, mortified at her raillery, dared her to the performance of her engagement. The evening was accordingly appointed, and the supper served up, in which there appeared to be nothing extraordinary. Antony smiling, called for a bill of the amount. Cleopatra, with an appearance of good-humour, suffered his raillery for some time in silence: at length, taking from her ear a pearl of immense value, and dissolving it in vinegar, she swallowed it, inviting her lover to pledge her with that which remained. Lucius Blancus, who stood near the queen, snatched from her hand the gem, declaring the wager already decided. For a moment Antony appeared confounded, till Cleopatra, laughing gaily, assured him, that not only these pearls, transmitted to her from a long race of illustrious ancestors, but the world itself, were it at her disposal, should, to afford him one moment's gratification, be lavished without regret. Transported by a compliment thus extravagant, Anthony was careful to return, by a profuse magnificence, the gallantry of his mistress.[69]

Several interesting aspects appear here. Cleopatra's role in the episode is based on personal rivalry and erotic seductiveness in her relationship with Mark Antony. Nevertheless, the scene is also a manifestation of rank and, furthermore, it involves the concept of ancestral pride. As will be discussed further on, the pearl is here a duplicate signifier, since it references sexuality as well as social prestige.

Around 1695, Carlo Maratti completed a portrait series of six illustrious women for the Tuscan banker Francesco Montioni. Among these, there was a portrait of Cleopatra.[70] The painting shows a glowing woman, beautifully dressed and in the attempt of dipping a pearl into a cup (Figure 13). As Stella Rudolph has pointed out, the number of replicas and copies made of this painting and that of the Lucretia portrait of the same series indicate an immediate success.[71] In the 1740s Pompeo Batoni painted a *Cleopatra* that survives today as a copy (Figure 14).[72] Although the narrative is the same as that used by Maratti, the painting shows some important differences. Cleopatra is shown

13 Carlo Maratti, *Cleopatra*, 1690s. Museo Nazionale di Palazzo Venezia, Rome.
Photo © Istituto Centrale per il Catalogo e la Documentazione.

14 Pompeo Batoni, *Cleopatra*, c. 1744–46 (copy). Collezione Pallavicini, Rome. Photo: Istituto Centrale per il Catalogo e la Documentazione.

exposed *en face* directly towards the viewer, while Maratti's Queen turns her head and body to the left towards that imaginary male counterpart the narrative requires. In the Batoni painting, this relationship is not seen, aside from the Queen's direct glance out of the canvas, which turns the viewer into the expected partner. Thus, the motif shifts from historical narrative or history painting into a traditional portrait of the Queen.

It is probable that the profusion of portrait series of illustrious and beautiful women which included the Cleopatra motif contributed to making the setting fashionable for portraits of Roman ladies.[73] The presence of paintings with general Cleopatra narratives within Roman elite collections became equally increasingly visible during the course of the eighteenth century.[74]

An unknown sitter probably painted in the 1740s by a Roman artist who could be identified as Marco Benefial (1684–1764) shows a similar posture to Batoni's Queen (Figure 15). The sitter is placed frontally. The pearl and the cup are clearly visible as she looks directly at the viewer. The pearl in her hand is combined with pearls on her dress, a detail which reinforces the importance of the pearl as a specific signifier. The setting is also adapted in a portrait of Vittoria Corsini by Agostino Masucci (1690–1768). This portrait maintains the direct posture of the sitter, although in a less immediate way. The cup is placed on a table, and the pearl is elegantly shown to the viewer as a gesture of great prestige. The pearl and the invisible yet expected male counterpart are essential to the reading of these portraits, since they clearly refer to a particular Cleopatra narrative.

The seductive pearl: marriage codex and sexuality

The popularity of the pearl episode as artistic motif during the first part of the eighteenth century is unquestionable.[75] In its entirety, the motif could easily appeal to the elite milieus. The lavishly given banquet scene could parallel contemporary luxurious living.[76] The main narrative, the open challenge between the Queen and Mark Antony, indicates a seductive eroticism between the lovers-to-be that stimulated the imagination of presumptive beholders. Yet portraits that apparently did not evoke the Cleopatra narrative featured pearls as signifiers of great dignity within the pictures. The presence of pearls as ornaments for luxurious gowns or elegant hairstyles was in contrast to pictures where the pearls are separated from the sitter's body but evidenced through physical indication.

In 1760, Pompeo Batoni painted an intimate portrait of a Roman noblewoman in her boudoir, recently identified by Carla Benocci as Duchess Girolama Publicola Santacroce Conti (dates unknown) (Figure 16).[77] Seated in front of her toilette table, with one hand the Duchess is holding a pearl necklace, which is reflected in the mirror together with the trembling light of a candle. Here Batoni clearly pays homage to Dutch seventeenth-century vanitas motifs as well

15 Attrib. Marco Benefial, *Portrait of unknown Lady as Cleopatra*, 1740s. Courtesy of Collezione Lemme, Rome. Photo: Collezione Lemme, Rome.

as hinting at contemporary French genre painting. Holding the viewer's eye, her other hand is gently loosening the bow of her *déshabillé*. The strong erotic character of the painting is stressed by the presence of the pearls that are exposed to the viewer as a subtle signifier of the erotic implication of the act of undressing. Originally the painting was, as its format suggests, set above a door in a

16 Pompeo Batoni, *Portrait of Girolama Santacroce Conti at her dressing table*, 1760. Museo di Roma. Rome (MC 138). Photo © Comune di Roma, Museo di Roma.

private drawing room in the Duchess's apartment at the Palazzo Poli in Rome. The drawing room was located next to Donna Girolama's bedroom, and was intended for the entertainment of an intimate circle. The inventory recalls its lavish and comfortable character through the presence of a table for card playing, several chairs and sofas, a harpsichord and sweets of all sorts.[78] Such information points to the fact that despite the portrait's very intimate character, it was displayed in such a way that it was seen by a number of people in a context of a semi-private character. The subtle social play between the Duchess and her presumed entourage, exemplified through the chosen context for the display of her portrait, is repeated in the picture setting as well as in other art works on display. Donna Girolama's apartment contained at least four different art works in which the Cleopatra theme was used.[79] The Duchess's portrait clearly evokes the Cleopatra narrative in a duplicate sense, through the presence of pearls and through the explicitly erotic attitude of the Duchess.

The pearl signifier used in the Santacroce portrait shows an adaptation of the Cleopatra narrative in a less strict setting. The fashion of placing the pearl on prominent display is equally clear in the Swedish painter Alexander Roslin's (1718–93) portrait of Maria Felice Colonna, Duchess of Buccheri and Villafranca (1731–71) daughter to the Roman prince Filippo III Colonna (Figure 17).[80] The sitter's sophisticated and elegant body language is here enhanced by the playful display of the rich string of pearls that adorns her costume. The conspicuous display of the pearls and Maria Felice's confident gaze implicate the Cleopatra narrative although not explicitly. The subtle use of the pearl's erotic potential was evidently used in portraits of married women. This may seem natural, since the sexual implications would not have been present in a portrait of an unmarried girl within the elite context. Yet the married women did not have a possibility of unlimited physical and social movement and display. In his

17 Alexander Roslin, *Portrait of Maria Felice Colonna, Duchess of Buccheri and Villafranca*, 1750s. Åmells Konsthandel/Fine Art Dealer. Reproduced by permission of Åmells London/Stockholm.

Voyage d'un françois en Italie Joseph-Jérome de la Lande testified as to what an impossible task it was for a Roman elite woman to be seen alone in public.[81] The enclosure created for very young girls through their convent education could naturally not be valid for the married woman, who was expected to have

a social life. Still, female physical movement was heavily restricted, and did not allow for public display alone outside the prescribed contexts, such as the family homes, the churches where they attended mass or the convents where it was customary to host visiting female relatives. The Cleopatra setting contains an implicit ambiguity that challenges these regulations.

An important comparison must at this point be made with reference to the British context. In 1759, Joshua Reynolds painted a portrait of one of the most celebrated courtesans in London at the time, Catherine Maria Fisher (d. 1767) known as 'Kitty Fisher' (Figure 18). The portrait shows the flamboyant woman in a Cleopatra setting with the same gesture of dissolving the pearl as in the previously discussed portraits of Roman aristocrats. Martin Postle has discussed Reynolds's familiarity with Francesco Trevisani's painting of the challenging banquet between the Egyptian queen and Mark Antony, painted for the cardinal Fabrizio Spada in 1702.[82] The choice of the setting may appear to be clear, considering the sexual exploitation of her own self that Kitty Fisher promoted. The implicit notion of the presence of an invisible male counterpart and the challenging display of the jewel in this context give an erotic and heavily sexual tone to the painting. Fisher's personal mythology implied a conspicuous behaviour that included an often-cited episode which directly connected to the tale of the Egyptian queen. On a particular occasion, the courtesan swallowed a banknote on a slice of buttered bread, a popular trick enjoyed by the audience, and certainly not unique to Fisher.[83] The crucial aspect of Fisher's personal connection to the Cleopatra setting is the explicit display of her sexual potential within that prestigious social space that portraiture as a genre heavily enjoyed in eighteenth-century England. Exclaiming the fame of a prostitute through the guise of Cleopatra is an interesting contrast to the portraits of Roman aristocrats that politely show the stigmatic pearl to the beholder. The sexual potential of these women could not be as outspoken as it was for Fisher. The Cleopatra setting became, on the contrary, a less apparent but still valid narrative in order to display a somewhat paradoxical female role, one sanctioned by the Church.

The Roman elite was subject to a social tradition in which a married couple would not socialise together in public. As women needed to be constantly accompanied and waited on this task fell upon a man chosen to perform this duty, a so-called *cicisbeo*.[84] The cicisbeo was often chosen before the marriage took place, and could be subsequently mentioned in the dowry contract, which was to be approved by the husband-to-be.[85] This *cavalier servente* accompanied the lady in society and shared the intimate moments of her day. Breakfast in the early morning, going to mass, assisting at the card table and taking her arm at the *conversazioni* in the evening: the cicisbeo was always present. The sociologist Marzio Barbagli has stressed in his study on the history of Italian family structure the need to examine this particular phenomenon further. He argues accordingly that one fundamental problem concerns the varied sources, which

18 Sir Joshua Reynolds, *Kitty Fisher as Cleopatra*, 1759. Kenwood House/The Iveagh Bequest, London. Photo © English Heritage Photo Library.

appear somewhat homogeneous in their spiteful content.[86] Much of the criticism came from the tourists travelling Italy, who experienced the custom as peculiar and sometimes tempting. In Italy, on the contrary, the greatest critics were among the enlightened intellectuals with reforms on their mind.[87] The cicisbeo was a popular figure in contemporary drama, but the satirical poet Giuseppe Parini (1729–99) used the custom in order to attack the lifestyle of the Italian

elite. In his poem *Il Giorno* the cicisbeo system is described as a decadent ritual: 'You will not walk without company since among the faithful brides of others there will be one who offers you the untouchable rite of the mundane world of which you are such a treasured part.'[88]

Parini's satirical tone and his description of the virtuous conduct of the cicisbeo's lady bring out the question of the sexual implications of these peculiar relationships. The issue is far from easily resolved. The custom of marrying very young girls to much older men might have reinforced that already-existing gap between husband and wife resulting from their non-acquaintance. Still, Barbagli argues rightly that marriages between people with a strong age difference were far from unique to Italy. Most European elite cultures experienced and supported them, however, without generating a system allowing for possible (and thus accepted) infidelity such as that of the cicisbeo. An expected distance between husband and wife had been increasing since the previous century, and represented an institutionalised regulation of marital life in elite Italy.[89] The sexual nature of the arrangement probably varied from case to case, implying a range of problems. The British female travellers experienced the system as astonishing, especially when confronting the accepted female manners before and after marriage:

> Before marriage their woman are nuns, and after it libertines . . . If dissatisfied with him [a husband chosen by the girl's parents] (as it generally happens) they are at liberty (from universal custom) to chuse their Cavalieri Serventi or Cecisbèi; who attend them to all public places, for their husband dare not, assist at their toilette, and, in a word, do every thing they are ordered; for which the ladies sacrifice their own virtue, and their husband's honour.[90]

Lady Anne Miller's sharp comments directly defend the traditional concept of female virtue, which states that a woman is sexually and morally faithful to her husband. The cicisbeo system reversed this codex through the institutionalisation of an infidelity that a traditional elite marriage might eventually experience. This regulation of extra conjugal sexuality was part of a general gender control in which women were able to play duplicate roles within their own marriage: as faithful consorts and mothers, and as seductive lovers. The paradox lies in the fact that these roles were not aimed at the same man. In his commentary on Plutarch's *Life of Anthony*, C.B.R. Pelling has shed light on the different role of Octavia, married to Antony and the role of Cleopatra, his lover: 'The contrast between an amica and an uxor recurs in Roman elegy, where life with an amica is naturally passionate, rewarding, and fragile, while married life is cold and flat. But in love-elegy the contrast normally centres on the woman's dual role – amica to one man, uxor to another – and the man's consequent torment or thrill.'[91]

Since Pelling's commentary examines the text in literary terms, his constant references to William Shakespeare's *Antony and Cleopatra* (1607) and to Virgil's

descriptions on the love and relationship between Dido, the Queen of Carthage and Aeneas, the Trojan hero and founder of Rome, make for interesting comparisons to the personal mythology of Cleopatra. Pelling sees strong similarities between Plutarch's Cleopatra and Virgil's Dido.[92] These female figures' love statements and pretences are more connected to a male way of expressing love, as seen in elegies.[93] If one considers these aspects with reference to the eighteenth-century Roman elite context, the social perspective is clear. The emotional expression and sexual transgressions of the above-mentioned heroines were made possible through their social rank. As 'queens', they had the possibility of breaking common gender roles and claiming their own sexuality.

Cleopatra is *amica* but she is also *uxor*. The multiple aspects of her personal mythology describe her, in relation to different men, as consort and mother as well as lover. Despite its apparent controversy, this combined female role was socially accepted and anchored within eighteenth-century Roman society through the cicisbeo system. Thus, the Cleopatra portrait setting could reflect the moral codex that occurred within the elite context and could exemplify it through the ambivalent figure of the Egyptian queen.

'A number of raw boys': social transition and initiation on the Grand Tour

The use of the ancient narrative in eighteenth-century portrait settings could sometimes help to exemplify qualities that were strictly related to the sitter in a personal sense. The portrait of Cornelia Costanza Barberini as the powerful Diana or the flamboyant setting with Kitty Fisher as Cleopatra clearly show the possibilities of reversing the reading of these settings according to particular circumstances in the sitter's life. In contrast, the large number of Roman ladies portrayed as the triumphant Cleopatra, or the equally numerous of young British males on Tour leaning on famous antiquities cannot be examined exclusively through a biographical standpoint. In the case of the Cleopatra setting, it has been pointed out that the specific gender discourse found in Rome had generated particular customs to which this narrative responded. It is possible to examine the Grand Tour portraits using similar standards. These settings referred to a temporary phase in the lives of the sitters, one which was regulated through strict schemes of expectations regarding the benefits of travelling as a social elite. Yet the settings also implied an elite masculinity and its processes within the general concept of elite travel. As Matthew Craske has noted, the Grand Tour discourse was driven between the idea of cosmopolitanism and the practice of national prejudice.[94] This is an important statement, since it connects the Tour culture to both its need of and rejection of cultural appropriation as well as to social display and its manifestations. The cosmopolitan ideal was strictly linked to the image of the well-educated aristocrat with *savoir-faire*, a goal which could

only be reached through movement and experience. This experience, however, was mostly controlled and fixed within the prescribed frameworks of the Tour. Classical education at home had to be completed by a physical experience of Rome, its cultural life and its ancient remains.[95] The approach to this heritage was governed by expectations that went far beyond the inclinations of the travellers themselves. Yet they believed (or were at least taught to do so) that this physical impact would lead to a transformation of their personalities and characters into fulfilled social personae.[96] The physical attitudes of conquest expressed in the Tour portraits stressed the desire of bringing something of this travel culture back into the home context. Playful use of historical costumes helped to emphasise the nationality of the sitters and the vogue for portraiture in their country of origin, where the Tour portraits were destined to be part of extensive ancestral galleries. Still, other important aspects were crucial to this discourse. Social initiation, perfection of gender roles and the ever-present risk of transgression represented the expected and the feared in terms of travel aims and the making of the elite male.

On the move: initiation and expected change on the Grand Tour

Tobias Smollett has colourfully described the harsh reality of the elegant sitters portrayed while on Tour: 'I have seen in different parts of Italy, a number of raw boys, whom Britain seemed to have poured forth on purpose to bring her national character into contempt: ignorant, petulant, rash and profligate, without any knowledge or experience of their own, without any director to improve their understanding, or superintend their conduct.'[97] Many people shared Smollett's views. Craske sees these critics as responding to a bourgeois and anti-cosmopolitan culture that saw the educational purpose of the Tour as an excuse for a mere holiday.[98] The debates concerning the usefulness of educational travel for elite males increased during the 1720s and 1730s. Sarcastic comments were increasingly published in the press, that is to say, about thirty years before the Tour reached its climax as a socio-cultural phenomenon.[99] As Jeremy Black has noted, much of the criticism had a xenophobic content which was meant as a warning concerning any foreign impact on the future rulers of Britain.[100] Yet travelling constituted, at least within the specific elite discourse, the proper means in order to become ready for public life. The educational aspect of the Grand Tour within the travelling period involved a process of change including all sorts of experiences. The transitory and temporary state of the Tour experience is reflected in the travellers' portraits, through subtle elements that evoke the concept of movement. The previously examined portrait of Peter Beckford (Figure 5) contained this element through a particular elaboration of the landscape setting. Yet there were other ways to indicate the important concept of transition and change through the metaphor of physical movement.

In 1778, Batoni painted a portrait of a man recently identified as Francis Bassett, Baron de Dunstanville (1757–1835) (Figure 19).[101] The sitter is inserted full-length in an imaginative landscape overlooking the Castel Sant'Angelo to the left and Saint Peter to the right. Travel equipment is represented through the presence of a walking stick and a map of Rome, clearly displayed to the viewer.[102] Bassett is leaning on a frontally placed pedestal, representing a bas-relief that refers to an antique notorious in the eighteenth century.[103] In 1704, the marble group had received the nomination *Lucius Papirus with his Mother* from a somewhat satirical episode narrated by Aulus Gellius in *Noctes Atticae* (AD second century). In 1756 Johann Joachim Winckelmann (1717–68) dismissed the identification of the motif due to the fact that the female figure's hairstyle and clothing was recognisably Greek. He proposed a possible identification, still partially accepted today, that the sculpture instead shows a decisive moment in Sophocles' *Electra* when Orestes reveals himself to his sister, who believes him to be dead.[104] Nevertheless, the group's immense popularity and the emulation of casts and copies had resulted in less precise identifications which included names such as 'Friendship' and 'Fraternal greeting'.[105] These nominations clearly show that there was a predisposition to read the figures as males. When Batoni painted the Bassett portrait, Winckelmann had already made his point about the motif, but it is highly probable that the sculpture still maintained the older epithets, easily appealing to a large number of viewers without Winckelmann's expertise. The piece is not represented in any other of Batoni's catalogued portraits, which underscores the setting's interesting and possibly unique elaboration of the traveller's theme.

The fact that Batoni chose to use the sculpture in a bas-relief form was probably due to the ease of inserting the piece without spending time on painting the sculpture as a whole. The chosen size is also indicative of the piece's position within the painting. In the portraits of Peter Beckford and Richard Cavendish (Figures 5 and 6), the antiques occupied important positions through their interaction with the sitter. In the Bassett painting, the small-scale bas-relief has been effectively placed so that the viewer may see it properly, but there is no direct interaction with the sitter. If taking into consideration the sculpture's earlier nominations, the piece may be read in terms of caring, familiarity, guidance and youth versus age. Thus, the bas-relief constitutes an efficient and low-toned statement concerning a couple of the Tour's more important components and aims: knowledge through tutoring and social transition through guidance.

According to a general idea of elite male formation, the Tour was a period of necessary separation, which nevertheless also implied a subsequent return and alliance with the familiar. In eighteenth-century educational treatises this separation was often seen as urgent, with reference to the feminine sphere of the mother:

19 Pompeo Batoni, *Portrait of Francis Bassett*, 1778. Courtesy of Museo del Prado, Madrid. Photo: Museo del Prado, Madrid.

His constitution is first ruined by Indulgence, his Genius left unmotivated, and himself deprived of all but domestic Knowledge: and thus is our young Nobleman, by being ignorant of the more noble and politer Education of his own Sex; naturally under the Conduct and Tuition of his Mamma, becomes, instead of a fine Scholar in his Manners, a compleat Fop: the extent of his learning to read a Play-Bill, and his conversations to the limits of a Tea-Table.[106]

The figure of the mother was seen as a presence that kept males within a home context far from public life, and where her bad influence would affect her sons as well as their male tutors.[107] The separation that travelling offered was consequently a good thing but nevertheless dangerous. If travel had as its purpose to refine and remake the future public man, it also allowed for experiences that the home context would not see as necessarily beneficial. The fear of foreign influence consisted of different aspects which also incorporated sexual experiences and experimentation. The travellers constantly transgressed the prescribed rules of cultural education and proper consumption while on Tour. Attending horse fairs instead of lessons at the Forum was not uncommon, neither was the preference for brothels, gambling and heavy drinking.[108] It is obvious that such unfortunate prospects of manhood could not be promoted as successes for the nation. However, if travelling meant leaving the maternal sphere, the caretaking role had to be fulfilled by someone else. Most aristocratic men were accompanied on their Tour by a tutor who was responsible for their welfare and their educational programme. In Batoni's portraits, the tutor is seldom present (if ever), in comparison with other artists' work in the genre. A comparison between the Bassett portrait and the one of Douglas, 8th Duke of Hamilton (1756–99) together with his physician and tutor Doctor John Moore (1729–1802) and the latter's son painted by Gavin Hamilton (1723–98) illustrates this difference (Figure 20). Hamilton's portrait is a straightforward statement of the Tour's hierarchical and socio-cultural purpose. The centrally positioned Duke, posed full-length, indicates his high rank, which is clearly reinforced by the devotional attitudes of both his dog and his tutor's son. In contrast, John Moore constitutes a didactic link between the scene and the beholder. His practical clothing, walking stick and the wide gesture towards the topography of Campo Vaccino emphasises his role as an educator in the field. Furthermore, Moore is instructing us as to what the Duke has already assimilated. This is an important observation, one that also shows the difference between Hamilton's portrait and most of Batoni's settings. The Duke's absent look and attitude is not only significant as regards his far superior social position in comparison with the other sitters. It is also an indication that the reception of knowledge has taken place. Consequently, Hamilton's painting can be read as a picture that offers different chronological levels which correspond to two different stages in the sitter's life: before and after the Grand Tour. This attempt to catch a complete vision of the expectations of the Tour is elaborated differently in Batoni's portraits, which

20 Gavin Hamilton, *Portrait of Douglas Hamilton, 8th Duke of Hamilton and 5th Duke of Brandon, Dr John Moore and Sir John Moore as a young boy*, 1775–77. Scottish National Portrait Gallery, Edinburgh. Photo © Scottish National Portrait Gallery, Edinburgh.

decisively work against too strong a link between the imaginary setting and the Roman context. In Hamilton's portrait, the topographical setting is accurately given, which links the painting more clearly to the phase in the Duke's life when it was produced. In contrast, with the setting in the Bassett portrait Batoni has created an implicit context that responds metaphorically to an abstract experience of the city of Rome. The presence of Castel Sant'Angelo and Saint Peter's within an unlikely distance from one another indicates an ambition to link and display the sitter's experience of both ancient and modern Rome. Practical equipment and the presence of the map give the very same indication of movement that is present in many of Batoni's paintings and hinted at in Hamilton's portrait. Yet with Batoni the sitter is alone, apparently independent and apparently confident, without the necessary help to acquire knowledge and *savoir-faire*. It is the sculpture that constitutes, through its own narrative, a subtle statement of the necessity of guided education.

Interestingly enough, Batoni was also commissioned to paint a portrait of the 8th Duke of Hamilton. The portrait is dated 1775 and was, according to Anthony Morris Clark, painted at the same time as that done by Gavin Hamilton.[109] For this occasion, Batoni adopted a similar setting to that used for the portrait of Peter Beckford, featuring the group of *Roma* and *Weeping Dacia*. The landscape setting in the portrait of the Duke is given more topographical accuracy than in the former. The painting can be read as divided into two sections in which the foreground contains the sitter, confidently leaning on *Roma*'s pedestal. The background, divided from the foreground by a large tree that Batoni frequently used in his full-length paintings, shows what Clark has defined as the Temple of Sibyl in Tivoli. The building can more plausibly be identified with the Temple of Vesta, since it is a round temple while that of the Sibilla Tiburtina had a rectangular form. Yet the exact identification of the building is of little importance to the concept of movement and transition considered here. The previously examined portrait of Peter Beckford contained a landscape of general and formal character that evoked British garden planning and the country house context. The desired familiarity of the setting was reinforced by the presence of the *Roma*. Since the sculpture was taken out of its Roman context of display, its presence in the elegant natural setting would evoke the installation of casts in the country house parks and gardens. In the portrait of the Duke of Hamilton, the very same familiarity is present through a similar solution, but combining it with the Italianised landscape in the background breaks the time sequence in this painting into two distinctive phases which have already been noted in Gavin Hamilton's setting for the Duke: the actual Grand Tour and its aftermath. The background position of the Tivoli landscape underscores that the effects and experiences of travelling belong to the past. However, the Tour has led the sitter to a fulfilment of sociocultural character, permitting him to relate very confidently to the sculpture

that commemorates what he has conquered through physical movement and experience.

The richness of these Tour settings may be further demonstrated by mentioning Reynolds's portraits of the Society of Dilettanti from 1779. The images that triumphantly expose the knowledge and sociability of the initiated sitters can be seen as direct consequences of the Grand Tour portrait. While the Tour settings examined the concept of movement and change, Reynolds's portraits displayed the result as it was conceived in the home context.

From bachelor to married man: sexual initiation and homosociability on the Tour

The travel discourse reinforced homogeneous activities and the repetition of experiences and opinions. This repetitive behaviour was supposed to protect these men from what was seen as foreign and consequently problematic and uncertain. One of the more troubled issues involved sexuality and the travellers' meeting with sexual codes that differed from those they were used to.[110] Here is an intriguing paradox. The critics of the Tour saw the home context and maternal influence as seriously dangerous to the future rulers of Britain. Staying at home meant in the worst of cases a development of a 'sheepish softness' that clearly was opposed to the ideal view of elite masculinity.[111] Nevertheless, travelling involved other dangers. There was a growing fear of seeing these teenagers return as 'effeminate' and as 'unmanly foppish', adjectives that reveal a fear of homosexual experiences.[112] British criticism was seriously concerned with what was considered to be a risk for travelling males; bisexual/homosexual experiences were *de rigueur* within the sexual norm, at least in Rome and Florence.[113] Yet heterosexual liaisons were no less feared, and were linked to the spectre of sexually transmitted diseases. The latter and the former would both provoke the inability or desire to produce heirs, which in the long term would affect family continuity and responsibility in the home country.[114] Although blatant sexual narratives are not easy to locate in average European male portraiture, there are reasons to pose a question regarding the presence of a sexual theme within the Tour portrait narrative as it appears in Batoni's production.[115] The well-known sexual behaviour of a particular sitter might provoke sexually oriented readings of his portraits, but it is difficult to find such explicit erotic narratives as for example, the Cleopatra setting used for women. Yet the circumstances of the Tour portraits' production were exceptional, since the sitters were portrayed within a transitory period in which transgressions from expected rules were an unofficial part of the educational travel discourse. Ambiguously enough, the duty of elite portraiture was to reinforce social decorum and the conformed gender roles. Batoni's portraits could not explicitly elaborate the theme of sexuality, yet several of his paintings contain subtle hints which could assist a sexually

oriented reading. The issue of sexuality can in fact be examined in the same manner as the issues of the metaphorical and material appropriation of the ancient past.

In the portrait of Sir Sampson Gideon, painted in 1766–67, there are evident signifiers that explicitly project the picture into the sitter's future in an intimate sense (Figure 21). Sir Sampson (1745–1824) travelled in Italy in the years 1765–66 and once back in England, he married Maria Eardley Wilmont (1743–94), daughter to the Chief Justice Sir John Eardley Wilmont.[116] In this painting Batoni has elaborated a setting that combines outdoor and indoor contexts. The sitter is sitting in a chair holding a paper in his left hand while handing a small miniature portrait to the painting's second and unidentified sitter. Since the portrait was painted in the period in which Sir Sampson married, it is fully possible to suggest that his wife is the miniature's subject. Consequently, the paper in the sitter's hand could be seen as a letter from his wife, written during a period in which the couple were parted. The miniature constitutes the main reason for the sitters' interaction. As Sir Sampson looks at the companion while holding the miniature, the latter smiles with approval at the sight of the painting. This crucial detail suggests a bond of common expected duties that elite men shared while travelling and which constituted an important aspect of homosociability. This portrait's basic narrative does not involve the benefits of classical culture bestowed upon a traveller. The classical signifiers in this painting help to link the painting chronologically to a certain phase in the sitter's life but it is the sitter's future life and responsibilities that are focused on here. The transitory aspect of the Grand Tour is consequently stressed through the hinted presence of a wife in Sir Sampson's life.

The portrait examined above subtly hints at the future marital life of the sitter and consequently at an accepted and conformed sexuality. It is interesting to note that the classical signifiers in this painting, the *Minerva Giustiniani* placed on the table and the Temple of Vesta which is visible outside the opening in the wall in the semi-palatial construct in which the sitters are placed do not play a visibly active part within the narrative. In the previously analysed portrait of Richard Cavendish, the sitter's leaning on the sculpture of *Roma* and the goddess's holding the sphere of the world next to his mouth were discussed in terms of cultural and material appropriation. Cavendish's physical attitude and the direct intervention of the sculpture may also be discussed as signifiers of expected or desired erotic experiences. In contrast, the sculpture present within the portrait of Peter Beckford takes a more passive physical attitude, despite being a part of the narrative as a result of its direct gaze at the sitter. Although *Roma* in its original context had been connected to the male sphere, Batoni's elegant and varied elaborations of the sculpture's posture and body language offer a greater spectrum of reading possibilities than its past connotation would have provoked.

21 Pompeo Batoni, *Portrait of Sir Sampson Gideon and an unidentified companion*, 1767. Everard Studley Miller Bequest, 1963. National Gallery of Victoria, Melbourne, Australia. Photo: National Gallery of Victoria, Melbourne.

The sexual implications of the antiquities in Batoni's portraits may be stressed through the heartbreaking story of Louise Maximilienne Caroline, Countess Albany (1742–1824) and her infatuation with Thomas William Coke, 1st Earl of Leicester (1754–1842). It was rumoured that the Countess, who was the wife of Charles Edward Stuart, the Young Pretender (1720–88), had fallen in love with the handsome and wealthy young traveller during his stay in Rome in 1773.[117] In the portrait of Thomas Coke, which Batoni finished in 1774, the painter placed the sitter in front of the sculpture of *Cleopatra*, one of the most well-known antiques during the eighteenth century, and an absolute highlight for the tourists.[118] It has been suggested (most probably unfounded) that the Countess commissioned the painting and that Batoni used her features for *Cleopatra*.[119] Despite the doubtful plausibility of this story, it clearly shows that there was a predisposition to regard the antiquities as readable objects within these portrait settings. The choice of *Cleopatra*, today known as the *Sleeping Ariadne*, for this particular portrait is also significant given the general assumptions about the Queen's ambiguous mythology. Batoni had used the sculpture in other portraits, such as that of Thomas Dundas, 1st Baron Dundas (1741–1820) with the difference that the face of the sculpture was almost shadowed, and not emphasised as in the Coke portrait.[120] In this particular setting, Batoni evoked a distinct museum context, which clearly gave the *Cleopatra* a quite different role as an artefact belonging to the past.

There is an important similarity between the Thomas Coke portrait and that of Lord Archibald Hamilton (1740–1819). The latter became the 9th Duke of Hamilton after his nephew Douglas's death in 1799 (Figure 22). This oval painting is perhaps the most erotically explicit among Batoni's Tour portraits. The sitter is portrayed leaning his left arm on a pile of books and holding a map of Italy. Hamilton gazes out of the portrait to the right, leaving his features apparently lit from the outside. In the background, Batoni placed a somewhat awkward sculpture with a small crescent on the forehead which makes it possible to identify it as Diana/Artemis. The sculpture holds a peculiar position within the painting. The head is half hidden in the shadows and half lit by the same source that highlights Hamilton. The sitter is unaware of the presence of the sculpture, which makes for a reversed implicit viewing. Instead of being appropriated in a physical and metaphorical sense by the sitter, the sculpture, half alive and half petrified, takes control and objectifies the male sitter. Hamilton shares along with many of Batoni's other sitters an expression of completion. The map and the books are typical Tour signifiers that stress the narrative of transition, movement and change. These issues may be supplemented by erotic experiences, of which the sculpture is a possible signifier. The multiple aspects of the goddess Diana implied her connection to Selene/Luna, the goddess of the Moon and a combination of Greek and Roman divinities. Her ancient iconography included the crescent placed on her forehead and, sometimes, a torch.[121]

22 Pompeo Batoni, *Portrait of Lord Archibald Hamilton*, 1760s. Formerly Dunbrody Castle. Photo: Photographic Survey, Courtauld Institute of Art.

If examined as Selene/Luna, the sculpture may be read in terms of expected, desired or fulfilled sexual initiation. According to the myth, Selene saw Endymion, the handsome son of Zeus and the nymph Calyce, by chance and desired him from a distance. The first time she ever saw him he was asleep in a cave on Mount Latmus, and she drew closer and kissed his closed eyes. The only way to consummate her desire was to seduce him while sleeping, that is to say, while he was unaware of the sexual act. This unawareness stemmed from two different

issues. Endymion himself could not bear the thought of growing older, from which his dreamless sleep protected him. Equally, Selene, probably due to her mythological connection with the chaste Diana/Artemis, could not receive his physical passion and preferred to love him according to the nature and limits of her own desire. Eventually, she bore him fifty daughters.[122]

The myth illustrates the themes of self-limited or hidden sexuality, but it also poses questions regarding artistic reception. The Tour discourse included the expected refinement through an experience of good art, which in Batoni's portraits, on a general narrative level, is represented by the famous artefacts of the guidebooks and travel accounts. The specific reception situation is rarely directly expressed in his portraits. On the contrary, the sitters are shown in a post-receptive state after a certain transformation caused by the aesthetic experience has already taken place, a fact which also makes them socially competent in a socio-cultural and professional context. In the Hamilton portrait, the main narrative is about this transformation, but is skilfully elaborated through a sexual metaphor. Endymion represented a new ideal for masculinity with a strong homoerotic character that was to be reinforced from the 1790s up to the early nineteenth century.[123] Within the visual arts, the motif became more frequent in the aftermath of the French Revolution, especially after the display of *Sleep of Endymion* by the French artist Anne-Louis Girodet-Trioson (1767–1824) at the Paris salon in 1793.[124] The presence of the Diana sculpture in the Hamilton portrait dismisses a plausible homoerotic element since it is the authority of female (heterosexual) sexuality and the objectification of the male sitter that is at play here.[125]

The intense gaze of the Diana antique turns the sitter into a sexually desirable object, which conforms to the myth of Endymion and his unawareness of being sexually consumed. This unawareness is crucial, since it points to the chaste and innocent nature of the official image of the young tourist and the ambivalent views on sexuality connected to the Tour.

Notes

1. J. Engell, 'The modern revival of myth: its eighteenth-century origins', in M.W. Bloomfield (ed.), *Allegory, myth and symbol* (Cambridge, Mass. and London: 1981), p. 246.
2. J. Engell, 'The modern revival of myth', pp. 245–71.
3. On this vast subject, see for instance, G. Perry, 'Women in disguise: Likeness, the grand style and the conventions of feminine portraiture in the work of Sir Joshua Reynolds', in G. Perry and M. Rossington (eds), *Femininity and masculinity in eighteenth-century art and culture* (Manchester and New York: 1994), pp. 18–40 and M. Pointon, *Strategies for showing: Women, possession and representation in English visual culture* (Oxford: 1997), pp. 59–88 and pp. 173–227.
4. Sir J. Reynolds, *Discourses on art*, p. 72.

5. K. Retford, *The art of domestic life: Family portraiture in eighteenth-century England* (New Haven and London: 2006), p. 29.
6. BAV, Archivio Barberini, Indice II, MS 1897, *Capitoli matrimoniali fra D na M a Felice Barberini e D. Bartolomeo Corsini*.
7. F. Devoti, *Il teatro d'Imeneo aperto nell'inclite nozze degli eccellentissimi Principi il Signor D. Bartolommeo Corsini e la Signora D. Felice Barberini* (Roma: 1758).
8. *Componimenti poetici per le felicissime nozze di Sua Eccelenza il Signor Principe D. Bartolomeo Corsini con S. E. la signora D. Felice Barberini* (Roma: 1758).
9. E. Borsellino, *Palazzo Corsini* (Roma: 1995), p. 79.
10. *Componimenti poetici*, p. XI1. *L'Alma gentil Donzella, Che festosetta e schiva Splende sì vaga in viso Dé BARBERINI è quella Germe, ma quasi è Diva; Nelle tenere membra L'aurea mia Madre bella, E al maestoso ciglio Giuno Lei mi rassembra; Pallade alla favella Agli atti, ed al consiglio; E se ride, m'appare Teti, che scherza in mare.*
11. N. Boëls-Janssen, *La vie religieuse des matrons dans la Rome archaïque* (Rome: 1993), p. 138 and pp. 147–8.
12. *Componimenti poetici*, p. XI: *E Fama, che su'l tebro un lauro adorno Sorgesse, allor che l'infelice Enea Giunto per stabilir nuovo soggiorno Sposa, e Regno del Ciel quivi attendea. All'altra cima, sussurar d'intorno Schiera d'Api si vide, e ognun dicea Ben fausto per Lavinia essere il giorno Che d'un augurio tal lieto splendea. Tu Roma il sai che si famosi Eroi Tal portento produsse: eppur non sono Men felici oggi ancor gl'auspici Tuoi. Gia d'altri Api vegg'io l'etere ingombro, Altra Sposa, altri Eroi: ma che ragiono? Folle: se appena il ver descrivo, e adombro.*
13. On the importance of the figure of Aeneas in Augustan mythology, see P. Zanker, *The power of images in the age of Augustus* (Michigan: 1990), pp. 201–10.
14. This painting has been attributed to Pompeo Batoni, as a companion to that of her husband Don Giulio Cesare Colonna di Sciarra, signed in 1768. A.M. Clark, *Pompeo Batoni*, no. 328. Clark did not accept the attribution and suggested the name of Sebastiano Ceccarini instead.
15. J. Spicer, *A cultural history of gesture* (Cambridge: 1991), pp. 85–128.
16. BAV, Archivio Barberini, Indice II, MS 2731, fol. 50, *Inventario generale: di tutti i quadri esistenti nel Palazzo Barberini nell'anno 1845 con indicazione del patrimonio ed a cui appartengono: Ritratto della principessa D. Cornelia vestita da Diana, incognito.*
17. See, for instance T. Castle, *Masquerade and civilisation*, p. 312.
18. K. Nicholson, 'The ideology of feminine "virtue": The vestal virgin in French eighteenth-century allegorical portraiture', in J. Woodall (ed.), *Portraiture: Facing the subject* (Manchester and New York: 1997), p. 56.
19. G. Perry, 'Women in disguise', p. 23.
20. K. Nicholson, 'The ideology of feminine "virtue"', pp. 52–3.
21. K. Nicholson, 'The ideology of feminine "virtue"', p. 57.
22. E. Goodman, *The portraits of Madame de Pompadour: Celebrating the femme savante* (Berkeley, Los Angeles and London: 2000), pp. 50–79.
23. T. Crow, *Painting and public life in eighteenth-century Paris* (New Haven and London: 1985), pp. 1–22.
24. See for instance M. Postle, 'Painted women: Reynolds and the cult of the courtesan', in R. Asleson (ed.), *Notorious Muse: The actress in British art and culture, 1776–1812* (New Haven and London: 2003), pp. 22–55.

25 See for instance S. Tillyard, 'Paths of glory: Fame and the public in eighteenth-century London', in M. Postle (ed.), *Joshua Reynolds: The creation of celebrity* (London: 2005), pp. 61–9.
26 R. Graves, *The Greek myths*, pp. 50–2 and pp. 115–18.
27 Quoted from K. Nicholson, 'The ideology of feminine "virtue"', p. 52. See also J. Seznec and J. Andhémar, *Diderot: Salons* (4 vols, Oxford: 1957–67), vol. 1, p. 206
28 See, for instance, S. West, 'Patronage and power', pp. 148–9.
29 On the subject, see K. Retford, *The art of domestic life*, pp. 30–4.
30 This issue is discussed with reference to English portraiture in England by K. Retford, *The art of domestic life*, pp. 34–8.
31 T. Mikocki, *Sub speciae deae*, pp. 95–6, no. II.2.7.
32 R. Graves, *The Greek myths*, pp. 83–6.
33 T. Mikocki, *Sub speciae deae*, pp. 100–1, no. II.2.16.
34 On the Batoni portrait, see A.M. Clark, *Pompeo Batoni*, p. 255, no. 166.
35 R. Graves, *The Greek myths*, pp. 55–6.
36 T. Castle, *Masquerade and civilisation*, p. 5.
37 T. Castle, *Masquerade and civilisation*, p. 312.
38 M. Piccialuti, *L'immortalità dei beni*, p. 37.
39 C. Pietrangeli, *Palazzo Sciarra* (Roma: 1987), p. 94, notes 97 and 99.
40 N. La Marca, *La nobiltà romana*, pp. 175–88.
41 C. Castiglione, 'Extravagant pretensions: Aristocratic family conflicts, emotion, and the "public sphere" in early eighteenth-century Rome', *Journal of Social History*, 38:3 (Spring 2005), pp. 685–703.
42 C. Castiglione, 'Extravagant pretensions', p. 686.
43 BAV, Archivio Barberini Colonna di Sciarra, tomo 137, fasc. 6, Letter from Maria Artemisia Barberini Colonna di Sciarra to her father Giulio Cesare Colonna di Sciarra, 27 January 1752, fols 353–45: *Quando Vostra Ecc.za venne a favorirmi, e consolarmi, avendo intese le mie premure di abbracciar lo Stato Religioso, ebbe la bontà di dirmi che si sarebbe quanto prima portata da me la Sig.a Madre colla quale avrei potuto spiegare i miei sentimenti.*
44 On this conflict, see for instance S. Norlander Eliasson, 'A faceless society?', pp. 37–8.
45 BAV, Archivio Barberini Colonna di Sciarra, tomo 137, fasc. 5, Letters from Cornelia Costanza Barberini di Sciarra to her son Urbano Barberini Colonna di Sciarra, no pagination. See also N. La Marca, *La nobiltà romana*, pp. 182–7.
46 Biblioteca Angelica, Rome (hereafter BA), Archivio dell'Arcadia, MS 37, fol. 244 r. *A sua Eccellenza La Sig.ra Principessa Donna Cornelia Barberini Donna tutto è in te grande e tutto imprime In noi rispetto, meraviglia, e amore, E la mente, e il parlare, e il Senno, e il core Il giusto, il vero, il grave, e il dolce esprime: Se te il Gran Tebro avea, quando alle cime Giunse di gloria il femminil valore, E l'altre Dame per le vie d'onore Vinsero il tempo, che i gran nomi opprime. Men chiare andrian nel secolo vetusto, Per valor, per costanza, e per consiglio Porzia, Veturia, e la moglie d'Augusto, Che la Patria a salvar d'ogni periglio Bastava il genio tuo nobile augusto, E il folgorar del signoril tuo ciglio.*
47 F. Valesio, *Diario di Roma*, G. Scano (ed.) (6 vols, Milano: 1977–79), vol. 5, p. 372.
48 R. Graves, *The Greek myths*, pp. 55–6.

49 *Componimenti poetici*, p. XCV: *Intanto Tu, che il Barberino sangue Fosti prescelta a riparar dal grande Fato amico di Roma, indi potesti Di generosa prole andar'superba, Fra le Latine madri.*
50 T. Mikocki, *Sub speciae deae*, pp. 144–5.
51 T. Mikocki, *Sub speciae deae*, p. 138.
52 T. Mikocki, *Sub speciae deae*, pp. 140–1.
53 See for instance R. Brilliant, *Portraiture* (London: 1991), pp. 102–4.
54 On the issues of historical portrait and display, see D. Solkin, *Painting for money*, pp. 2–7 and p. 20.
55 T. Castle, *Masquerade and civilisation*, p. 56.
56 T. Castle, *Masquerade and civilisation*, p. 57.
57 M.T. Silvestrini, 'Le donne nell'Italia moderna: Rappresentazioni, appartenenze, identità', in A. Cottino (ed.), *La donna nella pittura italiana del sei e settecento: Il genio e la grazia* (Torino: 2003), p. 33.
58 See for instance C. Pancera, 'Figlie del Settecento', in S. Ulivieri (ed.), *Le bambine nella storia dell'educazione* (Rome and Bari: 1999), pp. 189–213.
59 See for instance the portrait of an Altieri princess by Pier Leone Ghezzi in *Il Seicento ed il Settecento romano nella Collezione Lemme* (Roma: 1998), pp. 150–3.
60 Archivio di Stato di Roma, Conventi femminili soppressi, Santa Caterina da Siena a Magnanapoli, busta 4637, giustificazioni 1750–52, no pagination.
61 *Lady Knight's letters from France and Italy 1776–1795*, Lady Eliott-Drake (ed.) (London: 1905), p. 20. On Lady Knight and her daughter Cornelia's travelling in Italy, see also B. Dolan, *Ladies on the Grand Tour: British women in pursuit of enlightenment and adventure in eighteenth-century Europe* (New York: 2001), pp. 291–2.
62 Quoted from C. Chard, *Pleasure and guilt on the Grand Tour*, p. 92.
63 A. Vickery, *The Gentleman's daughter: Women's lives in Georgian England* (New Haven and London: 1998), pp. 40–1.
64 Quoted from M. Pieretti, 'Margherita Sparapani Gentili Boccapaduli, ritratto di una gentildonna romana (1735–1820)', *Rivista storica del Lazio*, 8–9:13–14 (2000–1), p. 85. [*I*]*ntanto che fui sposa mia madre mi conduceva nelle conversazioni, e negli spettacoli, cosa novissima per me, onde tutto esaminavo e mi divertiva. Mia madre mi dava molte istruzioni, perché mi conducessi come ella bramava. Mi diceva contate che per la novità tutti gli occhi saranno sopra di voi; parlate poco, abbiate un contegno savio e composto, non bisogna farsi definire perchè se incomincieranno a dire che siete una sciocca lo diranno per tutta la vostra vita, siate sempre in guardia di voi medesima, non prestate orecchio agli elogi ma procurate con la vostra condotta di meritarli.*
65 On this vast subject, see for instance S. Walker and P. Higgs (eds), *Cleopatra of Egypt: From history to myth* (London: 2001).
66 M. Pointon, *Hanging the head*, pp. 141–57.
67 See for instance V. Jones, 'The Tyranny of Passions': Feminism and heterosexuality in the fiction of Wollstonecraft and Hays', in S. Ledger, J. McDonagh and J. Spencer (eds), *Political Gender: Texts and contexts* (London: 1994), pp. 173–88.
68 Book IX, cap. LVIII.
69 M. Hays, *Female Biography; or Memoirs of illustrious and Celebrated Women of all ages and countries* (3 vols, London: 1803), vol. 3, pp. 353–5.

70 S. Rudolph, *Niccolò Maria Pallavicini: L'ascesa al tempio della virtù attraverso il mecenatismo* (Roma: 1995), pp. 98–100 and p. 102.
71 S. Rudolph, *Niccolò Maria Pallavicini*, p. 98.
72 A.M. Clark, *Pompeo Batoni*, no. 96.
73 On the fashion of portrait series of beautiful women in seventeenth-century Roman villas, see C. Benocci and T. di Carpegna Falconieri, *Le Belle: Ritratti di dame del Seicento e del Settecento nelle residenze feudali del Lazio* (Roma: 2004).
74 See for instance the continuous presence of these motifs within the Colonna family collection. E.A. Safarik, *Collezione dei dipinti Colonna: Inventari 1611–1795* (New Providence, N.J, London and Paris: 1996), p. 1,046.
75 Artists who adopted the motif include for instance Giovanni Battista Tiepolo (1696–1770) who used it for an extensive fresco painting at Palazzo Labia in Venice in the years 1745–46.
76 On the connection between this particular motif and elite lifestyle, see A. Zanella, 'Francesco Trevisani e il Teatro Arcadico', in E. Debenedetti (ed.), *Carlo Marchionni: Architettura, decorazione e scenografia contemporanea. Studi sul Settecento Romano*, 4 (Roma: 1988), p. 407.
77 C. Benocci, 'L'inventario del 1808 del Palazzo Poli a Fontana di Trevi ed un ritratto di Pompeo Batoni', *Strenna dei Romanisti*, 63 (2002), pp. 31–45.
78 C. Benocci, 'L'inventario del 1808', p. 40.
79 C. Benocci, 'L'inventario del 1808', p. 38.
80 S. Norlander Eliasson, '"Roslin Svezzese": Alexander Roslin in Italy', in M. Olausson (ed.), *Alexander Roslin* (Stockholm: 2007), pp. 48–51.
81 J.J. de la Lande, *Voyage d'un françois en Italie faits dans les années 1765 & 1766* (Jverdon: 1769–70), p. 37.
82 M. Postle, 'Painted women', in M. Postle (ed.), *Joshua Reynolds*, p. 182.
83 M. Postle, 'Painted women', in M. Postle (ed.), *Joshua Reynolds*, p. 182. See also J. Peakman, *Lascivious bodies: A sexual history of the eighteenth century* (London: 2004), p. 68.
84 L. Valmaggi, *I cicisbei: Contributo alla storia del costume italiano nel secolo XVIII* (Torino: 1927), pp. 1–2.
85 L. Valmaggi, *I cicisbei*, pp. 137–8.
86 M. Barbagli, *Sotto lo stesso tetto: Mutamenti della famiglia in Italia dal XV al XX secolo* (Bologna: 1984), pp. 331–2.
87 James Boswell was among those British men who experienced being temporary *cicisbei*. M. Barbagli, *Sotto lo stesso tetto*, p. 334.
88 G. Parini, *Il Giorno (1763–65)*, G. Ficara (ed.) (Milano: 1986), pp. 41–2. *Non però tu senza compagna andrai, ché tra le fide altrui spose Una te n'offre l'inviolabil rito del bel mondo onde sei parte si cara.*
89 M. Barbagli, *Sotto lo stesso tetto*, p. 335.
90 Quoted from C. Chard, *Pleasure and guilt on the Grand Tour*, p. 92.
91 Plutarch, *Life of Anthony*, C.B.R. Pelling (ed.) (Oxford: 1988), p. 247.
92 On this subject see also M. Hamer, 'The myth of Cleopatra since the Renaissance', in S. Walker and P. Higgs (eds), *Cleopatra of Egypt*, p. 303.
93 Plutarch, *Life of Anthony*, p. 247.

94 M. Craske, *Art in Europe 1700–1830*, p. 141.
95 S. Pasquali, 'Roma antica', p. 324.
96 C. Hornsby, 'Introduction, or why travel?', pp. 1–25.
97 T. Smollett, *Travels through France and Italy*, p. 252.
98 M. Craske, *Art in Europe 1700–1830*, p. 107.
99 J. Black, *The Grand Tour in the eighteenth century*, p. 288.
100 J. Black, *The Grand Tour in the eighteenth century*, p. 298.
101 M.D. Sánchez-Jáuregui, 'Two portraits of Francis Bassett by Pompeo Batoni', *Burlington Magazine*, 68:1,180 (2001). See also *Dictionary of British and Irish travellers to Italy*, compiled from the Brinsley Ford Papers by John Ingamells (New Haven and London: 1997), p. 58.
102 A.M. Clark, *Pompeo Batoni*, no. 406.
103 F. Haskell and N. Penny, *Taste and the antique*, no. 71.
104 A. Giuliano (ed.), *La collezione Boncompagni Ludovisi: Algardi, Bernini e la fortuna dell'antico* (Venezia: 1992), no. 21.
105 F. Haskell and N. Penny, *Taste and the antique*, pp. 97–8.
106 J.L. Costeker, *The Fine Gentleman: or, the Compleat Education of a Young Nobleman* (London: 1732), p. 10.
107 A. Fletcher, *Gender, sex and subordination in England 1500–1800* (New Haven and London: 1995), p. 317.
108 I. Littlewood, *Sultry climates*, pp. 1–52.
109 A.M. Clark, *Pompeo Batoni*, no. 388.
110 J. Black, *The Grand Tour in the eighteenth century*, pp. 202–20.
111 A. Fletcher, *Gender, sex and subordination*, p. 317.
112 M. Cohen, *Fashioning masculinity: National identity and language in the eighteenth century* (London and New York: 1996), p. 57.
113 A. Potts, *Flesh and the ideal: Winckelmann and the origins of art history* (New Haven and London: 1994), pp. 109–10.
114 J. Black, *The Grand Tour in the eighteenth century*, p. 203.
115 C.M.S. Johns, 'Portraiture and the making of cultural identity', p. 385.
116 A.M. Clark, *Pompeo Batoni*, no. 305; *Dictionary of British and Irish travellers to Italy*, p. 399.
117 A.M. Clark, *Pompeo Batoni*, no. 377.
118 F. Haskell and N. Penny, *Taste and the antique*, no. 24.
119 A.M. Clark, *Pompeo Batoni*, no. 377.
120 A.M. Clark, *Pompeo Batoni*, no. 278.
121 T. Mikocki, *Sub speciae deae*, pp. 104–5.
122 R. Graves, *The Greek myths*, pp. 210–11.
123 A. Solomon-Godeau, *Male trouble: A crisis in representation* (London: 1997), p. 69.
124 A. Solomon-Godeau, *Male trouble*, pp. 65–6. See also T. Crow, *Emulation: Making artists for revolutionary France* (New Haven and London: 1995), pp. 133–9.
125 T. Castle, *Masquerade and civilisation*, p. 312.

3

'Fare accademia': Arcadian discourse and social preservation

In 1759, during the month of June, the Roman elite was in mourning due to the announcement of the premature death of a young woman.[1] Although the event in itself was hardly unusual, the exceptionally high rank of the deceased created a public interest. Giacinta Orsini was born in 1741, the daughter of Domenico Orsini, Duke of Gravina (1719–89) and Paola Odescalchi (1722–42). In 1757, she had married Antonio Boncompagni Ludovisi, Duke of Arce (1735–1805) and she died the following year at the age of eighteen while giving birth.[2] In 1757–58, Pompeo Batoni painted her portrait (Figure 23).[3] The painting contains all the requisites of an official portrait of a highly positioned sitter according to European tradition: exclusive fabrics, classical architecture, ideal landscape and associations to intellectual and creative enterprises. As such, the painting was a perfectly readable image for an *ancien régime* beholder.

As discussed, the adaptations of ancient narratives into suitable portrait signifiers can be read as specific keys in order to understand the importance given to different aspects of elite discourse, such as gender roles, social expectations and cultural appropriation. Although the ambition of this study has been to question whether these narratives were homogeneously adapted by elite groups who apparently had gained their social success through similar processes, it is still relevant to pose a question regarding the existence of or, at least, the ambition to sustain a homogeneous discourse of the social use of Antiquity. One way to examine this issue is through the character and genres of texts that circulated within the elite contexts. In previous chapters, a number of different text genres have been accordingly used in order to unmask and label relations between words and images. Travel writing and celebratory poetry and fiction have consequently been examined as those means through which differences and possible similarities between elite discourses are traceable. Each literary genre constitutes in a way its own institution. Nevertheless, it is exactly in the concept of institutionalisation that a further discussion regarding a homogeneous adaptation of the social myth of Antiquity may be undertaken. Such an attempt particularly fits the eighteenth-century Roman context, which saw an increasing

23 Pompeo Batoni, *Portrait of Giacinta Orsini Boncompagni Ludovisi, Duchess of Arce*, 1757–58. Courtesy of Fondazione Cassa di Risparmio di Roma, Rome. Photo: Fondazione Cassa di Risparmio di Roma.

institutionalisation process of the idea of the classical world and its expressions throughout the establishment of academies and learned gatherings. The great centre of export that the city had turned into, within and outside Italy, emulated ideas and objects of a holistic concept of classicism which was defined by these particular contexts.[4] Even though academic discourse is not an object of this study, the particular environments that these institutions consisted of are crucial to consider in order to fully grasping the multifaceted use and emulation of the classical material and its importance for social display. And the greatest promoter and protector of this Roman classicism and its artistic expressions was the Accademia dell'Arcadia, the institution within which Giacinta Orsini had obtained a prominent position as a poetess.

The Accademia dell'Arcadia: a story of literary and social compromise

The genesis of the Accademia dell'Arcadia dates back to the late seventeenth century. Queen Christina of Sweden (1626–89), residing in Rome from 1654 onwards after her conversion to the Catholic faith, surrounded herself with a group of poets who undertook the task of creating a celebratory mythology for the Queen. From this *Accademia Reale* arose the Arcadia, founded in 1690, a year after the Queen's death.[5] Its genesis must inevitably be seen against the background of the favourable situation for scientific and literary academies in seventeenth-century Rome and an increasing conflict of purpose: delightful occasions or erudite gatherings.[6] This conflict was not only a matter of intellectual principle; it was also definitely a social one. The participation of the prelates in what was considered merely an example of mundane sociability became an issue of criticism.[7] Since Roman elite society was composed of an intricate mixture of clergy and nobility, the problem was far from easily resolved. The Accademia dell'Arcadia came quickly to a crucial turn in matters that were at least as connected to the limits of sociability, as they were preoccupied with literary purposes.

The poetic ambitions of this new institution were a direct consequence of the controversy between the ideals of classical poetry, as expressed in Virgil's bucolic oeuvre, the works of Petrarca and through the pastoral tradition in sixteenth-century Italy, and the expressive creations of Baroque poetry, primarily seen through the oeuvre of the poet Giovanni Battista Marino (1569–1625).[8] This controversy not only involved poetry as such but also its effect on its audience. Marino's art consisted of a carefully studied sense of surprise and sensuality that definitely contrasted with the careful language of classicist tradition.[9] Opposing this style, the ambitions of the founders of the Accademia dell'Arcadia were to keep poetical language free from excess and complicated metaphors that were, at least according to the Arcadians, hard on the reader. Surprise and wonder were definitely not highly ranked.

The proclaimed aims of the academy became thus to secure and promote a classical tradition unaffected by the attempted naturalism of baroque writing. From a literary point of view, the difference did not consist of the vogue for abstract imagery of poetic narrative, which had been equally present in *Seicento* poetry. The Arcadian classicism was a balanced idiom created for compromise, literally speaking. This particular linguistic (and poetical) balance found its visual equivalent in the traditional artistic theory of the Idea, as expressed through the writings of Giovanni Pietro Bellori (1616–90), librarian to Queen Christina of Sweden in Rome and a close friend of the classicist painter *par excellence*, Carlo Maratti.[10] Indeed, Bellori's thoughts on the painter's selective process and the choices among Nature's expressions can easily be compared to the poetical imagery of Arcadian poetry. These aims and the very connection between poetry and the visual arts may appear to be unproblematic. Nevertheless, it is possible to claim that this particular kind of classicism served other purposes that went beyond the artistic into the field of social hierarchy within the city of Rome.

The first decades of the eighteenth century had been characterised by a conscious cultural politics, aimed at consolidating Rome's position as a main European centre for Beauty and Truth in artistic terms, firm classicist slogans.[11] Side by side with the Accademia di San Luca, prime institution of the Fine Arts, the Accademia dell'Arcadia reinforced a single concept of aesthetics. The institutionalisation of the academy occurred during the pontificate of Gian Francesco Albani (1649–1721), Clement XI and a former member himself. His protection of the Accademia dell'Arcadia was undoubtedly as a result of his general cultural politics, involving an interest in reinforcing Rome's artistic position.[12] At the same time, papal favours provoked an increasing flood of texts commemorating occasions, specifically glorifying Clement's government.[13] The lawyer and prelate Giovanni Mario Crescimbeni (1663–1728), one of the academy's fourteen founders, was at the time not only keeper of the academy but also promoter of the celebrations of Clementine Rome. This put Crescimbeni in a strategic position in terms of cultural power. His great ability consisted of an acute eye for diplomatic and artistic balance, which was to be fundamental to the sought-after social expansion of the academy.

However, in 1711 a complicated schism grew out of a quarrel concerning Crescimbeni's re-election as keeper and the institution's prosperity was temporally disturbed. The lawyer Gian Vincenzo Gravina (1664–1718) broke with the academy and founded, along with a group of followers, the Nuova Arcadia, a counter-institution.[14] In his text *De la Ragion poetica*, he clarified his views on classical poetry and stressed the prime position of the Greeks as promoters of reality in a poetical sense. Within general Arcadian discourse, Francesco Petrarca (1304–74) was seen as the keeper of the classical legacy, and Gravina's great interest in philology and primary poetical sources distinguished him from the elegant and filtered classicism treasured by Crescimbeni.

What actually caused the rupture was a striking difference of opinion concerning the academy's poetic aims. As previously stated, the conflict over the erudite academies' activities in Rome concerned, on the one hand, what was considered a possible and positive social activity for clerical members, and on the other, the impropriety of turning the academies into places for mundane performances. Gravina's breakaway was firmly due to the latter. Not only did he attack the poetical style and content of the academy, he clearly condemned what he considered to be a frivolous activity that was beneath the purpose and dignity of the academy, namely the writing of commemorative sonnets and futile love poems.[15]

As a contrast, Crescimbeni had conceived the academy's aims, and above all its social possibilities, differently. He pictured an institution in which impartiality and neutrality, in a poetical and social sense, would help in constituting a universal academy with the capacity for great expansion outside the Papal States.[16] These politics of adjustment can undoubtedly be seen as an efficient tool to poetically please all and consequently to gain land as a result of a superior form of diplomacy. Nevertheless, Crescimbeni's attitude was heavily strategic and not simply involved with literary preferences, since he showed a conscious awareness of the socio-political structure on which intellectual and artistic efforts in Rome were dependent. Thus, he promoted a forum in which a specific literary paradigm could easily interact with the Roman socio-political structure, giving way to a strict Arcadian discourse.

The importance of Gravina's hostility and Crescimbeni's defensive attitude is connected to the fact that the former condemned a literary activity that was directly involved with the fashionable lifestyle of the Roman elite. The importance of elite sociability was one of the academy's more complex thematic issues, and constitutes a direct link both to the very structure of the academy itself and to the artistic expressions that sprung from its discourse.

The elite in Arcadia: sociability and pastoral disguise

The use of the word 'Arcadia' as the name of the institution is an important key to understanding its social significance in eighteenth-century Rome. The pastoral theme of Jacopo Sannazzaro's novel, published in 1504, provided the means of constructing an implicit structure within the institution. Each member of the academy was assigned an imaginary territory within the Greek region Arcadia. The name of the territory was added to a pastoral name chosen by the member. Furthermore, recitation of the members' poetry was to take place within the Bosco Parrasio, the Parrhasian grove, named after the city Parrhasius in the Greek Peloponnesus.[17] The crucial idea of the institution's own narrative was that of disguise transformed into a sociability of universal character. The juxtaposition between the imaginary and the real carried out through the pastoral narrative offered variations on how to actually exploit the institution in terms

of social preservation, diplomatic and political affirmations and a sought-after conformism regarding artistic expressions.

The connection between the Arcadian academy and the visual arts in eighteenth-century Rome has long been noted by art historians such as Stella Rudolph, Anna Lo Bianco, Liliana Barroero and Stefano Susinno.[18] This acknowledgement has effectively created a broader view on how to connect the *ut pictura poesis* doctrine to the stylistic innovations that occurred in Roman painting during the first half of the eighteenth century.[19] In a recent study, Vernon Hyde Minor has pointedly stressed the existence of an Arcadian discourse as a neglected field of study in order to fully comprehend eighteenth-century visual culture in Rome.[20] Yet an exclusive study of different artistic fields and their aesthetic correspondences and analogies limits the picture of the full effects of Arcadian discourse and its importance as a strictly social phenomenon. Despite the aesthetical ambitions of the academy, its genesis, institutional structure and development clearly indicate a strong connection to contemporary social hierarchies, with a particular emphasis on the social processes of the elite. An examination of the Arcadian discourse as being interwoven between social control and artistic codes may offer new insight into its connection to the ruling groups, their social mythologies and, consequently, their portraiture.

In 1708, Crescimbeni published *Arcadia*, a metaphorical tale of the academy's genesis and activities that served as the academy's manifesto.[21] The text narrates the journey of a number of nymphs and poets from the Bosco Parrasio, mythical haven of the Arcadian shepherds and shepherdesses, towards Mount Elide, the place of the Olympian Games, the major festival of the Arcadians and celebrated every fourth year. During this journey, the nymphs make several encounters with other members in full pastoral guise, all of them engaged in different activities that allude to their true profession (or rank) in society outside the institution.

In an important article on *Arcadia*'s relation to Roman social structure, the literary historian Amedeo Quondam has shown how Crescimbeni consciously linked fiction and fact together in this text. *Arcadia* is structured as the very process of the actual creation of and, subsequently, the activity of the institution.[22] As the reader follows the different activities of the shepherds and shepherdesses, Crescimbeni emphasises the practices through which the academy professes its art. And since the academy members act according to well-known patterns of elite lifestyle, this becomes a crucial theme in the text. The movement of the nymphs towards a state of intellectual completion and acceptance within the institution, metaphorically seen as the Mount Elide, is accompanied by a series of events and activities in which the nymphs are sometimes allowed to take part and sometimes simply remain as spectators. For instance, the nymphs are trained to appreciate art, but they are not encouraged to paint.[23] They admire Nature cabinets, collections of porcelain, marbles, medals and coins in the roles

of spectators, but not as active connoisseurs.[24] In contrast, activities such as dances and hunting engage the nymphs directly. The theme of elite social training in process is evident, and so is the social framework of Crescimbeni's imaginary system. Consequently, *Arcadia* is a text that is as much a description of society life as of the organisation of a literary institution.

Furthermore, *Arcadia* is full of allusions not only to the art of sociability but above all to the mere idea of being part of an academy, *fare accademia*. In this sense, the text points decisively at the intellectual and artistic effort as a social game.[25] The analogy established between academic practice and the performance of a game occupies an important role, since it sets a particular tone of how to experience the activity and the formation of an intellectual environment. By portraying the Arcadians as playing a social game, Crescimbeni's compromise is not only a solution to how to present Accademia dell'Arcadia to a vast and varied audience (and future commissioners and readers) but he also defines the character of its ideal practice. Even more in accordance with Gravina's harsh criticism, a closer look at the real identity of the featured players in *Arcadia*, apparently hidden by pastoral masks, shows that they all actually belonged to the Roman aristocracy.[26] The light-hearted approaches to the concept of *fare accademia* may consequently be linked to the social practices of the contemporary elite among whom intellectual sociability, under the influence of the traditions of the French *salon*, gained a new importance during the eighteenth century.[27]

Crescimbeni's *Arcadia* is a metaphor involving a number of levels. It presents an elite approach to the process and concept of learning as well as uncovering the relationship between the cultural and intellectual consumer and the producer of knowledge and art. A strict reading of *Arcadia* exposes the elite, despite its pastoral guise, as active commissioners and connoisseurs in training, similar to those fellow shepherds who appear as active artists, collectors and scientists. There is an important paradox between the Arcadian utopia, where *pastori* and *pastorelle* happily interact despite different social status, and the social reality of eighteenth-century Rome, where social transgressions were not easily committed.[28] These apparent contradictions are hidden in the text through the pastoral mask. As examined previously in this study, inverted identities helped to transgress social boundaries in an accepted way. Through the pastoral narrative, the elite would mix in apparently impossible spheres and explore scientific and artistic efforts as a result of mundane curiosity.[29] The extreme consequence of this *fare accademia* is a complex appropriation of knowledge and art, produced elsewhere, and re-adapted into social pleasure without dangerous implications.

This reading of Crescimbeni's *Arcadia* can be used in order to understand the academy's social importance. It sheds light on some fundamental themes in the narrative that are of crucial importance to contemporary portrait settings. The genre itself occupied a position of certain dignity within the institution.

Portraits of shepherds and shepherdesses were commissioned in order to preserve and legitimate the memory and status of the institution.[30] Among the academic activities, the celebration of dead members through literary portraits was frequent.[31] Yet a closer examination of portrait settings situated beyond this academic context nevertheless indicates an interesting dependence on its discourse. The major themes that Crescimbeni metaphorically elaborated in *Arcadia*, such as sociability, cultural appropriation, the ambivalent distinction of the concept of social class and the abhorrence of it through disguise, were already well-known social strategies for the domestic and foreign elites who operated in Rome. Despite the differences in the manner in which these practices and attitudes were adapted to suit many needs, Crescimbeni's grand ambition of uniting the world under a pastoral flag aimed at something altogether different. His vision consisted of a homogeneous adaptation of pastoral narrative into a universal language that would not only suit the arts but above all the social mythologies of eighteenth-century Europe. Portrait settings dependent on Arcadian discourse provide evidence of this ambition.

'The sweet Bride and the learned Lady': the duplicate roles of a shepherdess

Pompeo Batoni's portrait of Giacinta Orsini, in Arcadia known by her pastoral name *Euridice Aiacense*, is remarkable considering that it was produced within an elite context where elaborated portraits of this kind were rare. The basic structure of the setting, in which the sitter is placed in an anonymous palatial space overlooking a landscape, was definitely traditional and had often been used by Batoni, especially for foreign sitters. Nevertheless, several distinct signifiers differ from those adapted for the Grand Tourists. The presence of the lyre and the laurel garland in the sitter's hand, as well as the very precise episode depicted within the background landscape, constitute components that were rarely seen in Tour portraits. The elegantly adorned mantle indicates a distinctive social class that goes beyond a general idea of 'elite' into the sphere of highest nobility. The painting is, when examined closely, a curiously ambiguous picture in which supernatural and realistic elements are combined in order to create a decisive contrast.

Despite her death in her late teens, Giacinta Orsini had gained wide fame in Rome as a skilled poetess and a scientific talent.[32] Although no precise date has been found regarding her official entrance into the Accademia dell'Arcadia, she must have been very young. In 1755, when she was fourteen years old, her fellow shepherd Francesco Saverio Brunetti published the book *Compendio sferico, mitologico, geografico e poetico alla Nobilissima Euridice Ajacense* in her honour. This text, which has the character of a charming schoolbook in verse, contains an interesting collection of notions that stress what was seen as suitable knowledge for an elite woman. Mythological tales and poetic exercises are

combined with a geographical tour of the world as well as well-chosen events of ancient history. A quick comparison between the text's content and Batoni's portrait clearly shows a correspondence between Brunetti's explanation of the armillary sphere and its presence on the table next to the Duchess.[33] This was an effective way to forward Giacinta's scientific interest as well as to consciously establish a connection between the honorary writings composed for the Duchess and Batoni's own work. The correspondence between the verse and Batoni's chosen signifier shows an interaction between literary and pictorial production that was sought after as an important part of Arcadian discourse.

She and her fellow Arcadians cleverly elaborated Giacinta's personal mythology within the academic context. In comparison with other similar texts, for instance those composed in honour of Cornelia Costanza Barberini, the celebration of a noble woman who took an active part within the academy demanded a different use of themes and metaphors. The social status and gender of the young poetess were of major importance in this sense. Giacinta's noble birth gave her a natural place within Crescimbeni's system according to *Arcadia*. Her sex could no longer be seen as troublesome. As Elisabetta Graziosi has shown, the scientific academies of the seventeenth century had been generally closed to women.[34] Nevertheless, the female presence was always a decisive part of that general elite social sphere, one which Crescimbeni's academy tended to embrace. The Roman *conversazione*, a specific assembly type regularly held in the nobility's palaces, constituted a permitted and even desirable place for women.[35] Female sociability played an important part in this context since women, despite being subordinated to men, filled an enormously significant role as hostesses. This role implied both political duties and strategies: polite courting of a woman was not only a tribute to traditional chivalry but a way of approaching males close to the particular woman.[36] Diplomatic and political activities often took place within the *conversazione* situation for these reasons.[37]

The *salon* concept, on which the *conversazione* was partly based, was, however, different from the erudite academy. Crescimbeni's conscious strategy of combining the traditional academic context with the spirit of aristocratic gatherings constituted a successful compromise. The first women to whom the Accademia dell'Arcadia had permitted access in 1691 were the Neapolitan princess Anna Beatrice Spinelli Carafa and Maria Selvaggia Borghini, a poetess from Pisa.[38] These women evidently represented the forthcoming role models of ideal *pastorelle*: an aristocratic lady, used to the company of writers and intellectuals but more of a consumer than an actual producer of poetry, and an erudite, unmarried bourgeoise, closely connected to the university circles of Pisa.[39] These two members, however, should be considered exceptional, since it was only in the year 1700 that Crescimbeni defined the prerequisites for female acceptance in the academy. They were supposed to be not younger than twenty-four years old, well-bred and good at poetical exercise.[40] According to Crescimbeni's attitude

of compromise, there were two accepted female roles within the academy. The aristocratic women were linked to mundane sociability, in which poetry and visual arts constituted a delight of leisure. Middle-class women, in contrast, were connected to a more traditionally male context such as a scientifically erudite milieu. It is of great importance to note that the second type was to be perceived as virginal, that is to say, having an unmarried life far from the mundane spheres of the *salons*, closer to the convent context.

In Giacinta's own oeuvre, gender politics is a theme which sheds light on women's complex and ambiguous possibilities in social life:

> Such gentle and thankful rimes have awaken inside my breast such ardour and vanity
> That I take a new delight in creating poetry
> And who of my sex and of my age
> Who on the Tiber was ever the object of such verse?
> Not even the grand Vittoria had such a great poet among
> so many to celebrate her by election.[41]

These verses are composed as an instant reply to a fellow *pastore*, which was the usual manner of the Arcadians' performances during their meetings. Here Euridice/Giacinta evokes an image of her own humble poetical talent at the same time as she indicates that her fortune is praised despite her gender and young age. The remembrance of the sixteenth-century poet Vittoria Colonna (1490–1547) is a tribute to a tradition not only of female poets but of aristocratic female poets, among whom Euridice/Giacinta is now a part.[42] This reverence to social class clearly shows the importance the traditional elite held within the Arcadian context. Yet a prominent social position and poetical skills were not necessarily seen as compatible. The celebratory poems written by the Arcadians on the occasion of the shepherdess's wedding to Antonio Boncompagni Ludovisi interestingly point to Giacinta's wit and knowledge as a contrast to traditional female virtue. The result is an apparently ambiguous approach to the married state: 'The sweet Bride and the learned Lady meet in her / Love claims her his prisoner, Superior he appears and yet she is triumphant / She seems to be Love's enemy and yet she is a lover.'[43]

The playful and contradictory tone of these verses connects the Wise Lady's hesitation about Love to the secret ardour of the Sweet Bride. Still, the bride jests with Love and she hides her true love under the mantle of indifference. Knowledge and female virtue are thus to a certain extent seen as opposites. In Giacinta's own verses, the theme is handled with greater complexity:

> I wish that I could sit down at the erudite ground myself:
> But time is missing us Ladies and it runs faster than it should.
> We must respect the strange confines of feasts and fashions,
> Ladies, and adapt the fragile feet at dancing;

> Alas! We must use the finest Arts, regulate the glances, the actions,
> The tones of voices and compose our hair in front of a glass of flatteries.
> Happy age, when our ornaments were the graces and natal beauty:
> Serene eyes and beautiful, laughing lips:
> The blonde and black locks still lost themselves over long backs
> And the small hip was only covered in candid veils,
> No pearls, or strings but a beautiful and selected garland ornamented our heads
> And our mirrors were the transparent Source, or the brook.
> Yet was not our liberty closed within double walls
> But outdoors the soft and temperate air we enjoyed.[44]

In these intriguing verses, Euridice/Giacinta describes the fragile conditions of the female possibilities of physical and social freedom, and she links these to the question of physical time. The initial point is her wish to take part within an erudite context, although she is aware of the fact that she is not allowed to possess the actual time that erudition demands. In sequence she portrays two modes of femininity that represent two distinct periods in a woman's life. The first, connected to the married state of an adult woman, is mainly characterised by control, both physical and social. A woman must control her body as well as making it pleasing. This image is contrasted with another that evokes a different age of innocence, when physical beauty was not artificial. The poet celebrates an age in which a woman's hair was loose and flower garlands compensated for a lack of pearls, and, when appropriate, mirrors were transparent sources of water. The image here is complex, since it not only pictures a woman in her unmarried state with loose hair, no jewellery and dressed in 'candid [white] veils', a subtle metaphor for the virginal body. The pearl represents a piece of jewellery with strong sexual and female connotations related to the birth of the goddess of Love, Venus, as well as the Cleopatra narratives. It is contrasted to the ornament of a garland, *serto*, which traditionally can be connected to the production of poetry. The youthful unmarried state is thus a condition for poetical efforts, an age when social artifice is unnecessary and poetical inspiration is sought after in a source that also represents oneself through the metaphor of the mirror. In the final lines of the quote, Euridice/Giacinta evokes the contrasting imagery of double walls and the soft air of life outdoors. The walls are intriguing metaphors for the accepted bounds of female life in the Roman-Catholic world: either the convent or marriage. The life outdoors represents a predisposition for poetical efforts and, surely important to the pastoral intentions of the academy, can very well be associated with the theatre of the Accademia dell'Arcadia, the Bosco Parrasio, which had been situated since 1725 on the Janiculum.[45] The design of the site was eventually undertaken by one of the *pastori*, the architect Antonio Canevari (1681–1764) (Figure 24).[46] The design is intriguingly connected to a scheme of physical and spiritual movement, quite in accordance with the Renaissance ideal of a metaphorical garden. The central axis links the entrance to the

24 Antonio Canevari, *Project of the theatre of the Accademia dell'Arcadia, Bosco Parrasio*, 1727. Courtesy of Accademia di San Luca, Rome. Photo: Accademia di San Luca.

25 Jonas Åkerström, *The reunion of the Accademia dell'Arcadia 17th of August 1788*, 1790. Courtesy of Nationalmuseum, Stockholm. Photo © Nationalmuseum, Stockholm.

veritable peak of the setting, the amphitheatre where the Arcadians recited their poetry.[47] A perhaps unique image of this upper part of the Bosco Parrasio can be found in the Swedish artist Jonas Åkerström's (1759–95) drawing from 1790 (Figure 25). The sculptural setting planned for the different levels of the garden was never realised, but its presence in Canevari's design gives an idea of its part in the architectural process of leading the *pastorelle* and *pastori* to the top.

In Crescimbeni's *Arcadia*, the very same metaphorical journey explained the formation of the academy, but it also embraced the journey of women (in the role of nymphs) towards the access point of the Olympian Games and poetical glory. The journey, and the process through which they are acquainted with the other shepherds' activities, is full of allusions as to how learning leads to awareness and, consequently, to a place within the academy itself. In Crescimbeni's system, the concept of *fare accademia* can be translated as movement in both a physical and abstract manner. In this sense, the design of the Bosco Parrasio parallels the structure of *Arcadia*'s narrative.

In Batoni's painting of Giacinta/Euridice, intended for the portrait collection of the Arcadians, this theme is of fundamental importance to the setting. The juxtaposition of different spaces in the painting is analogous to Giacinta's

description of the female life stages: a life indoors, marked by the patrician column and the quantity of precious objects, establishes an accepted female state of being either a wife or a daughter. Giacinta/Euridice's body is wrapped up in a red velvet mantle adorned with fur that clearly states her social position. In contrast, the open space in the background alludes to that life outdoors, so praised in her poetry. Youth, the unmarried state, freedom from artifice and the possibility of poetical inspiration are associated with a life outside the walls of accepted feminine roles. A low wall on the sitter's right creates a clear border between the two separate worlds. The landscape setting outside the palace structure evokes the mythological moment when the winged horse Pegasus causes the poetical inspiration to flow. In Batoni's painting, a number of poets are already drinking from the running waters of creative inspiration. Several art historians have connected this scenery to Giacinta/Euridice's association with the Accademia dell'Arcadia.[48] This observation is undoubtedly correct but not entirely sufficient, since it does not consider the actual physical context where the Arcadians met and recited their poetry, an activity for which the Pegasus theme is a perfect metaphor. In order to explore Batoni's setting, it is therefore useful to turn back to Canevari's design of the ideal Bosco Parrasio. The sculptural programme was originally carefully planned to fit not only the Arcadian ideals in terms of poetry but also the intended activity within the theatre/garden.[49] On the first level, the flood divinities of the Tiber and the Arno would evoke the origins of Roman and Tuscan poetry, while Apollo stretched the laurel garland towards the approaching visitors. The iconography was completed in the amphitheatre at the top of the staircase, with Pegasus breaking the rock of the imaginary Mount Helicon and creating the flow of poetic inspiration.[50] The winged horse is clearly visible in Canevari's design (Figure 26). Since the drawing was engraved and published in 1727, the intended design of the Bosco Parrasio, even if never completed, must have been well known within those circles that were interested in the activities of the academy.[51] Thus, Batoni's allusion to Pegasus' importance within the portrait of Giacinta/Euridice should not only be read as a general indication of the sitter's skill in poetry and her connection with the Accademia dell'Arcadia. More likely, the artist wanted to indicate the physical spot in Rome where the Arcadians held their meetings and, even more precisely, the most prominent part of that spot: the theatre at the top of the garden's structure to which the staircase led and where the *pastori* and *pastorelle* performed their art. As previously stated, the structure of the Bosco Parrasio implied movement and a slow rising from the bottom of the hill towards the top. When Batoni inserted the final stage of the structure into the portrait, there is a metaphorical implication that Giacinta is among those who reached the top and drank from the Muses' source. Her status as a muse herself may be stressed through the presence of *Minerva Giustiniani* on the table. As indicated by Hyde Minor, Ovid narrates how Minerva visits Mount Helicon and the

26 Antonio Canevari, *Project of the theatre of the Accademia dell'Arcadia, Bosco Parrasio*, 1727 (detail). Accademia di San Luca, Rome. Photo: Accademia di San Luca.

Hippocrene source and eventually promises to protect the Muses from every danger.[52]

The presence of the Hippocrene source/the top stage of the Bosco Parrasio also implies that Giacinta is among those who were entitled to profess their poetry in front of an audience that did not entirely consist of people who were shepherds or shepherdesses themselves. The indication of the theatre's upper

level may in this sense be seen as an important equivalent to Giacinta's regal mantle: an indication of rank and secured social position. The academy's archive contains a great amount of commemorative poetry in her honour, which follows the events of her life very closely. Her birthdays and wedding day were celebrated, and her sudden and tragic death was officially mourned. This was surely due in part to her poetical skill, but her fellow *pastori* primarily revered her social status as a princess of Rome. The poetry composed in her honour is full of allusions to social factors connected to her family and to her rights as a noble of Rome. Giacinta is described as 'excellent lady, Rome's pride and the honour of the might Race from which you have descended to us'.[53] Physical and intellectual praises are constantly combined with social reverence. The ambivalent spaces of outdoors and indoors return here in order to establish a difference between a traditional female sphere behind walls and the context of *fare accademia* in the open air: 'Tell me, why abandon the honours of the paternal roof / And lay under the beech on the soft meadow with the herd and laugh at the flowers?'[54]

The question has an obvious rhetorical purpose but points, nevertheless, to a crucial point. The pastoral disguise permits an evasion from the traditional sphere of aristocratic femininity into an alternative one where social levelling is banned, at least on a superficial level. The Roman duchess abandons the palatial context, cited in the Batoni portrait through the traditional scheme of column, drapery and wall, and joins a 'herd' of fellow poets (apparently from different social levels) in the open space of the Bosco Parrasio, metaphorically set within the background of the Batoni painting.

At this point, a particular problem should be discussed. Portraiture is a genre that involves a fundamental acceptance of the concept of display. And display is an inevitable consequence of performance. The papal policy of prohibiting women to perform publicly was constantly transgressed within the multiple spheres of Roman society life.[55] Women performed in private theatres, in aristocratic homes, and they performed in convents.[56] The Arcadian context offered an alternative space where female performance and social display was acceptable. The Bosco Parrasio was either private or public, since it was conceived as an intellectual state of mind as well as a topographical spot. As a consequence, the garden was part of a social field where women could take part. The complexity of Batoni's portrait of Giacinta Orsini references these two worlds, which were both made socially acceptable for the sitter through the ideology of the institution itself. Nobility, poetry and sociability work together. Consequently, the Arcadian narrative as it appears in the painting is not self-sufficient, but is instead enhanced and fulfilled through the social status of the sitter.

Hyde Minor has suggested that the connection between the Bosco Parrasio and eighteenth-century Rome should be read as a speculative reality.[57] This is an important notion that includes the fact that the academy's poetical exercises and choreographed gatherings constituted a vivid image of a social process that

was linked to the world outside the academic context. The concept of games and masks, as they appear in Crescimbeni's *Arcadia*, helped to soothe the problematic concerning social status and the limitations concerning interactions between people that did not belong to the same class. In the portrait of Giacinta Orsini, Batoni solved the ambivalent concept of outdoors and indoors as metaphors for pastoral life in terms of elite life. As different they are, the academic discourse aimed at the visualisation and legitimisation of the latter.

Batoni's portrait of Giacinta/Euridice is in many ways an exceptional and personal document. Yet it is important to acknowledge that Giacinta's activities within Arcadia were a result of a family tradition, due to the fact that her father, Domenico Orsini, was a *pastore* himself.[58] Batoni's portrait relates to a certain extent to an already existing picture, a family portrait painted by Marco Benefial (1684–1764) in 1746 in remembrance of the death of the Duke's wife, Paola Odescalchi (1722–42) (Figure 27).[59] The portrait features the dead Duchess in the guise of Letho, turning her eyes and hands in a pleading gesture towards the sky where her husband has taken the guise of Zeus. The maternal gesture of Anna Paola involves her children, six-year-old Giacinta and the four-year-old Filippo, whose birth had caused the Duchess's death in 1742.[60] The children are fashionably dressed and yet equipped to fit within the painting's narrative: the crescent on Giacinta's head and the arrow in her hand connects her with Diana/Artemis, while her brother is holding Apollo's bow. The picture works on two narrative levels that are comparable to those examined in the portrait of Giacinta as an adult. The tale of Letho and her twins was a treasured motif in Arcadian circles.[61] In the Orsini family portrait, the mountains, the lake and the turbulent action in the background all reference the episode narrated by Ovid when Letho, during her exile due to Juno's jealousy, transformed a group of farmers into frogs as they tried to prohibit her from bathing her children.[62] The setting is similar to a painting made in the 1730s by Placido Costanzi (1702–59) where Letho is painted with a similar gesture, with her gaze aimed towards the sky.[63] Although the figure of Jupiter is absent in Costanzi's painting, it is clear that Letho's pleading body language is directed at the father of her children. This theme of maternal protection is crucial to the Orsini portrait. The motherless children are entrusted by their dead mother into the care of their father. In contrast, the implied portraits of Giacinta and her brother constitute a direct link to the social status of the family. Fashionable and precious clothing with typical mourning signifiers establishes the social status of the children as well as the reason behind the commission of the painting. In contrast, their parents' full disguise and the outdoor setting are governed by Arcadian discourse. In Batoni's portrait of the grown Giacinta, the pastoral world and that of social decorum were visualised through a traditional separation between architecture and landscape. Benefial used costume in order to make this separation clear. Moreover, he inserted details that can be seen as connecting the narrative to a

27 Marco Benefial, *Paola Odescalchi Orsini and her children Giacinta and Filippo Berualdo*, 1746. Museo di Roma (MR 16957), Rome. Photo © Comune di Roma, Museo di Roma.

Christian iconographic tradition.[64] The parrot sitting in the laurel tree dedicated to Apollo was, according to medieval symbolism, an image of the Immaculate Conception and consequently related to innocence.[65] In contrast, the dog standing next to Filippo is connected to the sacrament of Confession through a complex association to the medieval bestiary, where the dog's predisposition to nurture itself from faeces was seen as a parallel to humankind's regret over committed sins. The Christian metaphors used in this portrait efficiently show its commemorative purpose. Instead of the Duchess, Virgin Mary the Immaculate protects the children, whose purity will be secured through the sacrament of Confession.

Like the commissioner of the portrait, Domenico Orsini, Marco Benefial was an Arcadian shepherd. He was received into the academy in 1743 with the pastoral name *Distanio Etneo*, three years before he painted the Orsini family portrait.[66] Benefial was consequently well aware of the aspects of compromise within Arcadian discourse concerning social involvement, which did not exclude any component of Roman society. The proclaimed protectors of the Accademia dell'Arcadia were the Holy Child and Queen Christina of Sweden. Religion was, in this sense, not defeated by profane culture. Hyde Minor has rightly stressed that Crescimbeni's institutional structure can be compared to an ecclesiastical-monarchical model.[67] To this observation it is possible to add that this model should be directly seen as the Papal States, where the pope constituted a duplicate version of secular and sacred monarch. The choices of the Holy Child and the Swedish Queen as protectors were convenient, since they metaphorically responded to the dichotomy of sacred/profane power. Since the social culture of the Roman elite was modelled and visualised through the same pair of opposites, the combination of ecclesiastical connections and the appropriation of ancient culture constituted the very essence of the elite's self-awareness. The Arcadian structure responded to this duality, and offered a realm where it could be staged and visualised as an ongoing process of the fulfilment of Roman society and its hierarchy. Benefial's portrait is an interesting example of this issue, since the painting elaborates pure classical themes in conjunction with Christian morals. The shift between supernatural and real stresses the parallels between the pastoral world and the actual social arena.

Benefial's and Batoni's portraits were eventually displayed together in Palazzo Orsini-Savelli in Rome.[68] Even if the Orsini family experienced Arcadian discourse through personal activity and involvement, it is still possible to state that the social strategy of the academy and its balanced ideology came to influence a number of the settings of those portraits of Roman aristocrats which actually somehow involved a classical narrative. If the Romans generally refused the foreign travellers' preferred setting, that is, the direct link between the sitter and Antiquity in terms of purchasable (or appropriable) commodities, they favoured settings that involved the idea of Antiquity from a different perspective, one

which was relevant to their own context of consumers as well as producers. The spreading of Arcadia's activities into the desired field of the city's rulers provoked necessary and useful adaptations of this idea. Batoni's and Benefial's portraits of the members of the Orsini family are documents that permit an exploration of the Arcadian context in full: the social elite's delight in *fare accademia*, the complex making of institutional and personal mythologies, and an evident and conscious interaction between the visual and the literary fields.

Shepherds on Tour: British travellers in Arcadia

> There has been within these two or three days, a fashion started for most of the British travellers to become Arcadian pastors. I got their first Patents of Diplomas for Lord Warkworth, Lipgeatt; I have sent since for Eleven or Twelve others, and the great amusement is, using their Pastoral Name, & Disputing about the value of their Arcadian Province, with Schemes for Crusades, to rescue the land out of the hands of the Turk.[69]

The playful tone of Daniel Crespin's words not only recalls the joyful journey of Crescimbeni's nymphs in the formation process of the Arcadian academy. It also directly reflects the travellers' curiosity when faced with the academy's presence during their Roman stay. Crespin's use of the word 'fashion' is important here, since it indicates that the visits to the Bosco Parrasio and, indeed, the enrolment to become members, were more than occasional and probably became as customary among the travellers as their visits to the Forum. Crescimbeni's ambitions could as a result be fully realised. The enrolment of kings, diplomats and wealthy tourists as well as artists, architects and prelates not only completed the idea of the academy as a microcosm in terms of social harmony and equality, but also assured that the institution remained a powerful network of sociopolitical dignity. However, academic ambitions were always contrasted to the desirable elegance of society life. Despite the careful and programmatic aesthetic of the Arcadians, and despite the pastoral disguises and subtle reversing of identities, their assemblies were also mundane events where spectators would grasp whatever they could from the poetical recitals and the heavily symbolic architecture of the Bosco Parrasio.

The travellers reacted differently to the academy's activities, and their accounts also indicate the diverse functions of the institution. When John Moore attended one of its assemblies, he was fortunate enough to observe the performance of Maria Maddalena Morelli Fernandez (1727–1800), the acclaimed shepherdess *Corilla Olimpica*:

> She appeared one night at the academy of the Arcadians, and her presence charmed the numerous company ... After she had been given a subject, she began, accompanied by two violins, to sing the verses which she composed as she went. How great was the variety of ideas and the elegance and propriety of language. The

performance lasted more than an hour, and during that time she made only three or four pauses; each of about five minutes, which she seemed to use more to gather strength and to rest her voice than to collect her thoughts ... [O]nly gradually did she become animated, her voice rose, her eyes shone; the warmth and the beauty of her expression seemed supernatural.[70]

In 1793, the Scottish Banker Sir William Forbes (1739–1806) experienced the academy in this way:

> This afternoon, we were indebted to the kindness of Lady Throckmorton for an entertainment of a peculiar nature. It was our admission to a meeting of the Arcadians, as they are called, which was held for the purpose of receiving the Princess of Sweden as a member of that Society. The Arcadians are a Body of literati, Male & Female who under the pastoral idea of being shepherds & shepherdesses of arcadia, assembled at stated times for the discussion of literary subjects. When we arrived at their Hall, which is a building of no great show or ornament, the walls hung round with old portraits, I suppose of learned members of the society, we found the Arcadians already assembled heavily employed in reciting Complimentary pieces both in prose & verse, addressed to the Princess, who was seated near the upper end of the Hall ... Those pieces were composed and recited by members of distinguished rank both for learning and noble birth. Some of the pieces were in Latin. Others in Italian, both of which languages Her Royal Highness was totally ignorant.[71]

Several interesting notions appear in these comments. While Doctor Moore vividly described the aesthetic appreciation of the Arcadian way of reciting poetry, Sir William tended to uncover the academy's ceremonies in a quite different manner, pointing to the institution's reverence of social rank. The Swedish princess Sofia Albertina (1753–1829) visited Rome in 1793 one year after the assassination of her brother Gustavus III (1746–93). Since the King had been admitted to the academy a decade earlier, his sister followed his example. Consequently, the event had a certain dignity, and it was heavily attended by foreign and Roman spectators.[72]

The diffusion of Arcadian colonies in Italy and eventually in other parts of Europe was due to a desire for expansion that involved a conscious acceptance of members of different social classes. At the same time, the academy constituted an arena of artistic commerce since artists, architects, musicians and painters were able to meet future patrons and commissioners disguised by the apparently egalitarian pastoral mask.[73] As Amedeo Quondam has rightly stressed, this apparently acceptable interaction between social classes touched upon a specific notion of utopia that was linked to the original concept of the idealised meaning of Arcadian existence.[74] In contrast, the utopian aspect recalls the issue of refuge and evasion from a social reality that cannot support the claims of Arcadian ideals. This problematic contradiction has been defined by Quondam as a counter-Utopia.[75] The idea of equal shepherds and shepherdesses who interacted

across social boundaries was resolved through the neutralising concepts of games and pastoral disguise. Still, the event that Forbes pointedly described is nevertheless a ceremony which strictly followed early modern decorum: the royalty was dutifully praised by a number of nobles in a ceremony which confirmed the prevailing social order.

For the British travellers, the social activities within the Bosco Parrasio were pleasant alternatives to the regular Roman *conversazioni* that most travellers found insupportably dull.[76] Arcadia offered artistic experiences and social glamour, but was its discourse at all influential in the portraits that the travellers commissioned? Looking closely at a pair of portraits, originally in the Leeson collection in Ireland, might help to address the question. The Leeson family settled in Ireland during the second half of the seventeenth century and became engaged in the brewery business, which would lead to the prosperity and nobility of the family. In 1744–45, Joseph Leeson (1701–83), later 1st Earl of Milltown, undertook a journey to Italy.[77] He bought several art works during the Tour, and sat for Batoni as probably one of the first of the painter's tourist commissioners.[78]

The Leeson collection contained two female portraits signed by Batoni that show the sitters in the guises of the goddess Diana and a shepherdess (Figure 28).[79] In the Giacinta Orsini portrait, the juxtaposition between outdoors and indoors was emphasised through her own poetical production, where these metaphors played a crucial role in examining the potentials of the accepted female spheres. In the Leeson portraits it is evident that this juxtaposition has been completely overcome. The outdoor setting has replaced the hint of a classically built room and the only reminder of the presumed social standards of the sitter in terms of material culture is the bench, apparently carved out of a rock. The rocky mountain in the background is of the same kind as those present in Benefial's portrait of the Orsini family and Batoni's of the grown Giacinta. Its particular character and decisive position works beyond the idea of a neutral idealised landscape and references the natural characteristics of the region Arcadia in Greece. The painting is an explicit example of Batoni's interest in and elaboration of the academic Arcadian discourse.

Not surprisingly, Sergio Benedetti has established the Italian identity of at least one of the sitters.[80] He has convincingly proved that the sitter for the Diana portrait was the Marquise Caterina Gabrielli, who was a part of the circle of Princess Agnese Colonna Borghese (1702–80). Benedetti launches the plausible idea that the shepherdess in fact is a portrait of the latter.[81] Both women moved in circles where Arcadians were present and influential. For instance, Agnese Borghese's brother-in-law, Cardinal Francesco Borghese (1693–1759) was a *pastore*.[82] It is highly probable that they were accepted members themselves. Several sonnets preserved in the archive of the Accademia dell'Arcadia recall the name of Caterina Gabrielli as an acclaimed actress in

28 Pompeo Batoni, *Portrait of a Lady of the Leeson family as Diana*, 1751. Courtesy of National Gallery of Ireland, Dublin. Photo © National Gallery of Ireland.

plays performed at the Villa Mondragone in Frascati, one of the Borghese family's country seats.[83]

The presence of these portraits in the Leeson collection clearly shows that close connections between the tourists and the Arcadian community were not uncommon. However intricate this relationship might have been, the Arcadian

discourse, in terms of its relevance for portrait settings, appears to have been reserved for the enclosed community of the Roman elite without reaching out to the foreign travellers. If this hypothesis is correct, it is nevertheless intriguing to imagine what possible influences the Arcadian narratives could have had on the travellers when planning their Tour portraits.

The Arcadian landscape and the Grand Tour portrait

An important theme examined within this study is the use of landscape and its different metaphors regarding the appropriation of the idea of Antiquity as well as its actual territories. Both the Grand Tour discourse and that of the Accademia dell'Arcadia addressed these issues as being related to social status and the prevailing hierarchies. In Batoni's portrait of Giacinta Orsini, the juxtaposition between outdoors and indoors indicated the permitted and ambivalent spheres of social movement for an elite woman in eighteenth-century Rome. The concept of outdoors was elegantly elaborated within her poetry, but it also referenced a particular (and ambivalent) state of evasion from hierarchical pursuits. When examining Batoni's attempts to experiment with an Arcadian discourse within his Tour portraits, these issues become crucial.

In order to examine further the importance of landscape, it is useful to give attention to Batoni's manner of painting female travellers, not the least since the painter's general portrait production presents a relatively few female portraits. The existing ones differ from each other in terms of their settings with reference to the national identity of the sitters as well as to current portrait traditions in their country of origin. With the exception of Giacinta Orsini's portrait, Batoni rarely used elaborated settings for those known portraits he painted of Roman women. His attempts to give the paintings a further narrative were limited to the Cleopatra signifiers previously examined in this study or to the Arcadian context being discussed here.[84] The few known portraits that he painted of British women on Tour completely lack the complex settings he elaborated for their male equivalents. Signifiers that indicated an experience of the foreign were limited to the choice of comfortable travel clothes, as in the portrait of Lady Mary Fox, later Baroness Holland (1746–78) painted in 1767–68, or to an explicit view of a well-known site like the Colosseum in the portrait of Georgina Poyntz, Countess Spencer (1738–1814) painted in 1764.[85]

What connects Batoni's portraits of Roman and British women is their indoor setting. Lady Fox was painted in front of a deep red curtain, which contrasted elegantly with her carefully painted grey costume. The anonymous setting references the studio context of the artist and stressed the sitter's temporary visit. The portrait of Countess Spencer was far more traditionally arranged, presenting the sitter in a chair by a table covered with cultural objects. The background view, overlooking the Colosseum, indicated that the sitter had made a journey. Yet these

paintings do not discuss the sitter's experience of travelling or launch questions regarding subsequent personal change, as do the male Tour portraits examined.

Batoni's portraits of Roman women used the same enclosed setting, which clearly depended upon a well-known and accepted portrait type and indeed excluded the idea of a female figure involved within a landscape without a pastoral disguise. In contrast, the Arcadian landscape, as well as refusing the idea of concrete physical movement, favoured an abstract illustration of mental change and its process in which the sitter was socially unbound. The concept of evasion from those social duties that the traditional Tour portrait could not escape may in this sense be translated as temporary leisure.

When examining Batoni's Tour portraits from the 1750s, it is clear that informality played a decisive role. In 1745, he had painted Joseph Leeson wearing a domestic gown adorned with fur. Six years later, a similar costume was used for the portrait of the sitter's son Joseph Leeson (1730–1801), later 2nd Earl of Milltown, when travelling through Italy with his father and the cousin Joseph Henry of Staffran (1727–87).[86] The casual clothing was combined with rather intimate settings modelled on the anonymous interior, which was embellished through columns and draperies, or with natural settings with vast landscapes in the background. None of these held the dignity that landscapes eventually gained within Batoni's Tour portraits.[87] Nature and intimacy, stressed through informal clothing, were definitely themes that Batoni explored during this period, although in a quite conservative manner and one dependent on general portrait traditions.[88] Most of these paintings conformed to traditional gender role-playing in which the woman was associated with a sphere of semi-gods while the man escaped that particular kind of setting.[89] The classical elements were thus adapted to fit contemporary gender roles and to satisfy pictorial convention and its traditions.

As a contrast, Batoni explicitly used an Arcadian setting when he painted the family of Sir Matthew Fetherstonhaugh, Bt (1714–74) in 1751.[90] The latter travelled in Italy during the years 1749–52. Like Joseph Leeson, Sir Matthew was an upcoming actor within the social arena. His Grand Tour, with its extensive art purchases and commissions, helped to refine a position that had been gained through financial prosperity.[91] The portrait series included two paintings of himself (Figure 29), two of his wife Sarah Lethieullier (Figure 30) and the pictures of his brother the Rev. Utrick Fetherstonhaugh (Figure 31) and his sister-in-law Katherine. Lady Sarah's brother Benjamin Letheullier (1729–97) travelled with their half-brother Lascelles Raymond Iremonger, and their portraits finally completed the family series. Since Batoni painted two identical series, one of them was installed at Uppark, the country seat in West Sussex purchased by Sir Matthew in 1747.[92]

In this portrait series, the outdoor context prevails, with the exception of the setting chosen for one of Sir Matthew's portraits, where a low wall and a thin

29 Pompeo Batoni, *Portrait of Sir Matthew Fetherstonhaugh with wreaths of fruit and corn*, 1751. Uppark, The Fetherstonhaugh Collection (accepted in lieu of tax by H.M. Treasury and allocated to The National Trust in 1990). Photo © NTPL/John Hammond.

30 Pompeo Batoni, *Portrait of Sarah Lethieullier, Lady Fetherstonhaugh as Diana*, 1751. Acquired by the National Trust from the family in 1971. Uppark, The Fetherstonhaugh Collection (The National Trust). Photo © NTPL/John Hammond.

31 Pompeo Batoni, *Portrait of the Rev. Utrick Fetherstonhaugh as Apollo*, 1751. Acquired by the National Trust from the family in 1971. Uppark, The Fetherstonhaugh Collection (The National Trust). Photo © NTPL/Prudence Cuming.

column to the right create the same juxtaposition between outdoors and indoors as in the portrait of Giacinta Orsini. The landscapes that broadly appear in the background all present the rocky hills and mountains previously mentioned, which link the series to the geographical characteristics of the region of Arcadia.

The Fetherstonhaugh portraits establish a clear visual connection between the Arcadian discourse and that of the British travellers. Anthony Morris Clark noted the outdoor setting of the series, and defined the pictures as 'allegoric, fanciful and romantic' by a comparison with Thomas Gainsborough's experimentation with outdoor settings dating from the same period.[93] Despite the fact that Clark used the words 'pastoral' and 'Arcadian' in order to describe the costumes of the sitters, he did not reflect on the paintings' dependence upon that specific academic environment which dominated artistic life in eighteenth-century Rome. The comparison with Gainsborough's work also indicates that he did not consider the very precise circumstances of the genesis of the portrait series as being fundamental to their settings. Unconsciously, he connected the sitter's clothing to the typical elite activities in the countryside, and described the paintings as allegorical in connection with a particular elite lifestyle, the very same that the Accademia dell'Arcadia in Rome tried to uphold as a narrative for its own institution. In order to explore the differences between these early settings for British travellers and those produced from the 1760s onwards, it is useful to consider the Roman Arcadian discourse and the country house context in Britain as related.

In the first chapter of this study, the country house was discussed as part of the socio-political importance of landowning, and in terms of its implication for the Grand Tour portraits painted in Rome. It was equally stressed that the bucolic character of landscape, as presented within Batoni's portraits of British travellers, had an important connection to British garden design and its relation to domestic architecture. Moreover, the Grand Tour portraits that Batoni produced from the 1760s onwards were eclectic assemblages, where a metaphorical relationship between the sitter, the socio-cultural aims of the Tour and the appropriation of the idea of Rome and the ancient world was established. These paintings were carefully arranged in order to uphold decisive borders between familiar and foreign elements within the image.

The Fetherstonhaugh portraits reflect a different ambition, depending more upon metaphorical aspects of country life and engaging differently with the issue of cultural appropriation. These paintings tend to be less involved with the experience of actual travelling and its effects, and more concerned with the particular lifestyle that awaited the travellers at home. The male clothing in these paintings clearly indicates different aspects of elite life in the country. One of the two portraits of Sir Matthew presents him in a coat adorned with fur, which was matched with a shepherd's spear and an accompanying dog. The reference to blood sports is evident. The costume in the second painting is different. A

long and wide coat, elegantly swept around Sir Matthew's body, indicates a greater informality, which works in opposition to the hunting coat in the former portrait. The explicit outdoor setting in the first portrait and the presence of a dog indicate physical activity connected to the idea of elite outdoor life. Equally, the informal robe in the second painting is used in connection with an implied indoor context that points to the leisure aspect of the elite's living conditions and the pleasures of beholding land from a comfortable distance. While physicality, in the active and passive sense, may be seen as a theme in Sir Matthew's portraits, the images of his wife Lady Sarah are more vague. The Diana narrative connects the sitter to the same outdoor life as that hinted at in the hunting portrait of Sir Matthew, just as the Pomona narrative used in the portrait of Katherine stresses the traditional tight link between the female and the natural. It is, however, plausible to suggest that Batoni's choice for Lady Sarah was more correlated to the difficult task (for a Roman painter) of inserting a female figure without a pastoral guise within a landscape context which had no socially securing narrative.

The basic narrative of the Grand Tour portrait was about appropriation and the artist's task of how to transform that concept into readable pictorial signifiers. The Roman Arcadian discourse could not be appropriated in a material sense, but it is plausible that it was easier for the travellers to connect to its pastoral narrative than to many other cultural practices in Rome. Since Crescimbeni had pictured the academy as a universal world in which the pastoral codes helped to make the expressions of cultural and scientific discourses intelligible, and were controlled by an elite without national borders or geographical distances, its discourse could be adopted as something both foreign and familiar. The Arcadian narrative as such was not foreign within the British context. On the contrary, it was well anchored within its literature through, for instance, the work of the Elizabethan author Sir Philip Sidney (1554–86), *The Countess of Pembroke's Arcadia*, published in 1590.[94] The text is a romance with a pastoral theme and a highly idealised picture of shepherds' lives intertwined with rather violent excursions connected to contemporary political and religious matters. Although the similarities to Crescimbeni's *Arcadia* remain on a superficial level, based on the pastoral framework, it is interesting to note a different use of the idea of landscape. While Crescimbeni's metaphors were related to the process of affirmation of the Arcadians as artistic consumers, Sidney's text focuses on political government, peace and natural resources:

> This country Arcadia among all the provinces of Greece hath ever been had in singular reputation; partly for the sweetness of the air and other natural benefits, but principally for the well-tempered minds of the people who (finding that the shining title of glory, so much affected by other nations, doth indeed help little to the happiness of life) are the only people which, as by their justice and providence give neither cause nor hope to their neighbours to annoy them, so are they

not stirred with false praise to trouble others' quiet, thinking it a small reward for the wasting of their own lives in ravening that their posterity should long after say they had done so. Even the Muses seem to approve their good determination by choosing this country for their chief repairing place, and by bestowing their perfections so largely here that the very shepherds have their fancies lifted to so high conceits that the learned of other nations are content both to borrow their names and imitate their cunning. [95]

The landscape present in the Fetherstonhaugh portrait series operates on two separate levels, both clearly adapted in order to fit within a British context. Primarily, it evokes the idea of country house living as it developed during the course of the eighteenth century, with a precise connection to the civilised landscape separated from its farming and economic aspects.[96] The landowner's position, here represented by Sir Matthew and his relatives, is that of spectator rather than actor.[97] Secondarily, the series shows a number of activities that involve landowning in different ways: hunting is contrasted with the cultivation of fruits and flowers. The portrait of Utrick Fetherstonhaugh (Figure 31) holding Apollo's lyre while the god's twin sister Diana's bow and arrows are seen hanging in a laurel tree constitutes the series's strongest connection to the Roman Arcadian discourse. At the same time, these signifiers could well work to indicate the cultivated aspects of country house living through activities concerning artistic collecting and reading and writing poetry.

The pastoral guise adopted abroad was a common language in which the elite recognised itself despite different national identities. Since portraiture with pastoral settings was traditionally anchored within the visual culture of the European elite, the Fetherstonhaugh portraits must also be approached with reference to the ongoing social rise of this family. The commission of such portraits was probably used to stress the social affirmation of families by their choice of a mythological portrait.[98] Thus, Batoni inserted these family members into a narrative of social and historical dignity. The very act of travelling in Italy was a part of that process of social affirmation. Since the portraits' Arcadian narrative operated as a social code, it helped the families to insert themselves within a history of elite family continuity which they could not actually claim. As the portraits were made in Rome and by an Italian artist, the specific circumstance of the act of commission became equally important. The cultural experience of travelling connected to the affirmed elite's tradition of social formation.

Batoni's use of a strict Arcadian setting for British sitters was not to continue. From the 1760s onwards, he established the successful formula that combined contemporary and ancient elements together with a carefully set landscape with (sometimes) appropriate buildings and art works. The Arcadian narrative might have appeared to be less involved with the experience of travelling and therefore inappropriate for a portrait so heavily connected to a determined period in the

sitter's life. It is, however, possible to discuss Batoni's more frequent Tour portrait settings with reference to an important issue connected with Arcadian discourse: the concept of physical and abstract movement.

Movement and change in Arcadia

Circa 1695, Carlo Maratti completed a portrait for the Marquis Niccolò Maria Pallavicini (1650–1740), a Ligurian nobleman who had settled in Rome in 1676 after several journeys in Europe. With the help of his uncle, the cardinal Lazzaro Pallavicini (1602–80), he soon became one of the more wealthy bankers in the city, and eventually an important art patron (Figure 32).[99] The painting, which has been extensively analysed by Stella Rudolph, offers several starting points for a number of issues, among which the Arcadian theme is of interest here.[100] Both artist and sitter were closely connected to the academy. The Marquis had joined the institution in 1692 using the name *Salcindo Elafio*.[101] Maratti followed in 1704 as *Disfilo Coriteo*.[102] As Rudolph points out, Crescimbeni described Pallavicini in his account of the deceased members of the academy, highlighting his interest in the arts, particularly regarding his activities as a patron of contemporary artists such as Maratti.[103] Crescimbeni's emphasis on Pallavicini's appreciation of the arts and his eagerness to create a collection are interesting, since the author completely neglects portraying the Marquis as an active poet, surely the most important skill for an Arcadian shepherd. This detail clearly demonstrates Crescimbeni's objectives as they were presented in *Arcadia*: the elite shepherd is praised through his trained appreciation of the arts, and not as a producer of art. Curiously enough, this particular dualism is approached in Maratti's painting. On the right-hand side, the artist inserted his own self-portrait, a classical tribute to the value and status of the artist's profession as well as a direct indication of the amiable relations between himself and the sitter.[104] If artistic activity was praised through the figure of Maratti, the sitter, dressed in classical drapery, evokes the fulfilment of artistic appreciation through the metaphor of movement. From the position of the sitter, who is already on his way, the presumed journey is outlined with a distinct path towards Mount Helicon crowned by the Temple of Virtue. The intermediary on this journey is Apollo, who invites Pallavicini to undertake it, with an elegant hint at Virgil encouraging Dante's journey in the *Divine Comedy*.

In *Arcadia*, Crescimbeni chose Maratti's art as *exemplum* for the pictorial activities of the shepherds. He allowed the nymphs, under the guidance of the artist's daughter Faustina Maratti Zappi (1679–1745), an acclaimed poetess within the academy, to explore his paintings while visiting his hut.[105] Among the examined paintings, the portrait of Pallavicini and his progress towards the Temple of Virtue constitutes the climax of the narration.[106] The portrait's position within the text evidences its strong programmatic character as an Arcadian

32 Carlo Maratti, *Self-portrait with the Marquis Niccolò Maria Pallavicini (Il Tempio di Virtù)*, 1692–95. Stourhead, The Hoare Collection (The National Trust). Photo © NTPL/John Hammond.

product. Artistic production and artistic appreciation were emphasised as attainable aims in terms of intellectual development. In Maratti's portrait, this was indicated by showing the sitter in accordance with the top of Mount Helicon and the Muse's source. The ceremonial movement professed within the theatre of Bosco Parrasio perfectly reflects the settings of these paintings, including the different moments and stages in this particular progress.

The social implications of these settings become clearer if one considers the more material aims of the Arcadian movement. As previously pointed out, Amedeo Quondam's analysis permits the drawing of parallels between the ambitions of the academy in terms of artistic expressions and the expected activities of the elite. Pallavicini's intellectual development eventually resulted in a magnificent art collection, which in turn was an important social signifier for an elite male settling in Rome. An art patron of Pallavicini's calibre was equally able to favour artists for future commissions. The painting may in this sense be seen as a perfect outline of Crescimbeni's ambitions within the academy: a context without social boundaries made possible by pastoral masks, with the permitted economic transactions resulting in artistic productions. It is not coincidental that both the commissioner and the painter appear side by side in the painting.

As previously shown, Batoni's Grand Tour portraits can be read with reference to movement and change as metaphorical aspects of the social aims of travel. It is possible to launch the idea that he might have used Maratti's setting in the Pallavicini portrait when creating his Tour portrait formula. The portrait of Sir Wyndham Knatchbull-Wyndham (1737–63) is a good example (Figure 33). The sitter is exposed in an anonymous interior marked by classical architecture and a seventeenth-century chair. If social position is highlighted through traditional signifiers such as columns, drapery and the Van Dyck costume, the view of the background is an important marker of what has been or is supposed to be gained with reference to the travelling experience. Just as in the portrait of Giacinta Orsini, foreground and background serve to juxtapose two different life stages. In Sir Wyndham's case, it is the life before and after the Grand Tour that is shown. The sitter indicates the position of the temple building with a gesture that stresses a situation of either display or orientation. Sir Wyndham has taken the place of Apollo in Maratti's painting, and he consequently holds a duplicate role as both guide and disciple. The goddess Minerva, who is present in Maratti's painting in the background between Apollo and the artist, appears in Batoni's painting in sculptural form, creating strong ties between the sitter and the ancient mythical world. The settings used for the Fetherstonhaugh family explicitly exposed the relationship between Arcadian discourse and social status. In contrast, the duplicate setting used for Sir Wyndham explored the elite travellers' relation to the process of socio-cultural change, the aim of the Grand Tour, by using pictorial metaphors connected to the institutional environment of Arcadia.

33 Pompeo Batoni, *Portrait of Sir Wyndham Knatchbull-Wyndham*, 1758. Los Angeles County Museum of Art, Gift of the Ashmanson Foundation. Photo © 2006 Museum Associates/LACMA.

A museum context: learning and display as Arcadian virtue

In Crescimbeni's *Arcadia* the nymphs partook of all sorts of scientific and cultural experiences during their visits to the different shepherds. This detail in the text enhances the author's juxtaposition of pastoral narrative and descriptions of the elite's consumption of knowledge and art. When examining the relationship between Arcadian discourse and portraiture in eighteenth-century Rome, this apparent paradox is of outmost importance. Amedeo Quondam's social analysis of *Arcadia* demonstrates the academy's ambition of summoning and neutralising knowledge in order to make it socially palatable and non-threatening. At the same time, the text opens up interesting questions regarding views on categorising and display, issues that are of general importance in eighteenth-century portraiture.

It is possible to state that the Arcadian discourse provoked a specific understanding of portrait settings, in which Antiquity as a concept held a decided position. The pastoral disguise on which the Arcadian idea was based used the classical narratives for contemporary purposes and created new and fashionable mythologies that would suit established as well as up-and-coming elites. In this sense, the concept of Antiquity was not only adapted but also seen as a concrete and plausible standard for the understanding of social life and its hierarchies. The Grand Tour portrait could only partly respond to this, since one of the purposes of this specific genre was to demonstrate the beneficial effects of the appropriation of ancient material culture. The Tour portrait's characteristics relied upon a strong narrative of display, a direct consequence of appropriation. On some occasions, these portraits were modelled on museum contexts, offering the concept of the process of acquiring knowledge as a guarantee of social refinement as well as constituting an act of fashion. The travellers' and the Arcadian discourse were interesting equivalents.

In *Arcadia*, there is a strong focus on the concept of display and ordered things. Just as Quondam points out, the text connects pastoral games to the cultural consumption of the elite.[107] To this it must be added that the text also emphasises the very contexts of this consumption, not just the practice itself. The journey of the nymphs and their visits to the shepherds' huts can be read as metaphors of the organisation of collections within an elite home. Accordingly they were permitted to pass through libraries and galleries and to admire collections of visual arts, sculpture and scientific objects.

In 1777, the French artist Laurent Pécheux (1729–1821) painted a portrait of the Marquise Margherita Gentili Sparapani Boccapaduli (1735–1820) (Figure 34). The erudite Marquise, who has already been introduced in this study, joined the Accademia dell'Arcadia using the name *Semira Epirense*. Her participation in the academy was most probably due to her increasing interest in the natural sciences rather than any lively activity as a poetess.[108] Her portrait provides an

34 Laurent Pécheux, *Portrait of Margherita Gentili Sparapani Boccapaduli*, 1777. Private Collection, Rome.

interesting comparison to that of Giacinta Orsini, and the setting sheds light on a different aspect of Arcadian discourse, one that became translated into a virtue: collected instead of produced knowledge.

The Marquise is shown in her cabinet in the family palace in Rome, surrounded by well-documented and identifiable objects.[109] The display of a great variety of object categories underscores the extent of the Marquise's interest.[110] In this sense, the portrait is a personal document, but it also demonstrates the important connection between the social elite and the practice of collection. Such a focus inserts the portrait of the Marquise into a wider context than her personal one, namely that of the Accademia dell'Arcadia.

Was Margherita's portrait unique in eighteenth-century Rome in showing a woman in control of her own knowledge? Considering what is presently known about other Roman female portraits from the relevant period, the Marquise's portrait must be seen as a singular object, one contextually connected to the Arcadian environment. A somewhat different portrait of an anonymous sitter by an anonymous artist, most probably painted in Rome, shows that the display of knowledge might have been more widespread as a setting than is currently thought to be the case (Figure 35). The enigmatic portrait shows the sitter with the intent of demonstrating a tiny cast of an ancient cameo, taken from the portable cabinet to her left. A magnifying glass in her hand indicates that she is about to examine the object, which shows the profile portrait of a man.[111] The miniature portrait attached to the sitter's dress shows the features of a man who most probably was closely related to the sitter. Federico Zeri has suggested that the sitter might have been a member of the Pikler family, well-known collectors in eighteenth-century Rome.[112] There is, however, another possibility. In the service of the German collector Baron Philipp von Stosch (1691–1757) in Rome was one Cristian Dehn (1696–1770) who made his living by selling paste gems and sulphurs.[113] His own cabinet of casts contained about five thousand original gems as well as ancient and modern paste gems. At his death in 1770, his daughter Faustina and her husband Francesco Maria Dolce inherited the so-called 'Museo Dehn'. Two years later, it was catalogued and partly published by Dolce himself.[114] In the description of his father-in-law's collection, Dolce writes about his wife Faustina: 'His only daughter Faustina, who as a child worked on these pastes with her deceased parent, was the heiress not only of her father's skills but of his Museum and having decided to follow the will of her Father by composing and giving to the prints this Description, I have not wanted to fail in this, being her consort.'[115] Although it has not been possible to find documented evidence, the portrait might represent Faustina Dehn Dolce with her father's cabinet. If that were the case, the male miniature portrait on her dress could represent either her father or her husband in the role of participant in her connoisseurship. These assumptions about the sitter's identity are relevant to this study, since they point at the fact that the actual production of knowledge

35 Unknown artist, *Portrait of a Lady with Cameo cabinet*, eighteenth century. The Walters Art Gallery, Baltimore. Photo © The Walters Art Gallery, Baltimore.

in eighteenth-century Rome was not necessary an elite affair. The apparent similarities regarding the narrative of display between the portrait of Margherita Boccapaduli and the possible one of Faustina Dolce are challenged when taking the different social identities of the sitters into consideration.

When considering previously examined portraits of Arcadian members, it appears clear that the portrait of the Marquise approaches the concepts of knowledge, connoisseurship and artistic production in a quite different way. These differences must also be seen as necessary in relation to the history of eighteenth-century portraiture and its settings. In Batoni's portrait of Giacinta Orsini, the sitter's social status and poetical activities were displayed through an ambivalent use of traditional state portrait signifiers and the allegorical traditions of the sixteenth and seventeenth centuries. The sitter is balanced on a ledge illustrated by architectural elements, which confirmed the border between two different modes of life. The artist thus managed to present the dualism of the Duchess's social persona, yet in a socially accepted manner. In contrast, Maratti's portrait of the Marquis Pallavicini was completely modelled on an allegorical idiom based on academic tradition. The sitter became completely inserted into a narrative that didactically explained his appreciation of the arts, and his refinement through this process. Pécheux's portrait of Margherita Boccapaduli brought the Arcadian discourse into a somewhat new arena, since it completely avoided a metaphorical explanation of the Marquise's activities as shepherdess and collector. In this sense, the portrait may appear more easily connected to the Grand Tour portrait settings through its evident exposé of the benefits of material culture transformed into manageable items. Nevertheless, the Tour portraits operated within a separate discourse, in which the concepts of claimed ownership and material appropriation were stronger than an actual process of acquired knowledge and artistic appreciation. The museum context seen in the Marquise's portrait established a situation of evident possession that the Tour portraits could not claim. There is no reason to believe that the Marquise's interest in the natural sciences was not vivid or of a lasting duration. In her personal memoirs, she described the matter as follows:

> I must confess that I have always been full of curiosity but equally far from consistent training, I have always been easily distracted; I even lack memory; I am a curious one: I love literature, science; I respect the arts but I have never trained in anything. I have always cultivated natural science due to my curiosity, this examining of nature has always interested and amused me but without serious application.[116]

Recent studies on Margherita's library have shown both consistency and a dedication for scientific knowledge, something which may counter her own rather modest description of her intellectual training.[117] If taken into consideration that these memoirs were probably written over a long period of time, it is highly probable that the Marquise referred to her own accomplishment with the modesty of an adult woman, conscious of her own limits. Nevertheless, the quotation is important, since it acknowledges the mundane and superficial approaches to knowledge that constituted a fundamental part of elite sociability in early modern

Europe. The amount of different object categories, including items from the natural world as well as from the artistic field with direct reference to Antiquity, bears witness to Quondam's suggestion of the Accademia dell'Arcadia as a context of cultural control through the supervision of the elite.[118]

The continual conscious awareness of the contemporary socio-political scene shows the extent to which the Accademia dell'Arcadia elaborated an aesthetic which flattered both the innate and the visiting powers of the city. The academy's discourse inserted its Roman and foreign members into a mythical context of socio-cultural control and conservatism that related to the idea of cultural and material appropriation, which in turn was so closely related to the social legitimation process of the European elite. Socio-political strategies combined with artistic commissions and networks were thus coordinated within that complex system which Crescimbeni had envisioned and realised. The Grand Tour culture could relate to this particular discourse, since the academy's practice of cultural control in a metaphorical sense was similar to that expected from the Tour.

It is a fundamental aspect of Arcadian discourse that, while it involves a subtle mantle of unspoken democracy, it nevertheless permits the idea of status quo to be constantly legitimated. The art of making poetry was, within the Arcadian context, eventually translated into the appropriation of culture, science and even diplomacy. These were all activities that did not originally belong to the Arcadian context, and which did not directly involve the commissioning elite. Yet through academic adaptation these activities could be socially polished and, so to speak, disarmed as possibly threatening tools within a potentially changing society. Accordingly, it is appropriate to see the Accademia dell'Arcadia and its expressions as one of the most efficient means of preserving the *ancien régime* in eighteenth-century Europe.

Notes

1. BA, Archivio dell'Arcadia. MS 37, fol. 159 r. *In morte di Donna Giacinta Orsini*.
2. F. Mazzocca et al. (eds), *Il neoclassicismo in Italia*, pp. 462–3.
3. A.M. Clark, *Pompeo Batoni*, no. 206; C. Pericoli, 'La Pinacoteca dell'Accademia dell'Arcadia', *Capitolium*, 6 (1960), pp. 9–14.
4. On this subject, see E. Borsellino and V. Casale (eds), *'Roma: 'Il tempio del del vero gusto'* (Firenze: 2001).
5. M.P. Donato, *Accademie romane: Una storia sociale* (Roma: 2000), pp. 64–7.
6. M.P. Donato, *Accademie romane*, pp. 58–64.
7. M.P. Donato, *Accademie romane*, p. 59.
8. L. Barroero and S.Susinno, 'Roma arcadica', p. 89.
9. For a more complete survey of the Arcadian poetry, see C. Calcaterra, *Il barocco in Arcadia e altri scritti sul Settecento* (Bologna: 1950) and W. Binni, *L'Arcadia e il Metastasio* (Firenze: 1963).

10 G.P. Bellori, *Le vite dé pittori, scultori e architetti moderni*, E. Borea (ed.) (Torino: 1976), pp. 13–25.
11 M.P. Donato, *Accademie romane*, p. 71.
12 On this subject see C.M.S. Johns, *Papal art and cultural politics: Rome in the age of Clement XI* (Cambridge and New York: 1993).
13 M.P. Donato, *Accademie romane*, p. 72.
14 M.P. Donato, *Accademie romane*, p. 73.
15 M.P. Donato, *Accademie romane*, p. 73.
16 G.M. Crescimbeni, *Disinganno di chiunque si fosse lasciato persuadere dalla lettera anonima intitolata Della division d'Arcadia* (Napoli: 1711).
17 I. Carini, *L'Arcadia dal 1690 al 1890: Memorie storiche* (Roma: 1891), pp. 39–40.
18 See for instance S. Rudolph, *Niccolò Maria Pallavicini*; A. Lo Bianco, 'L'Arcadia in pittura', *Coro Polifonico Romano 'Gastone Tosato': Stagione 1991–92* (Roma: 1992), pp. 95–103.
19 L. Barroero and S. Susinno, 'Roma arcadica', pp. 94–5.
20 V. Hyde Minor, *The death of the Baroque and the rhetoric of Good Taste* (Cambridge: 2006), p. 117.
21 G.M. Crescimbeni, *L'Arcadia del Can. Gio. Mario Crescimbeni Custode della medesima Arcadia, e Accademico Fiorentino. A Madama Ondedei Albani cognata di N.S. Papa Clemente XI*, Stamperia Antonio dé Rossi (Roma: 1708).
22 A. Quondam, 'Gioco e società letteraria nell'*Arcadia* del Crescimbeni: L'ideologia dell'istituzione', *Arcadia. Accademia letteraria italiana. Atti e memorie*, 6 (1975–76), p. 167.
23 G. M. Crescimbeni, *Arcadia*, pp. 129–36.
24 G.M. Crescimbeni, *Arcadia*, pp. 91–112.
25 A. Quondam, 'Gioco e società', pp. 171–2.
26 A. Quondam, 'Gioco e società', p. 171.
27 M.P. Donato, *Accademie romane*, pp. 120–4.
28 A. Quondam, 'Gioco e società', pp. 188–93.
29 A. Quondam, 'Gioco e società', p. 186.
30 G.M. Crescimbeni, *Arcadia*, pp. 11–13 and pp. 26–44; C. Pericoli, 'La Pinacoteca dell'Accademia dell'Arcadia', pp. 9–14.
31 See for instance, *I Giuochi Olimpici celebrati in Arcadia nell'Ingresso dell'Olimpiade DCXXXIII. In onore degli Arcadi illustri defunti* (Roma: 1754).
32 M. Natoli and F. Petrucci (eds), *Donne di Roma dall'Impero Romano al 1860* (Roma: 2003), pp. 150–2; A. Lo Bianco and A. Negro (eds), *Il Settecento a Roma* (Roma: 2005), p. 183.
33 F.S. Brunetti, *Compendio sferico, mitologico, istorico, geografico e poetico alla Nobilissima Pastorella Euridice Ajacense da Melanzio Trifiliano pastore arcade* (Roma: 1755), p. 7.
34 E. Graziosi, 'Arcadia femminile: Presenze e modelli', *Arcadia. Accademia letteraria italiana. Atti e memorie*, 9 (1994), p. 249.
35 E. Graziosi, 'Arcadia femminile', p. 251.
36 R. Ago, 'Giochi di squadra', pp. 256–64.
37 E. Graziosi, 'Arcadia femminile', p. 251.

38 E. Graziosi, 'Arcadia femminile', p. 253.
39 E. Graziosi, 'Arcadia femminile', pp. 253–4.
40 E. Graziosi, 'Arcadia femminile', p. 256.
41 *Rime degli Arcadi* (14 vols, Roma: 1716–81), vol. 12, pp. 77–88. *Rime così gentili e così grate, Ah saputo svegliarmi entro del petto, Tale insolito ardir, tal vanitate. Ch'io prendo in verseggiar nuovo diletto, E chi mai del mio sesso, e di mia etate, Chi fu sul Tebro di tal rime oggetto, Neppur la gran Vittoria ebbe un tal Vate Fra l'ampio stuolo a celebrarla eletto.*
42 A particular interest was apparently shown to Vittoria Colonna and other female poets of the sixteenth century within the Academia dell'Arcadia. E. Graziosi, 'Arcadia femminile', p. 260.
43 *Adunanze degli Arcadi pubblicate nelle nozze di sua Eccellenza la signora D. Giacinta Orsini dé Duchi di Gravina Con Sua Eccellenza il Signor Don Antonio Boncompagno Ludovisi Duca d'Arce dé Princ di Piombino All'Emo, e Rmo Principe il Signor Cardinale Domenico Orsini* (Roma: 1757), p. 10. *La dolce Sposa E la dotta Donzella Si confondono in lei: sua prigionera La vanta Amor, insuperbisce, e pure Ella par trionfante: Par nemica d'Amor, e pure è amante.*
44 Rime degli Arcadi, pp. 77–88. *Vorrei poter nell'erudite suole Sedere anch'io: ma il tempo a Noi Donzelle Manca, e fugge più ratto, che non suole. Dobbiam del fasto, e delle mode Ancelle Seguir le leggi di stranier confine E alla danza adattar le piante snelle; Misere! Usar dobbiam le arti più fine I sguardi a regolar, gli atti, gli accenti, E a un vetro adulator comporre il crine. Felice etàte, in cui nostri ornamenti Eran le grazie, e la beltà natìa, Gli occhi sereni, e i bei labbri ridenti: biondo, o il nero crine errando già Al tergo sparso, e il fianco sempliceto Sol di candidi veli si coprìa. Non perle, o nastri, ma un bel serto eletto Ci ornava il capo, e specchio ci facèa Il Fonte trasparente, o il Ruscelletto. Non già fra doppj muri si chiudéa La nostra libertà, ma a cielo aperto L'aer dolce, e temprato si godèa.*
45 The site was donated to the Arcadians in 1725 by the Portuguese king John V. At the same time he was proclaimed protector of the institution after the death of Pope Clement XI in 1721. M.P. Donato, *Accademie romane*, p. 75.
46 See for instance, V. Hyde Minor, *The death of the Baroque*, pp. 130–1.
47 A survey of the history and design of this monument is found in D. Predieri, *Bosco Parrasio: Un giardino per l'Arcadia* (Modena: 1990).
48 M. Natoli and F. Petrucci (eds), *Donne di Roma*, pp. 150–2; A. Lo Bianco and A. Negro (eds), *Il Settecento a Roma*, p. 183.
49 On the theatre's iconography see D. Predieri, *Un giardino per l'Arcadia*, pp. 72–81 and V. Hyde Minor, *The death of the Baroque*, pp. 141–51.
50 D. Predieri, *Un giardino per l'Arcadia*, p. 79; L. Barroero and S. Susinno, 'Roma arcadica', pp. 100–1.
51 A. Lo Bianco and A. Negro (eds), *Il Settecento a Roma*, pp. 123–4.
52 V. Hyde Minor, *The death of the Baroque*, p. 150.
53 BA, Archivio dell'Arcadia, MS 37, fol. 333 r, *A Sua Eccellenza La Signora D. Giacinta Orsini Nata Duchessa di Gravina: Donzella eccelsa onor di Roma, onore dell'alta Stirpe onde fra noi sei scesa.*
54 BA, Archivio dell'Arcadia, MS 37, fol. 357 r. *A Sua Eccellenza La Signora D. Giacinta Orsini fra gli Arcadi Euridice del Signor D. Francesco Ruspoli … Má come,*

dimmi, abbandonar l'onori del patrio tetto, e sotto un faggio o un'orno posare il fianco con il gregge attorno Sull'Erbe molli a ridere de i Fiori?

55 E. Grantaliano, 'Donne di spettacolo nello Stato della Chiesa', *Rivista storica del Lazio*, 8–9:13–14 (Roma: 2000/1), pp. 190–1.
56 L. Cairo, 'Luoghi scenici nella Roma del Settecento', in G. Petrocchi (ed.), *Orfeo in Arcadia: Studi sul teatro a Roma nel Settecento* (Roma: 1984), pp. 273–88.
57 V. Hyde Minor, *The death of the Baroque*, pp. 150–1.
58 Stella Rudolph, 'Le committenze romane di Domenico Corvi', in A. Lo Bianco and W. Curzi (eds), *Domenico Corvi* (Roma: 1999), pp. 20–1.
59 G. Falcidia, 'Per un ritratto di Marco Benefial', *Bollettino dei Musei Comunali di Roma*, 11:1–4 (1964), pp. 19–33; L. Barroero, *Benefial* (Milano: 2005), p. 22.
60 *Nel Funerale per l'Illustrissima, ed Eccellentissima Signora D. Paola Odescalco Duchessa di Gravina. Orazione detta in napoli nella insigne basilica di S. Filippo Neri il dí XVII settembre MDCCXXXXII. Dal padre Giambattista Botti della Compagnia di Gesù* (Napoli: 1742); A. Cottino (ed.), *La donna nella pittura italiana del Sei e Settecento: Il genio e la grazia* (Torino: 2003), p. 174.
61 L. Barroero and S. Susinno, 'Roma arcadica', p. 101.
62 Ovid, *Metmorphoses*, book VI, vv. 314–81.
63 A. Lo Bianco and A. Negro (eds), *Il Settecento a Roma*, p. 210.
64 A. Cottino (ed.), *La donna nella pittura italiana*, p. 174.
65 See for instance L. Impelluso, *Nature and its symbols* (Los Angeles: 2004), p. 302.
66 L. Barroero, *Benefial*, p. 69.
67 V. Hyde Minor, *The death of the Baroque*, p. 118.
68 G. Rubsamen, *The Orsini inventories* (Malibu: 1980), inventory dated 1794.
69 The Paul Mellon Centre for Studies in British Art, London, Brinsley Ford Papers, Box file 88 'Arcadian Society', excerpt from letter of Daniel Crespin to James Grant, dated in Rome, 11 March 1763.
70 The Paul Mellon Centre for Studies in British Art, Brinsley Ford Papers, Box file 88 'Arcadian Society'.
71 The Paul Mellon Centre for Studies in British Art, Brinsley Ford Papers, Box file 88 'Arcadian Society', excerpt from Sir William Forbe's Journal, vol. 5, 1 April 1793.
72 *Ragguaglio o sia giornale della venuta in Roma di Sua Altezza Reale Sofia Albertina Principessa di Svezia Abbadessa di Quedlimburgo sotto nome di Contessa di Wasa* (Roma: 1793), p. 12.
73 L. Barroero and S. Susinno, 'Roma arcadica'.
74 A. Quondam, 'Gioco e società', p. 184 and p. 191.
75 A. Quondam, 'Gioco e società', p. 191.
76 See for instance, J. Moore, *A View of Society and Manners in Italy*, vol. 1, pp. 384–5.
77 S. Benedetti, *The Milltowns: A family reunion* (Dublin: 1997), p. 1.
78 S. Benedetti, *The Milltowns*, pp. 20–1.
79 S. Benedetti, *The Milltowns*, pp. 28–31.
80 S. Benedetti, 'Un ritratto inedito di Pompeo Batoni ed alcune notizie sulla sua committenza', in M.G. Bernardini, S. Danesi Squarzina and C. Strinati (eds), *Studi di Storia dell'Arte in onore di Denis Mahon* (Roma: 2000), pp. 361–5.

81 S. Benedetti, 'Un ritratto inedito', p. 365, note 29.
82 E. Fumagalli, *Palazzo Borghese: Committenza e decorazione privata* (Roma: 1994), p. 20.
83 BA, Archivio dell'Arcadia, MS 37, fol. 329 v, *Alla Signora Marchesa Caterina Gabrielli rappresentante nel Ballo della Tragedia Galatea addolorata per la morte di Aci*; fol. 347 v, *Alle glorie del Signore Abbate Gioacchino Pizzi per il Celebre Sonetto fatto in lode alla Nobil donna Marchesa Gabrielli, rappresentante la parte di Galatea, nel ballo fatto nella famosa Tragedia della Zaira rappresentata nella Villa di Mondragone in Frascati*.
84 See for instance a portrait of an unknown woman in the guise of Cleopatra, A.M. Clark, *Pompeo Batoni*, no. 448.
85 A.M. Clark, *Pompeo Batoni*, no. 323 and no. 269.
86 A.M. Clark, *Pompeo Batoni*, no. 146; S. Benedetti, *The Milltowns*, p. 3 and pp. 22–3.
87 See for instance the portrait of Thomas Dawson, later Viscount Cremorne, painted in 1750–51. A.M. Clark, *Pompeo Batoni*, no. 145.
88 A.M. Clark, *Pompeo Batoni*, no. 134 and no. 135.
89 K. Retford, *The art of domestic life*, pp. 26–37.
90 A.M. Clark, *Pompeo Batoni*, no. 154 and no. 163.
91 F. Russell, *The hanging and display of pictures 1700–1850* (Washington: 1985), pp. 133–4.
92 *Uppark*, The National Trust (London: 1995), pp. 17–25.
93 A.M. Clark, *Pompeo Batoni*, no. 154.
94 On this vast subject, see for instance J. Rees, *Sir Philip Sidney and Arcadia* (Madison, N.J.: 1991).
95 Sir P. Sidney, *The Countess of Pembroke's Arcadia*, V. Skretkowicz (ed.) (Oxford: 1987), Book I, p. 16.
96 See for instance, J. Brewer, *The pleasures of the imagination*, pp. 627–9.
97 J. Brewer, *The pleasures of the imagination*, p. 630.
98 On this subject, see K. Retford, *The art of domestic life*, pp. 149–85.
99 A. Lo Bianco and A. Negro (eds.), *Il Settecento a Roma*, p. 236.
100 S. Rudolph, *Niccolò Maria Pallavicini*, pp. 73–86.
101 S. Rudolph, *Niccolò Maria Pallavicini*, p. 73.
102 S. Rudolph, 'Una visita alla capanna del pastore Disfilo, "Primo dipintore d'Arcadia"' '(Carlo Maratti)', *Atti del Convegno di Studi per il III Centenario dell'Accademia dell'Arcadia* (Roma: 1991), p. 387.
103 G.M. Crescimbeni, *Notizie istoriche degli Arcadi morti* (3 vols, Roma: 1720), vol. 2, pp. 168–9.
104 On the relationship between Pallavicini and Maratti as expressed in this particular portrait see for instance S. Rudolph, *Niccolò Maria Pallavicini*, pp. 78–80.
105 G.M. Crescimbeni, *Arcadia*, pp. 129–32. See also S. Rudolph, 'Una visita alla capanna del pastore Disfilo'.
106 G.M. Crescimbeni, *Arcadia*, p. 136; S. Rudolph, 'Una visita alla capanna del pastore Disfilo', p. 400.
107 A. Quondam, 'Gioco e società', pp. 132–5.

108 F. Mazzocca et al. (eds), *Il neoclassicismo in Italia*, p. 477.
109 I. Colucci, 'Antonio Canova, la Marchesa Margherita Boccapaduli e Alessandro Verri: Lettere ed altre testimonianze inedite', *Paragone*, 64 (1998), pp. 64–5; M. Pieretti, 'Margherita Sparapani Gentili Boccapaduli', p. 89, note 38.
110 I. Colucci, 'Il salotto e le collezioni della Marchesa Boccapaduli', *Quaderni Storici*, 2 (2004), pp. 449–94.
111 F. Zeri, *Italian paintings in the Walters Art Gallery* (2 vols, Baltimore: 1976), vol. 2, no. 428.
112 F. Zeri, *Italian paintings*, no. 428.
113 On Baron von Stosch, see for instance L. Lewis, 'Philipp von Stosch', *Apollo*, 63 (1967), pp. 320–7 and P. Zazoff, *Die antiken Gemmen* (Munich: 1983), pp. 3–67.
114 A. Wilton and I. Bignamini (eds), *Grand Tour*, no. 262. See also L. Pirzio Biroli Stefanelli, 'Note in margine alla "Descrizione Istorica del Museo di Cristiano Dehn" di Francesco Maria Dolce', in E. Debenedetti (ed.), *Collezionismo e ideologia: Mecenati, artisti e teorici del classico al neoclassico*, *Studi sul Settecento romano*, 7 (Roma: 1991), pp. 273–84.
115 Quoted from L. Pirzio Biroli Stefanelli, 'Note in margine', p. 274. *L'unica sua figlia Faustina, quale da bambina con il defondo genitore aveva lavorato tali impressioni, Erede essendo, non solo delle sostanze paterne, ma specialmente del suo particolare Museo, avendo determinato eseguendo la volontà di suo Padre, far comporre, e dare alle stampe tale Descrizione, non ó voluto mancare, quale di lei consorte, che venisse data esecuzione a tale pia volontà figliale.*
116 Quoted from M. Pieretti, 'Margherita Sparapani Gentili Boccapaduli', p. 89. *Devo confessare che sono stata sempre piena di curiosità, ma altrettanto aliena dall'applicarmi con qualche Costanza, sono stata sempre soggetta a distrarmi; manco anche di memoria; sono una testa curiosa: amo le lettere, le scienze; le arti le rispetto ma non mi sono mai applicata a niente. La storia naturale l'ho sempre coltivata per la mia curiosità, questo esame della natura mi ha sempre interessata e divertita senza una seria applicazione.*
117 F. Tarzia, *Libri e rivoluzioni: Figure e mentalità nella Roma di fine Ancien Régime (1770–1800)* (Milano: 2000), pp. 119–80.
118 A. Quondam, 'Gioco e società', pp. 132–5.

Conclusion

Between 1780 and 1782, Sir Joshua Reynolds painted a portrait of the wife of Lord George Cavendish, Lady Elizabeth Compton (Figure 36). The picture, which was exhibited at the Royal Academy the same year as its completion, is in many ways quintessential proof of Reynolds's artistry. It presents the female figure as a human statue of magnitude within a landscape of highly dramatic proportions. The sitter, dressed in a vaguely classical costume, physically takes charge of the canvas as her slim, long body leans on a notably empty pedestal. With one leg crossing the other and her left arm firmly placed at her side, the portrait of Lady Elizabeth is a paraphrase not merely of a seventeenth-century portrait tradition but of the classic Grand Tour portrait as it had come to be developed in the Roman studio of Pompeo Batoni in the 1760s. A quick comparison between Reynolds's Compton portrait and Batoni's portrait of Peter Beckford (Figure 5) stresses their strictly formal connection. Nevertheless, such a comparison cannot exclude a variety of differences that separate the images from each other. These differences do not involve formal solutions as such. On the contrary, they involve those connotations which sustain the components within the pictures, such as the complex antique in one of them and the empty pedestal in the other, the similar body language of sitters of different gender and the landscape itself. The lack of an antique, whose supposed presence is stressed through the very existence of the pedestal, becomes a key factor in the portrait of Lady Compton. It is the very legacy of portrait tradition itself that tricks the beholder, who searches in vain for the missing component within the otherwise so familiar setting. The sitter's classical dress and her 'male' body language are confusing as well, since they transgress the socially bound ideas of an accepted display form for an elite lady. In a way, it is possible to suggest that Lady Compton has conquered the antique in order to place herself in the role of both mythological signifier and fashionable lady. However one prefers to read this picture, it is definitely a cleverly elaborated assemblage, heavily dependent on a portrait legacy that might have implied rather diverse social meanings in other contexts, far away from the Royal Academy.

Nature, classical heritage and their social implications are among the key terms that Reynolds's portrait brings to mind. These terms also bring forward

36 Sir Joshua Reynolds, *Portrait of Lady Elizabeth Compton*, 1780–82. Andrew W. Mellon Collection. Image © 2006 Board of Trustees, National Gallery of Art, Washington.

the focal point of this study, where a main concern has been to discuss the existence or non-existence of desired homogeneity regarding the reading of eighteenth-century European portraiture. An important factor in this discussion concerns the particular importance given to the social idea of Antiquity as it had come to be developed within general elite discourse in Europe during the early modern period. Consequently, the aim has been to examine the ways in which two entirely different groups of the European elite approached this idea of Antiquity and its expression in portraits produced in eighteenth-century Rome. Through the readings of different portrait settings, it has been possible to trace how apparently similar assimilations supported different social aims in different parts of Europe.

The extreme consequence of such a reading is a clearer picture of the multiple functions of the myth of Antiquity within the social strategies of the eighteenth-century European elite. Ancient Rome, particularly its political system, religious system and architecture, was the very quintessence of a Western mythology that had in itself a long history. The elite cultures of the early modern era had adapted its forms, rituals and associations in order to exemplify their rights to rule. The myth of Rome had a long continuity but each society from the fifteenth century onwards chose its own way to adopt and adapt it.

The elite groups at stake in the study had deeply different presuppositions concerning this matter. The Roman papal nobility resided in the city. They were the owners of collections of ancient sculpture and of many of the territories where archaeological activities were in full flow. The British elite, on the contrary, increased their travels to Rome during the second part of the century in an institutionalised form of educational travel, namely the Grand Tour.

The Roman families lived in the actual centre of the ancient Roman heritage, while the British tourists experienced ancient Roman culture from a distant geographical perspective. Both Romans and British were, however, eager to appropriate the city from both a material and a symbolic point of view. They experienced the city of Rome in a period that saw a profound widening of the concept of Antiquity. None of them were strangers to the archaeological activities, the antique market, or the traditional education based on the reading of Livy, Horace and Virgil, nor to the pictorial idiom of classicism or the practice of collecting. Yet their approaches to all of these socio-cultural expressions were subjected to diverse prerequisites which mainly depended upon a varied approach to Antiquity in all its forms: as a narrative norm, a historical phase, an item of collection or a political myth. The issue of geographical belonging, which in this case would have placed the Roman elite in a favourable position, was of less importance. Their foreignness in relation to Antiquity remained equal.

The use of Rome in the social processes of the European ruling classes was definitely not new in the eighteenth century, but this use came to gain wider and more complex implications. This was because the views on what the concept of

Antiquity really consisted of expanded. The eighteenth century saw the birth of professional archaeology, a development of the idea of museums and a flood of critical texts that were spread by the publishing market. Antiquity became suddenly more fixed as a historical phase, with canonical rises and declines. It was represented in the form of items within collections, but it was also a literary and artistic norm, eventually institutionally defined as classicism. As a result of these different aspects, Antiquity was experienced by European society as both a past and a possible future, in terms of ideal projections. The consumers of this varied myth of Antiquity increased, but they were no longer only the traditional elite in terms of aristocratic rank and birthright. On the contrary, most aristocracies of the *ancien régime* experienced difficulties in maintaining their economic position in society, while others managed to remain on top, above all, through their skills in industry, warfare and the beginnings of colonisation.

The eighteenth-century British and Roman elites were each other's antithesis. A main theme of this book has been to explore in which ways their social processes were linked to the myth of Antiquity and the subsequent impact on portraiture. Naturally, neither the British nor the Roman elite could claim to be the proper inheritors of Republican or Imperial Rome. The Roman genealogies of both the feudal and the papal families were based on ready-made mythologies in which ancient tales, myths and histories were adapted to their specific needs. As a contrast, the British elite, which increased itself through creating new titles in the eighteenth century, could not claim any direct (or fictive for that matter) descent from the Roman past. But since Britain had once been a Roman colony, with its territory as witness to this through its material remains, the relationship with the symbolic values of Antiquity was experienced through a sort of claimed familiarity. This is strongly visible not only in British political rhetoric during the first half of the eighteenth century but also in national archaeological activities and architectural enterprises.

The Roman elite had come to act according to a social strategy which had essentially been formed during the sixteenth and seventeenth centuries, when the up-and-coming papal families established themselves in the city. The crisis that occurred in the following century regarding finances, lost family lines and waning political influence did not affect their social self-awareness. The strategies of displaying material prosperity such as art and antique collections, urban palaces, villas and a well-preserved archive were combined with carefully treasured genealogies, linking the family name to the Church or, in the best of cases, to a patrician dynasty of Republican Rome. These families had quickly engaged Antiquity in their own process of social affirmation. By doing so, they manifested themselves to each other and to external society and secured their position on the unstable hierarchical field of the Papal States. In contrast, a prosperous elite in Britain experienced a golden age of expansion in the eighteenth century. Financial growth and the beginning of colonisation increased consumption,

which resulted in an explosion of markets as well as major investments in leisure activities. The myth of ancient Rome, as noted, had played a fundamental part in political rhetoric since the beginning of the century, creating associations between the ideals of the Roman Republic and those of a modern aristocratic oligarchy. The nobility did not experience any great crisis or decline in the social arena, and their increasing educational travel culture was proof of their sense of social stability.

How are these socio-cultural and financial differences, seen in the light of the use of the myth of Antiquity, visible within portraiture? Before addressing this question, it is useful to state that the genre's use and status were not equal within European elite cultures, even if it occupied a similar position within art theory in both Italy and England. In the eighteenth century, portraiture represented one of the most commissioned genres within the expanding art market. This was, above all, visible in the central and northern parts of Europe. Britain, France, the German principalities, the Russian empire and the Scandinavian monarchies are all examples of areas in which portraiture played a crucial role in the social process of both new and old elites and the governing dynasties. In Rome, the situation was clearly different. The ideas of spreading the family image and of affirming the status quo were traditionally anchored in the visible manifestation of material culture. Through art collections, sumptuous palaces and complicated rituals and ceremonies the leading families declared an image of compact unity which can be defined as almost emblematic.

Portraiture played a less prominent position among elite commissioners in eighteenth-century Rome, both in the sense of aesthetic object and a social tool. According to the documents consulted in this study, it appears clear that portraiture was displayed in the public areas of the palace whenever it held the status of *self as art*, that is to say, when it was valued more for its aesthetic qualities than for the importance of the sitter. Portraits of the reigning pope and important ecclesiastical family members could be displayed separately in public interiors or within the rest of the art collection. It was more common, however, that portraits of family members hung in private apartments far away from the public eye. Consequently, the genre's status as a private concern also reinforces the fact that the Romans used traditional allegory and history painting as modes of legitimacy in the more public areas of the palace.

In Britain, the situation was clearly the reverse. Portraiture held an enormously important position. Even if history painting and allegory were partly used in royal and aristocratic environments, especially in the seventeenth century, portraiture remained the most exploited genre in terms of social tools.

One of the initial questions of this study involved a commentary made by Isa Belli Barsali concerning the presence of ancient objects within portraits of foreign travellers to Rome, and the lack of the very same in portraits of Romans. This remark recalls the first theme in this book, which is how the increasing

experience of exploitation of natural resources for archaeological pursuits and its consequences could be implicitly involved in portrait narratives. In order to expand the discussion on the visual results of this, travel texts were cited in order to stress the strong links between word and image within the particular discourse involving the Grand Tour culture. The Tour portraits show the sitters inserted into settings characterised by imaginative topographies and identifiable ancient items, well known to the readers of the travel books. The fundamental aspect of these settings is that the sitter contemplates or physically dominates the fragments of ancient material culture, creating a clear border between past and present. Through the presence of an easily identifiable object and the contemporary attitude of the sitter, Antiquity becomes a 'past'. In this sense, the portrait becomes a clear visualisation of the discrepancy between past and present, and fits the educational aims of the Tour discourse. Consequently, the 'museum' contexts of these images were hinted at through the body language and attitudes demonstrated at the different stages of a process of fulfilled reception. At the same time, most of the Tour portraits painted for male sitters rejected indoor contexts, which would have suited the museum theme better, in favour of more or less ideal landscapes in which the antiques appeared as misplaced objects. This detail is of great importance, since it actually brings to light that the Tour portraits were commodities for export and, as such, cleverly elaborated to fit different stages in the sitter's life, that is, life during and after the Grand Tour. Thus, the elegant landscapes were signifiers that indicated an elite life in the British countryside. The antiques can accordingly be read as possible purchases (as casts or copies) but their meticulously provided identification may also indicate that they were important parts within a general narrative that also included themes such as appropriation and reversed colonisation.

The lack of these kinds of setting within portraiture painted for the Roman elite may seem banal and complex at the same time. Since increasing financial difficulties forced most elite families to effectuate grand scale sales of their collections, it is hard to imagine them being eager to promote visually social signifiers which they were actually losing. At the same time, it is fully possible that the strikingly evident character of the Tour portrait setting, in terms of claiming clear connections between the sitter and the ancient past, was regarded as inappropriate for an elite that had consciously constructed their social identity through fictive genealogies linking them to ancient Republican patrician families. The portraits of Sigismondo Chigi and Camillo Borghese, discussed in this study, represented an apparent connection with the traditional Tour portrait setting, including signifiers such as known ancient objects and landscape settings. Nevertheless, the socio-economic factors related above make it possible to read these paintings in quite different terms to those from the circumstances of the British Tour, since the natural settings as well as the antiques present in the portraits actually indicated concrete ownership. However, this ownership of land

and material culture was precarious and not projected into the future, and the Tour portraits gain further interest as assemblages representing the increasing process of material exportation and museum formation that was to peak during the nineteenth century. This new development of European cultural politics is fully visible in the portrait of Lady Caroline Crichton and the Bishop of Derry, where the site and its displaced object represent how a desired (and financially possible) purchase is linked to a Roman elite property and collection in decline.

The themes of conquest, appropriation and ownership were thus discussed as important components within the social process of these two elite groups. In order to expand on this, a different type of portrait was introduced into the study, involving gender and its importance to the choice of portrait setting in the contexts considered. The portrait type at stake here is the so-called historical portrait, an image that did not focus on the sitter in the position of viewer/ owner of famous ancient objects, but instead was linked to associations with a mythical character or a historical person. This form of narrative constituted a parallel image of Antiquity to that which was delivered in the Tour portraits, since it focused more on this myth as a normative code, free from historical categorisation and chronological limits. If ancient myths could be associated with eighteenth-century social actors, the limit between past and present became weak, non-determinant and of less importance.

Traditionally, the eighteenth-century portrait, with the sitter appearing with reference to ancient mythology, literature or history, has been regarded as a result of the vogue for masquerade within the ruling classes of the *ancien régime*. Gender scholars in recent times have launched the view that eighteenth-century masquerade culture did not socially imply mere leisure. Dressing up in masquerade costume was allowed only during periods of carnival or during the event itself. The identity switch can thus be seen as conscious playing with gender and class distinctions, which were questioned or at least challenged in several ways through dress codes, manners and social customs in general. On the other hand, the stage actor's profession was hardly socially accepted, at least in certain parts of Europe. In Rome, comparisons between portraits of a noblewoman dressed as an ancient divinity and an actress in dramatic costume would not have been socially possible. If one considers the great frequency of portraits in disguise, portraits of actors (at least in Britain) and the ambivalent views on masquerade culture both in Italy and in Britain, it is clear that a simple reading of those paintings where the sitter is associated with a different role is not possible.

Portraits in disguise made for Roman elite sitters had little concrete connection with either theatre or masquerade. On the contrary, the portrait's narrative, exemplified through associative objects, dresses and gestures, constituted a *parole*, in Roland Barthes's sense of the word, which offered a precise reading possibility. Here it is useful to stress that associations to ancient references, such as divinities or historical persons, must be read in terms of gender distinctions and social

customs according to the very precise European context the portrait was produced for. If one regards the images from this perspective, it is possible to adapt different readings to apparently similar settings, and explore how the myth of Antiquity was used in different ways according to the various social problematics and issues.

The portraits in disguise analysed in this study exemplify this reading possibility. These examinations, conducted with a particular regard for celebratory texts composed in honour of elite female sitters, have focused on a broader reading of the actual myths in use. The Diana/Artemis setting which was frequently used for eighteenth-century Roman noblewomen has thus been connected to a larger problematic concerning low nativity within the Roman eighteenth-century elite. The ambivalent character of this particular ancient divinity, as it was conceived during Antiquity, allowed for associations to social status, chastity, protection of motherhood and independence. All of these characteristics were of concern within the female spheres of the Roman elite, as has been demonstrated through the examination of the portrait of Cornelia Costanza Barberini.

The social customs and their limits and possibilities determined which associations with Antiquity were most socially useful. The Cleopatra setting, which was prevalent at this time, is an intriguing example of Roman social mythology in this sense. The episode of her life story most frequently chosen for this setting involved her challenging her lover Mark Antony to conspicuous consumption by dissolving a precious pearl in a cup of wine. The combination of portrayed women manifesting pearls in different manners became popular, and was directly connected to this particular Cleopatra narrative. The setting's popularity could be linked to the Roman use of an institutionalised courtier for the married woman, a social custom that was more a rule than an exception. Cleopatra's double role as a consort and a lover therefore suited this particular social phenomenon.

The discussion of gender distinction within the Tour portraits has been carried out in this study through a diverse reading of the ancient objects included in the paintings. Main themes discussed have involved the question of moral and educational guidance while on Tour, as well as desired (and non-desired) sexual experiences and the established prospect of returning home to a proper marriage. The historical portrait as such was not addressed to the travellers, who apparently wished to keep a clear border between the mythical past and present in their particular portrait type, which was to commemorate a specific phase in the sitter's life. The so-called Van Dyck costume represented an exception to this rule. However, its strong British connotation rather helped to reinforce the sitter's foreignness within the ambiguous setting of the Tour portrait, and was clearly aimed at a presentation of life during and after travel.

One of the main aims of the study was to reveal the multifaceted reading possibilities of apparently similar portraits when taking seriously into consideration their contexts of genesis and consumption. Consequently, the view that

eighteenth-century elite portraiture might be examined according to a homogeneous idea of Antiquity's social potential has been determinedly challenged. Nevertheless, this entire concept has been ultimately examined through an existing, separate discourse that came to regulate artistic commissions and productions in eighteenth-century Rome, namely that of the self-promoting Accademia dell'Arcadia. The rapid institutionalisation of this academy during the first decades of the eighteenth century created an essential forum for the promotion, control and elaboration of a classical ideal that was expressed literally and visually. Through a close examination of Arcadian texts, it has been possible not only to indicate the close connection between word and image within the academy's own mythology but above all to single out its importance as a keeper of the social values of the *ancien régime*. In this sense, the Arcadia quickly came to involve, within its own narrative and in a vivid, concrete social scene, representatives from different social strata, all engaged in upholding the structures of social hierarchy through pastoral games. Portraiture of Roman sitters which depended on the Arcadian discourse exemplified this elaborated manifestation of social rank through the protection and production of art. The portrait of the duchess/poetess Giacinta Orsini constitutes a landmark example, since it fully exploits the precarious link between art, rank and socially accepted aesthetics which was the main ambition of the Arcadian academy's promoters. The cautious classicist idiom that the academy promoted was, moreover, juxtaposed with those cultural activities that were encouraged as a part of the Arcadian discourse. The texts were full of allusions to shepherds and shepherdesses in the acts of hunting and dancing as well as collecting and displaying. In this sense, the Arcadian mythology directly involved the cultural education and politics of the European elites, in which the appropriation of both material and immaterial values of knowledge and culture were essential to their own self-image and right to rule. The portrait of Margherita Sparapani Boccapaduli conforms to this social strategy through its meticulously detailed 'showroom', where the Marquise literally placed her knowledge on display through her own collections.

Despite the considerable scholarship on the Grand Tour during the last twenty years, there has been no attempt to situate its portraiture as correlated to the Arcadian discourse as it had developed in Rome. This is surely because there are only a small number of paintings that might be discussed as Arcadian pictures. Among these is the Featherstonhaugh portrait series at Uppark in West Sussex, which clearly experiments with Arcadian themes for the travellers' purpose. Those paintings which show the family members in vague pastoral costumes, inserted into a rocky hilled landscape, referenced an abstract view of elite life rather than the experience of actual travel. The natural settings of these portraits were thus more connected to the prospect of returning home and the vogue for an idealised country life. In fact, the country house context occupied a particular place in British elite ideology which was strictly linked to the concept

of owning land and family continuity. The country house context was, furthermore, a place where the idea of Antiquity could be exploited and used within new architectural and garden settings. Arcadian themes were incorporated into the concept of a leisurely life in the countryside. At the same time, a country seat was a strong social signifier which established the social position of the owner. The myth of Antiquity, with its implicit idea of continuity, could therefore also serve newly established elites who were wealthy enough to buy an estate, and who were eager to construct a proper genealogy of their family, such as the Featherstonhaughs'.

The traditional Grand Tour portrait, with its imaginative topographies and narratives from the very centre of the ancient world, the city of Rome, paralleled rather than referenced the physical environment of the country house. The transitional character of these paintings, in terms of changes within the social role of the sitters, is reflected in the imaginative settings in which they are inserted. Their fanciful landscape settings and the haphazard manner of placing sculptures and landmarks together evoke the patterns of the elite environment in England rather than the topography of Rome. In this sense, the Tour portrait was clearly made in order to fit a context where the use of the myth of Antiquity was constantly activated: the country house milieu. However appealing a strict Arcadian theme, as expressed in some of the Roman portraits examined here, must have been for those tourists who became members and *pastori*, it could not fully give the intricate levelling of reading offered by a Tour portrait of Batonian proportion. The Arcadian theme, as expressed among the academicians in Rome, demanded an altogether full acceptance of the social powers of the homogeneous pastoral. In visual terms, the Arcadian narrative protected and promoted the elites' interests and established social status within a society that was inevitably changing. While the Tour portrait of classic proportions represents an important contemporary statement of a particularly strong elite's particular needs at a particular time, the Arcadian settings, specific to the Romans, evoked a social grandeur in crisis.

Bibliography

Primary sources

Biblioteca Apostolica Vaticana, Rome (BAV)

Archivio Barberini

Indice II, manoscritto 1897. *Capitoli matrimoniali fra D na M a Felice Barberini e D. Bartolomeo Corsini.*
Indice II, manoscritto 2731. *Inventario generale: di tutti i quadri esistenti nel Palazzo Barberini nell'anno 1845 con indicazione del patrimonio ed a cui appartengono.*

Archivio Barberini Colonna di Sciarra

Tomo 344, fascicolo 17. *1812 Descrizione e Perizia di tutti i Quadri spettanti al maggiorasco Barberini redatta dagli Esimj Pittori Gaspare Landi e Vincenzo Camuccini. Classificazione dei Quadri esistenti nel Palazzo Barberini* (sic!) *alle quattro Fontane appartenenti al Maggiorasco Barberini.*
Tomo 137, fascicolo 6. Letter from Maria Artemisia Barberini Colonna di Sciarra to her father Giulio Cesare Colonna di Sciarra, 27 January 1752.
Tomo 137, fascicolo 5. Letters from Cornelia Costanza Barberini Colonna di Sciarra to her son Urbano Barberini Colonna di Sciarra.

Archivio Doria Pamphilj, Rome

Scaffale 93, busta 69, intemo 8. *Memorie della Casa 1776–90: Succinto ragguaglio della funzione del Battesimo di Vittoria Doria Pamphilj.*

Biblioteca Angelica, Rome (BA)

Archivio dell'Arcadia

Manoscritto 37, folio 244 r. *A sua Eccellenza La Sig.ra Principessa Donna Cornelia Barberini.*
Manoscritto 37, folio 333 r. *A Sua Eccellenza La Signora D. Giacinta Orsini Nata Duchessa di Gravina.*

Manoscritto 37, folio 357 r. *A Sua Eccellenza La Signora D. Giacinta Orsini fra gli Arcadi Euridice del Signor D. Francesco Ruspoli.*
Manoscritto 37, folio 159 r. *In morte di Donna Giacinta Orsini.*
Manoscritto 37, folio 329 v. *Alla Signora Marchesa Caterina Gabrielli rappresentante nel Ballo della Tragedia Galatea addolorata per la morte di Aci*
Manoscritto 37, folio 347 v. *Alle glorie del Signore Abbate Gioacchino Pizzi per il Celebre Sonetto fatto in lode alla Nobil donna Marchesa Gabrielli, rappresentante la parte di Galatea, nel ballo fatto nella famosa Tragedia della Zaira rappresentata nella Villa di Mondragone in Frascati.*

Archivio di Stato di Roma, Rome

Conventi femminili soppressi

Santa Caterina da Siena a Magnanapoli. Busta 4637, giustificazioni 1750–52.

The Paul Mellon Centre for Studies in British Art, London

Brinsley Ford Papers

Box file 88 'Arcadian Society', excerpt from letter of Daniel Crespin to James Grant, dated in Rome, 11 March 1763.
Box file 88 'Arcadian Society', excerpt from Sir William Forbe's Journal, vol. 5, 1 April 1793.

Secondary sources

Adunanze degli Arcadi *pubblicate nelle nozze di sua Eccellenza la signora D. Giacinta Orsini dé Duchi di Gravina Con Sua Eccellenza il Signor Don Antonio Boncompagno Ludovisi Duca d'Arce dé Princ di Piombino All'Emo, e Rmo Principe il Signor Cardinale Domenico Orsini* (Roma: 1757).
Ago, R., 'Giochi di squadra: Uomini e donne nelle famiglie nobili del XVII secolo', in M.A. Visceglia (ed.), *Signori, patrizi e cavalieri nell'età moderna* (Bari: 1992).
Agosti, G., 'Adolfo Venturi e le gallerie fidecommissarie romane (1891–1893), *Roma moderna e contemporanea*, 1:3 (1993).
Ameyden, T., *Storia delle grandi famiglie romane*, C.A. Bertini (ed.) (Roma: 1915).
Austen, J., *Pride and prejudice*, James Kinsley (ed.) (Oxford: 1990).
Ayres, P., *Classical culture and the idea of Rome in eighteenth-century England* (Cambridge: 1997).
Barbagli, M., *Sotto lo stesso tetto: Mutamenti della famiglia in Italia dal XV al XX secolo* (Bologna: 1984).
Barroero, L., *Benefial* (Milano: 2005).
Barroero, L. and Susinno, S., 'Roma arcadica: Capitale universale delle arti del disegno', *Studi di Storia dell'Arte*, 10 (1999).
Barthes, R., *Mythologies* (London: 1993).

Beckford, P., *Familiar letters from Italy, to a friend in England* (2 vols, Salisbury 1805), vol. 2.
Belli Barsali, I., 'Il Batoni ritrattista', in I. Belli Barsali (ed.), *Mostra di Pompeo Batoni* (Lucca: 1967).
Bellori, G.P., *Le vite dé pittori, scultori e architetti moderni*, E. Borea (ed.) (Torino: 1976).
Benedetti, S., *The Milltowns: A family reunion* (Dublin: 1997).
Benedetti, S., 'Un ritratto inedito di Pompeo Batoni ed alcune notizie sulla sua committenza', in M.G. Bernardini, S. Danesi Squarzina and C. Strinati (eds), *Studi di Storia dell'Arte in onore di Denis Mahon* (Roma: 2000).
Benes, M., 'Landowning and the villa in the social geography of the Roman territory', in A. von Hoffman (ed.), *Form, modernism and history* (Cambridge, Mass.: 1996).
Benes, M., 'Pastoralism in the Roman baroque villa and in Claude Lorrain: Myths and realities of the Roman Campagna', in M. Benes and D. Harris (eds), *Villas and gardens in early modern Italy and France* (Cambridge: 2001).
Benocci, C., 'L'inventario del 1808 del Palazzo Poli a Fontana di Trevi ed un ritratto di Pompeo Batoni', *Strenna dei Romanisti*, 63 (2002).
Benocci, C. and di Carpegna Falconieri, T., *Le Belle: Ritratti di dame del Seicento e del Settecento nelle residenze feudali del Lazio* (Roma: 2004).
Bignamini, I. and Jenkins, I., 'The Antique', in A. Wilton and I. Bignamini (eds), *The Grand Tour: The lure of Italy in the eighteenth century* (London: 1996).
Binni, W., *L'Arcadia e il Metastasio* (Firenze: 1963).
Black, J., *The British abroad: The Grand Tour in the eighteenth century* (New York: 1992).
Black, J. and Gregory, J. (eds), *Culture, politics and society in Britain, 1660–1800* (Manchester and New York: 1991).
Bodart, D.H., 'I ritratti dei re nelle collezioni nobiliari romane del Seicento', in M.A. Visceglia (ed.), *La nobiltà romana in età moderna: Profili istituzionali e pratiche sociali* (Roma: 2001).
Boëls-Janssen, N., *La vie religieuse des matrons dans la Rome archaïque* (Rome: 1993).
Bolton, A., 'Mersham Hatch, Kent', *Country Life*, 64, 26 March 1921.
Borsellino, E., *Palazzo Corsini* (Roma: 1995).
Borsellino, E., *Musei e collezioni a Roma nel XVIII secolo* (Roma: 1995).
Borsellino, E. and Casale, V. (eds), *Roma: 'Il tempio del vero gusto'* (Firenze: 2001).
Boswell, J., *Boswell on the Grand Tour: Italy, Corsica and France 1765–1766*, F. Brady and F.A. Pottle (eds) (Melbourne, London and Toronto: 1955).
Boutry, P., 'Nobiltà romana e curia nell'età della restaurazione: Riflessione su un processo di arretramento', in M.A. Visceglia (ed.), *Signori, patrizi, cavalieri nell'età moderna* (Bari: 1992).
Bowron, E.P. (ed.), *Pompeo Batoni and his British patrons* (London: 1982).
Brewer, J., *The pleasures of the imagination: English culture in the eighteenth century* (London: 1997).
Brilliant, R., *Portraiture* (London: 1991).
Brunetti, F.S., *Compendio sferico, mitologico, istorico, geografico e poetico alla Nobilissima Pastorella Euridice Ajacense da Melanzio Trifiliano pastore arcade* (Roma: 1755).
Burke, P., 'The demise of royal mythologies', in A. Ellenius (ed.), *Iconography, propaganda and legitimation* (Oxford: 1998).

Caffiero, M., 'Tradizione o innovazione? Ideologie e comportamenti della nobiltà romana in tempo di crisi', in M.A. Visceglia (ed.), *Signori, patrizi, cavalieri nell'età moderna* (Bari: 1992).

Caffiero, M., 'Istituzioni, forme e usi del sacro', in G. Ciucci (ed.), *Roma moderna* (Rome and Bari: 2002).

Cairo, L., 'Luoghi scenici nella Roma del Settecento', in G. Petrocchi (ed.), *Orfeo in Arcadia: Studi sul teatro a Roma nel Settecento* (Roma: 1984).

Calcaterra, C., *Il barocco in Arcadia e altri scritti sul Settecento* (Bologna: 1950).

Campitelli, A., 'Il tempio di Eusculapio', in A. Campitelli (ed.), *Il Giardino del lago a Villa Borghese: Sculture romane dal classico al neoclassico* (Roma: 1993).

Campitelli, A., *Villa Borghese: Da giardino del principe a parco dei romani* (Roma: 2003).

Campitelli, A. (ed.), *Villa Borghese: I principi, le arti, la città dal Settecento all'Ottocento* (Milano: 2003).

Cappelletti, F., 'La Galleria Doria Pamphilj: Introduzione alla storia del palazzo e della raccolta', *Nuova Guida alla Galleria Doria Pamphilj* (Roma: 1996).

Caracciolo, M.T., 'Un patrono delle arti nella Roma del settecento: Sigismondo Chigi fra Arcadia e scienza antiquaria', in E. Borsellino and V. Casale (eds), *Roma: 'Il tempio del vero gusto'* (Firenze: 2001).

Carini, I., *L'Arcadia dal 1690 al 1890: Memorie storiche* (Roma: 1891).

Carpanetto, D. and Ricuperati, G., *L'Italia del Settecento: Crisi, trasformazioni, lumi* (Rome and Bari: 1998).

Castiglione, C., 'Extravagant pretensions: aristocratic family conflicts, emotion, and the "public sphere" in early eighteenth-century Rome', *Journal of Social History*, 38:3 (Spring 2005).

Castiglione, C., *Patrons and adversaries: Nobles and villagers in Italian politics, 1640–1760* (Oxford: 2005).

Castle, T., *Masquerade and civilisation: The carnivalesque in eighteenth-century English culture and fiction* (Stanford: 1986).

Chard, Chloe, *Pleasure and guilt on the Grand Tour: Travel writing and imaginative geography 1600–1830* (Manchester: 1999).

Cherry, D. and Harris, J., 'Eighteenth-century portraiture and the seventeenth-century past: Gainsborough and Van Dyck', *Art History*, 5:3 (1982).

Clark, A.M., 'The development of the collections and museums of 18th century Rome', *Art Journal*, 26 (1967).

Clark, A.M., *Studies in Roman eighteenth-century painting*, E.P. Bowron (ed.) (Washington: 1981).

Clark, A.M., *Pompeo Batoni: A complete catalogue of his works with an introductory text*, E.P. Bowron (ed.) (Oxford: 1985).

Cohen, M., *Fashioning masculinity: National identity and language in the eighteenth century* (London and New York: 1996).

Coltman, V., *Fabricating the Antique: Neoclassicism in Britain, 1760–1800* (Chicago: 2006).

Colucci, I., 'Antonio Canova, la Marchesa Margherita Boccapaduli e Alessandro Verri: Lettere ed altre testimonianze inedite', *Paragone*, 64 (1998).

Componimenti poetici per le felicissime nozze di Sua Eccelenza il Signor Principe D. Bartolomeo Corsini con S. E. la signora D. Felice Barberini (Roma: 1758).

Colucci, I., 'Il salotto e le collezioni della Marchesa Boccapaduli', *Quaderni Storici*, 2 (2004).
Costeker, J.L., *The Fine Gentleman: or, the Compleat Education of a Young Nobleman* (London: 1732).
Cottino, A. (ed.), *La donna nella pittura italiana del Sei e Settecento: Il genio e la grazia* (Torino: 2003).
Craske, M., *Art in Europe 1700–1830* (Oxford: 1997).
Crescimbeni, G.M., *L'Arcadia del Can. Gio. Mario Crescimbeni Custode della medesima Arcadia, e Accademico Fiorentino. A Madama Ondedei Albani cognata di N.S. Papa Clemente XI*, Stamperia Antonio dé Rossi (Roma: 1708).
Crescimbeni, G.M., *Disinganno di chiunque si fosse lasciato persuadere dalla lettera anonima intitolata Della division d'Arcadia* (Napoli: 1711).
Crescimbeni, G.M., *Notizie istoriche degli Arcadi morti* (3 vols, Roma: 1720), vol. 2.
Crow, T., *Painting and public life in eighteenth-century Paris* (New Haven and London: 1985).
Crow, T., *Emulation: Making artists for revolutionary France* (New Haven and London: 1995).
Cullen, F., 'Hugh Douglas Hamilton in Rome 1772–92', *Apollo*, 115 (Feb. 1984).
Delille, G., *Les noblesses européennes au XIXe siècle*, Actes du colloques de l'École française de Rome (Rome: 1988).
Devoti, F., *Il teatro d'Imeneo aperto nell'inclite nozze degli eccellentissimi Principi il Signor D. Bartolommeo Corsini e la Signora D. Felice Barberini* (Roma: 1758).
Dewald, J., *The European nobility 1400–1800* (Cambridge: 1996).
Dictionary of British and Irish travellers in Italy, compiled from the Brinsley Ford Papers by John Ingamells (New Haven and London: 1997).
Documenta 11 (Kassel: 2002).
Dolan, B., *Exploring European frontiers: British travellers in the age of enlightenment*, (Basingstoke: 2000).
Dolan, B., *Ladies on the Grand Tour: British women in pursuit of enlightenment and adventure in eighteenth-century Europe* (New York: 2001).
Donato, M.P., *Accademie romane: Una storia sociale* (Roma: 2000).
Ehrlich, T.L., *Landscape and identity in early modern Rome: Villa culture at Frascati in the Borghese era* (Cambridge: 2002).
Engell, J., 'The modern revival of myth: Its eighteenth-century origins', in M.W. Bloomfield (ed.), *Allegory, myth and symbol* (Cambridge, Mass. and London: 1981).
Falcidia, G., 'Per un ritratto di Marco Benefial', *Bollettino dei Musei Comunali di Roma*, 11:1–4 (1964).
Fletcher, A., *Gender, sex and subordination in England 1500–1800* (New Haven and London: 1995).
Foss, M. (ed.), *On Tour: The British traveller in Europe* (London: 1989).
Fumagalli, E., *Palazzo Borghese: Committenza e decorazione privata* (Roma: 1994).
Di Gaddo, B., *Villa Borghese: Il giardino e le architetture* (Roma: 1985).
Giardina, A. and Vauchez, A., *Il mito di Roma da Carlo Magno a Mussolini* (Roma: 2000).
Girouard, M., *Life in the English country house: A social and architectural history* (New Haven and London, 1978).

Giuliano, A. (ed.), *La collezione Boncompagni Ludovisi: Algardi, Bernini e la fortuna dell'antico* (Venezia: 1992).

I Giuochi Olimpici celebrati in Arcadia nell'Ingresso dell'Olimpiade DCXXXIII. In onore degli Arcadi illustri defunti (Roma: 1754).

Goodman, E., *The portraits of Madame de Pompadour: Celebrating the femme savante* (Berkeley, Los Angeles and London: 2000).

Grandesso, S., 'La vicenda esemplare di un pittore "neoclassico": Gaspare Landi, Canova e l'ambiente erudito romano', *Roma moderna e contemporanea*, 10:1 (2002).

Grantaliano, E., 'Donne di spettacolo nello Stato della Chiesa', *Rivista storica del Lazio*, 8–9:13–14 (Roma: 2000/1).

Grassi, L., *Teorici e storia della critica d'arte* (Roma: 1979).

Graves, R., *The Greek myths* (London: 1992).

Graziosi, E., 'Arcadia femminile: Presenze e modelli', *Arcadia. Accademia letteraria italiana. Atti e memorie*, 9 (1994).

Gross, H., *Roma nel Settecento* (Bari: 1990).

Guilding, A., 'The classical sculpture gallery in the 18th century country house', MA report, University of London: Courtauld Institute of Art (1994).

Hamer, M., 'The myth of Cleopatra since the Renaissance', in S. Walker and P. Higgs (eds), *Cleopatra of Egypt: From history to myth* (London: 2001).

Haskell, F., *Patrons and painters: A study in the relations between Italian art and society in the age of the Baroque* (New Haven and London: 1980).

Haskell F. and Penny, N., *Taste and the antique: The lure of classical sculpture 1500–1900* (New Haven and London: 1981).

Hays, M., *Female Biography; or Memoirs of Illustrious and Celebrated Women of all ages and countries* (3 vols, London: 1803), vol. 3.

Honour, Hugh, 'The great sham disproved', *Apollo*, 78 (Dec. 1963).

Hook, J.A., 'Urban VIII: The paradox of a spiritual monarchy', in A.G. Dickens (ed.), *The courts of Europe: Politics, patronage and royalty 1400–1800* (London: 1977).

Hornsby, C., 'Introduction, or why travel?', in C. Hornsby (ed.), *The impact of Italy: The Grand Tour and beyond* (London: 2000).

Hyde Minor, V., *The death of the Baroque and the rhetoric of Good Taste* (Cambridge: 2006).

Impelluso, L., *Nature and its symbols* (Los Angeles: 2004).

Jocteau, G.C., *Nobili e nobiltà nell'Italia unita* (Roma-Bari: 1997).

Johns, C.M.S., *Papal art and cultural politics: Rome in the age of Clement XI* (Cambridge and New York: 1993).

Johns, C.M.S., 'The entrepôt of Europe: Rome in the eighteenth century', in E.P. Bowron and J.J. Rishel (eds), *Art in Rome in the eighteenth eentury* (Philadelphia and London: 2000).

Johns, C.M.S., 'Portraiture and the making of cultural identity: Pompeo Batoni's *Honourable Colonel William Gordon (1765–66)* in Italy and North Britain', *Art History*, 27:3 (2004).

Jones, T., 'Memoirs of Thomas Jones', *Walpole Society*, 32 (1946–48).

Jones, V., ' "The Tyranny of Passions": Feminism and heterosexuality in the fiction of Wollstonecraft and Hays', in S. Ledger, J. McDonagh and J. Spencer (eds), *Political gender: Texts and contexts* (London: 1994).

Kenny, V., *The country house ethos in English literature 1688–1750: Themes of personal retreat and national expansion* (Brighton: 1984).
Lady Knight's letters from France and Italy 1776–1795, Lady Eliott-Drake (ed.) (London: 1905).
Laing, A., *In trust for the nation: Paintings from National Trust houses* (London: 1995).
La Marca, N., *La nobiltà romana e i suoi strumenti di perpetuazione del potere* (3 vols, Roma: 2000), vol. 1.
de la Lande, J.J., *Voyage d'un françois en Italie faits dans les années 1765 & 1766* (Jverdon: 1769–70).
Langdon, H., 'The imaginative geographies of Claude Lorrain', in C. Chard and H. Langdon (eds), *Transports: Travel, pleasure and imaginative geography 1600–1830* (New Haven and London: 1996).
Lanzi, L., *Storia pittorica della Italia dal Risorgimento delle belle arti fin presso al fine del XVIII secolo*, M. Capucci (ed.) (Florence: 1968).
Lewis, L., 'Philipp von Stosch', *Apollo*, 63 (1967).
Littlewood, I., *Sultry climates: Travel and sex since the Grand Tour* (London: 2001).
Lo Bianco, A., 'L'Arcadia in pittura', *Coro Polifonico Romano 'Gastone Tosato': Stagione 1991–92* (Roma: 1992).
Lo Bianco, A. and Negro, A. (eds), *Il Settecento a Roma* (Roma: 2005).
Mangia, P., *Il ciclo dipinto delle volte: Galleria Borghese* (Roma: 2001).
Mazzocca, F., Colle, E., Morandotti, A. and Susinno, S. (eds), *Il neoclassicismo in Italia da Tiepolo a Canova* (Milano: 2002).
McKendrick, N., Brewer, J. and Plumb, J.H., *The birth of a consumer society: The commercialization of eighteenth-century England* (London: 1983).
Michel, O., 'Giovanni Domenico Porta', *Mélanges d'archéologie et d'histoire: École française de Rome* (1968).
Mikocki, T., *Sub speciae deae: Les impératrices et princesse romaines assimilées à des déesses. Étude iconologique* (Roma: 1995).
Mitchell, W.J.T., 'Imperial landscape', in W.J.T. Mitchell (ed.), *Landscape and power* (Chicago and London: 1994).
Moore, J., *A View of Society and Manners in Italy with anecdotes relating to some eminent characters* (2 vols, London: 1791).
Natoli, M. and Petrucci, F. (eds), *Donne di Roma dall'Impero Romano al 1860* (Roma: 2003).
Negro, A., *I Rospigliosi* (Roma: 1999).
Nel Funerale per l'Illustrissima, ed Eccellentissima Signora D. Paola Odescalco Duchessa di Gravina. Orazione detta in napoli nella insigne basilica di S. Filippo Neri il dí XVII settembre MDCCXXXXII. Dal padre Giambattista Botti della Compagnia di Gesù (Napoli: 1742).
Nicholson, K., 'The ideology of feminine "virtue": The vestal virgin in French eighteenth-century allegorical portraiture', in J. Woodall (ed.), *Portraiture: Facing the subject* (Manchester and New York: 1997).
Norlander Eliasson, S., '"Roslin Svezzese": Alexander Roslin in Italy', in M. Olausson (ed.) *Alexander Roslin* (Stockholm: 2007).
Norlander Eliasson, S., 'A faceless society? Portraiture and the politics of display in eighteenth-century Rome', in D. Cherry and F. Cullen (eds), *Spectacle and display*, Art History Special issues (Oxford, UK and Boston, USA: 2008).

d'Oench, E., *The Conversation Piece: Arthur Devis and his contemporaries* (New Haven and London: 1980).
Ovid, *Metamorfosi*, P.B. Marzolla (ed.) (Turin: 1979).
Pacchioni, G., 'Il Lanzi e le "scuole pittoriche"', *Scritti di Storia dell'Arte in onore di Lionello Venturi* (Rome: 1956).
Pagano, S., 'Archivi di famiglie romane e non romane nell'Archivio Segreto Vaticano', *Roma moderna e contemporanea*, 1:3 (1993).
Pancera, C., 'Figlie del Settecento', in S. Ulivieri (ed.), *Le bambine nella storia dell'educazione* (Rome and Bari: 1999).
Parini, G., *Il Giorno (1763–65)*, G. Ficara (ed.) (Milano: 1986).
Pasquali, S., 'Roma antica: Memorie, materiali, storia e mito', in G. Ciucci (ed.), *Roma moderna* (Rome and Bari 2002).
Peakman, J., *Lascivious bodies: A sexual history of the eighteenth century* (London: 2004).
Pericoli, C., 'La Pinacoteca dell'Accademia dell'Arcadia', *Capitolium*, 6 (1960).
Perry, G., 'Women in disguise: Likeness, the grand style and the conventions of feminine portraiture in the work of Sir Joshua Reynolds', in G. Perry and M. Rossington (eds), *Femininity and masculinity in eighteenth-century art and culture* (Manchester and New York: 1994).
Piccialuti, M., 'Patriziato romano e cariche di Campidoglio nel Settecento', *Roma moderna e contemporanea*, 4:2 (1996).
Piccialuti, M., *L'immortalità dei beni: Fedecommessi e primogeniture a Roma nei secoli XVII e XVIII* (Roma: 1999).
Pieretti, M., 'Margherita Sparapani Gentili Boccapaduli, ritratto di una gentildonna romana (1735–1820)', *Rivista storica del Lazio*, 8–9:13–14 (2000–1).
Pietrangeli, C., *Palazzo Sciarra* (Roma: 1987).
Pirzio Biroli Stefanelli, L., 'Note in margine alla "Descrizione Istorica del Museo di Cristiano Dehn" di Francesco Maria Dolce', in E. Debenedetti (ed.), *Collezionismo e ideologia: Mecenati, artisti e teorici del classic al neoclassico. Studi sul Settecento Romano*, 7 (Roma: 1991).
Plutarch, *Life of Anthony*, C.B.R. Pelling (ed.) (Oxford: 1988).
Pointon, M., *Hanging the head: Portraiture and social formation in eighteenth-century England* (New Haven and London: 1993).
Pointon, M., *Strategies for showing: Women, possession and representation in English visual culture* (Oxford: 1997).
Polleroβ, F., 'From the *exemplum virtutis* to the apotheosis: Hercules as an identification figure in portraiture. An example of the adoption of classical forms of representation', in A. Ellenius (ed.), *Iconography, propaganda and legitimation* (Oxford: 1998).
Postle, M., 'Painted women: Reynolds and the cult of the courtesan', in R. Asleson (ed.), *Notorious Muse: The actress in British art and culture, 1776–1812* (New Haven and London: 2003).
Postle, M., 'Painted women', in M. Postle (ed.), *Joshua Reynolds: The creation of celebrity* (London: 2003).
Potts, A., *Flesh and the ideal: Winckelmann and the origins of art history* (New Haven and London: 1994).
Predieri, D., *Bosco Parrasio: Un giardino per l'Arcadia* (Modena: 1990).

Quondam, A., 'Gioco e società letteraria nell'*Arcadia* del Crescimbeni: L'ideologia dell'istituzione', *Arcadia. Accademia letteraria italiana. Atti e memorie*, 6 (1975–76).

Ragguaglio o sia giornale della venuta in Roma di Sua Altezza Reale Sofia Albertina Principessa di Svezia Abbadessa di Quedlimburgo sotto nome di Contessa di Wasa (Roma: 1793).

Redford, B., *Venice and the grand tour* (New Haven and London: 1996).

Rees, J., *Sir Philip Sidney and Arcadia* (Madison, N.J.: 1991).

Retford, K., *The art of domestic life: Family portraiture in eighteenth-century England* (New Haven and London: 2006).

Reynolds, Sir J., *Discourses on art*, R.R. Wark (ed.) (New Haven and London: 1988).

Ribeiro, A., 'Batoni's use of costume', in E.P. Bowron (ed.), *Pompeo Batoni and his British patrons* (London: 1982).

Ribeiro, A., *The art of dress: Fashion in England and France 1750–1820* (New Haven and London: 1995).

Rime degli Arcadi (14 vols, Roma: 1716–81), vol. 12.

Rosenthal, M. and Myrone, M. (eds), *Gainsborough* (London: 2002).

Rubsamen, G., *The Orsini inventories* (Malibu: 1980).

Rudolph, S., 'Una visita all campanna del pastore Disfilo, "primo dipintore d'Arcadia" (Carlo Maratti)', *Atti del Convegno di Studi per il III Centenario dell'Accademia dell'Arcadia* (Roma: 1991).

Rudolph, S., *Niccolò Maria Pallavicini: L'ascesa al tempio della virtù attraverso il mecenatismo* (Roma: 1995).

Rudolph, Stella, 'Le committenze romane di Domenico Corvi', in A. Lo Bianco and W. Curzi (eds), *Domenico Corvi* (Roma: 1999).

Russell, F., *The hanging and display of pictures 1700–1850* (Washington: 1985).

Safarik, E.A., *Collezione dei dipinti Colonna: Inventari 1611–1795* (New Providence, N.J., London and Paris: 1996).

Sánchez-Jáuregui, M.D., 'Two portraits of Francis Bassett by Pompeo Batoni', *Burlington Magazine*, 68:1,180 (2001).

Il Seicento ed il Settecento romano della Collezione Lemme (Roma: 1998).

Seznec, J. and Andhémar, J., *Diderot: Salons* (4 vols, Oxford: 1957–67), vol. 1.

Shawe-Taylor, D., *The Georgians: Eighteenth-century portraiture and society* (London: 1990).

Sidney, Sir P., *The Countess of Pembroke's Arcadia*, V. Skretkowicz (ed.) (Oxford: 1987).

Silvagni, D., *La corte e la società romana nei secoli XVIII e XIX* (Roma: 1884).

Silvestrini, M.T., 'Le donne nell'Italia moderna: Rappresentazioni, appartenenze, identità', in A. Cottino (ed.), *La donna nella pittura italiana del Sei e Settecento: Il genio e la grazia* (Torino: 2003).

Smiles, S., *The image of antiquity: Ancient Britain and the romantic imagination* (New Haven and London: 1994).

Smollett, T., *Travels through France and Italy*, F. Felsenstein (ed.) (Oxford, 1979).

Solkin, D., *Painting for money: The visual arts and the public sphere in eighteenth-century England* (New Haven and London: 1993).

Solomon-Godeau, A., *Male trouble: A crisis in representation* (London: 1997).

Speroni, F., 'Il gabinetto nobile: Un manifesto estetico in Palazzo Altieri', in E. Debenedetti (ed.), *Temi di decorazione: Dalla cultura dell'artificio alla poetica della natura. Studi sul Settecento Romano*, 6 (Roma: 1990).
Spicer, J., *A cultural history of gesture* (Cambridge: 1991).
Tarzia, F., *Libri e rivoluzioni: Figure e mentalità nella Roma di fine Ancien Régime (1770–1800)* (Milano: 2000).
Tillyard, S., 'Paths of glory: Fame and the public in eighteenth-century London', in M. Postle (ed.), *Joshua Reynolds: The creation of celebrity* (London: 2005).
Travaglini, C.M., 'Economia e finanza', in G. Ciucci (ed.), *Roma moderna* (Rome and Bari: 2002).
Uppark, The National Trust (London: 1995).
Umbach, M., 'Classicism, enlightenment and the "other": thoughts on decoding eighteenth-century visual culture', *Art History*, 25:3 (2002).
Valesio, F., *Diario di Roma*, G. Scano (ed.) (6 vols, Milano: 1977–79), vol. 5.
Valmaggi, L., *I cicisbei: Contributo alla storia del costume italiano nel secolo XVIII* (Torino: 1927).
Vickery, A., *The gentleman's daughter: Women's lives in Georgian England* (New Haven and London: 1998).
Visceglia, M.A., 'Introduzione', in M.A. Visceglia (ed.), *La nobiltà romana in età moderna: Profili istituzionali e pratiche sociali* (Roma: 2001).
Visceglia, M.A., *La città rituale: Roma e le sue cerimonie in età moderna* (Roma: 2002).
Visceglia, M.A., 'Figure e luoghi della corte romana', in G. Ciucci (ed.), *Roma moderna* (Rome and Bari: 2002).
Walker, S. and Higgs, P. (eds), *Cleopatra of Egypt: From history to myth* (London: 2001).
Warnke, M., 'Das Reiterbild des Baltasar Carlos von Velázquez', in K. Badt and M. Gosebruch (eds), *Amici amico: Festschrift für Werner Gross zu seinem 65. Geburtsag am 15.11.1966* (Munich: 1968).
West, S., 'Patronage and power: The role of the portrait in eighteenth-century England', in J. Black and J. Gregory (eds), *Culture, politics and society in Britain, 1600–1800* (Manchester and New York: 1991).
Wilton, A. and Bignamini, I. (eds), *Grand Tour: The lure of Italy in the eighteenth century* (London: 1996).
Zanella, A., 'Francesco Trevisani e il Teatro Arcadico', in E. Debenedetti (ed.), *Carlo Marchionni: Architettura, decorazione e scenografia contemporanea. Studi sul Settecento Romano*, 4 (Roma: 1988).
Zanker, P., *The power of images in the age of Augustus* (Michigan: 1990).
Zazoff, P., *Die antiken Gemmen* (Munich: 1983).
Zeri, F., *Italian paintings in the Walters Art Gallery* (2 vols, Baltimore: 1976), vol. 2.

Index

Accademia di San Luca 108
Accademia reale 107
Adam, Robert 47
Aeneas 51, 63, 72, 87
Aeneid 63, 72
Aeusculapius 49, 50–1
Åkerström, Jonas 117
Altieri, Marco Antonio 30
Ameyden, Theodor 29
Antiquity 1–3, 5, 7, 19, 21, 30–1, 33, 36, 52, 55, 60–1, 69, 73, 76, 105, 123, 128, 140, 145, 153–8, 160
Apollo 49, 50, 52, 69, 118, 123, 136, 138
Ara Borghese 52
Arcadia 107, 109, 110–13, 117, 121, 124–5, 126, 133–4, 136, 138, 140, 159
Artemis
 see Diana
Austen, Jane 14

Barberini
 family 18, 62, 63, 71
 Cornelia Costanza 69, 71–4, 87, 113, 158
 Francesco junior 70
 Urbano 70
Barberini Colonna di Sciarra
 Maria Artemisia 70–1, 75
 Maria Felice 60–4, 75, 82
 Urbano Maria 71
Barocci, Federico 18

Barroero, Liliana 110
Du Barry, Jeanne 67
Barthes, Roland 21, 157
Bassett, Francis 89
Batoni, Pompeo 1–3, 12–13, 18, 37, 39–41, 44, 46, 77, 80, 89, 93, 95, 97, 105, 112, 118, 120–1, 126, 128–9, 133, 135, 151
Beckford, Peter 37, 44, 52, 55, 88–9, 93, 95, 151
Bellori, Giovanni Pietro 108
Benedict XIV 11
Benocci, Carla 80
Black, Jeremy 88
Boccapaduli, Margherita 75, 140, 143–4, 159
Boncompagni, Maria Teresa 70
Boncompagni Ludovisi, Antonio 105, 114, 115
Boothby, Brooke 51
Borghese
 family 49, 51, 54, 127
 Camillo 49, 52, 54–5, 156
 Francesco 126
 Marcantonio 49
 Scipione 49
Borghini, Maria 113
Bosco Parrasio 109–10, 117–18, 119, 120, 124, 126, 138
Boswell, James 7
Bronzino, Angelo 18
Brunetti, Francesco Saverio 112
Burke, Peter 20

Caetani, Carlotta 69
Camuccini, Vincenzo 18
Canevari, Antonio 115
Castiglione, Caroline 70
Castle, Terry 69, 74
Cavallucci, Antonio 18
Cavendish, Richard 41, 89, 95
Chigi
 Sigismondo 26, 35–6, 54–5, 156
 Vase 26
Christina, Queen of Sweden 107–8, 123
Cicisbeo 84–7
Clark, Anthony Morris 4, 93, 133
Clement XI 41, 108
Clement XIV 27, 35
Cleopatra
 Queen of Egypt 76–7, 86
 myth 76–7, 87
 narrative 80, 82, 84, 87, 94, 97, 115, 128, 158
Colonna
 Agnese 124
 Filippo III 82
 Maria Felice 82
 Vittoria 114
Colonna di Sciarra
 family 70
 Francesco 70
 Giulio Cesare 61, 70
Corilla Olimpica 124
Corsini
 family 62
 Bartolomeo 61, 63, 75
 library 62
 Vittoria 80
Costanzi, Placido 18, 121
Cotes, Francis 69
Council of Trent 10
Counter-Reformation 7, 9–10, 30
country house 12, 45, 93, 133, 160
 living 135
 context 44–5, 46, 51, 93, 133, 159–60
 visit 14
 poems 45

Craske, Matthew 4, 87
Crescimbeni, Giovanni Mario 108–10, 112–13, 134, 136, 145
Crespin, Daniel 124
Crichton, Caroline 52, 55, 157

Dehn, Cristian 142
Dehn Dolce Faustina 142
De la Lande, Jérome 83
Devis, Arthur 45
Devoti, Fabio 61
Diana 64, 68–9, 72–4, 76, 87, 97, 99, 121, 126, 134, 158
Diderot, Denis 67
Divine Comedy 136
Dolan, Brian 13
Dolce, Francesco Maria 142
Doria Pamphilj
 family 10, 19
 Andrea 9
 Vittoria 9
 Leopoldina 9
Dundas, Thomas 97

Endymion 98–9

Fetherstonhaugh
 Matthew 129
 Utrick 135
 portrait series 133, 135
Frangipane
 family 30
Francis, Philip 54
Fisher, Catherine Maria 84
Forbes, William 125
Fox, Mary 128

Gabrielli, Caterina 126
Gaia Caecilia 63
Gainsborough, Thomas 47
Ganymede 68
Giardino del Lago 49, 51–2
Gladiatore 51
Gravina, Gian Vincenzo 105, 108
Graziosi, Elisabetta 113

Gideon, Sampson 95
Grand Tour 2, 11–13, 17, 36, 37, 41, 46, 87–8, 91, 93, 95, 128–9, 133–4, 138, 145, 151, 153, 156, 159
 portrait 1–2, 13, 36, 41, 46, 55, 74, 94, 128, 134, 140, 144, 151, 160

Hamilton, Archibald 97
Hamilton, Douglas 52, 91
Hamilton, Hugh Douglas 52
Hamilton, Gavin 91, 93
Haskell, Francis 3–4
Hays, Mary 76–7
Hebe 66–8
Hercules 68
Hervey, Frederick Augustus 52
Hippocrene source 119
Hoare Coalt, Richard 16
Honour, Hugh 3–4
Hyde Minor, Vernon 110, 118, 120, 123
Hymen 61, 64, 68

Isis 69

Johns, Christopher MS 41

Knatchbull-Wyndham, Wyndham 47, 138
Knight
 Ellis Cornelia 75
 Phillipina 75

Landi, Gaspare 18, 26
Lanzi, Luigi 5
Lavinia 63–4
Leeson, Joseph 126, 129
Lethieullier
 Benjamin 129
 Sarah 129
Letho 72, 121
Littlewood, Ian 11–12
Lo Bianco, Anna 110
Locatelli, Andrea 31

Lorrain, Claude 31
Lucretia 77

Maratti
 Carlo 18, 39, 77, 108, 136
 Faustina 136
Marino, Giovanni Battista 107
Massimo
 family 30
Masucci, Agostino 18, 26, 80
Matteini, Teodoro 26
Miller, Anne 75
Minerva 47, 118, 138
Minerva Giustiniani 95, 118
Montioni, Francesco 77
Moore, John 15, 91, 124–5
Museo Nazionale di Palazzo Venezia 16
Museo di Roma 17
Musters, Sophia 67–8
mythology
 classical 76, 153, 157, 158
 social 73–4, 84, 113, 159

Napoleon 51–2
National Trust 17
Nattier, Jean-Marc 65, 68
Nicholson, Kathleen 67
Niobe 72
Nocchi, Bernardino 49, 51
Nuova Arcadia 108

Odescalchi, Anna Paola 105, 121
Orsini
 family 121, 123–4, 126
 Domenico 121, 123
 Giacinta 105, 107, 112, 114–15, 117–21, 126, 128, 133, 138, 142, 144, 159
 Filippo 121, 123
Ovid 49, 118, 121

Pacetti, Vincenzo 50
Pallavicini
 Niccoló Maria 136, 144
 Lazzaro 136

Pallavicini-Rospigliosi
 family 19
Palazzo Altieri 30
 Barberini 39, 64
 dei Conservatori 41
 Poli 82
 Orsini-Savelli 123
Panini, Giovanni Paolo 31
Parini, Giuseppe 85
Peachey, John 41, 44
Pécheux, Laurent 40
Pegasus 118
Pelling, C.B.R. 86–7
Perry, Gill 67
Petrarca, Francesco 107
Philip V 70
Pikler
 family 142
Pliny 76–7
Plutarch 76
Pointon, Marcia 14–15, 18
Pompadour de, Jeanne Antoinette 67
Porta, Giovanni Domenico 27
Possesso 35

Quondam, Amedeo 110, 125

Retford, Kate 60
Reynolds, Joshua 60, 84, 151
Roma 41, 44, 46, 93, 95
Roslin, Alexander 82
Rospigliosi, Camillo 26, 35
Rudolph, Stella 77, 110, 136

Salviati, Vittoria 70
Sannazzaro, Jacopo 109
Santa Caterina da Siena a
 Magnanapoli 70, 75
Santacroce, Girolama 80, 82
Selene 69, 97–9
Shonibare, Yinka 12

Sidney, Philip 134
Silvagni, Davide 30
Smollett, Tobias 45, 88
Spencer
 Georgiana 128
 Robert 49
Spinelli-Carafa, Anna Beatrice 113
Susinno, Stefano 110

Tarquinus Priscus 63
Temple of Sybil 47
Titian 18
Trevisani, Francesco 18, 39
Tor dé Specchi 75

Uppark 129, 159
Urban VIII 8, 62

Van Dyck
 Anthony 18, 47
 costume 46–7, 49, 138, 158
Vickery, Amanda 75
villa
 concept 31–2, 45, 50
 Borghese 31, 49–52, 55
 Mondragone 127
Virgil 136, 153
Visceglia, Maria Antonietta 9
Visconti, Ennio Quirino 26
Von Stosch, Philipp 142

Walpole, Horace 8, 40
Weeping Dacia 41, 93
West, Shearer 47
Wilmont Eardley, Maria 95
Winckelmann, Johann Joachim 26, 89
Wright of Derby, Joseph 51

Zeri, Federico 142
Zeus 66, 68, 98, 121